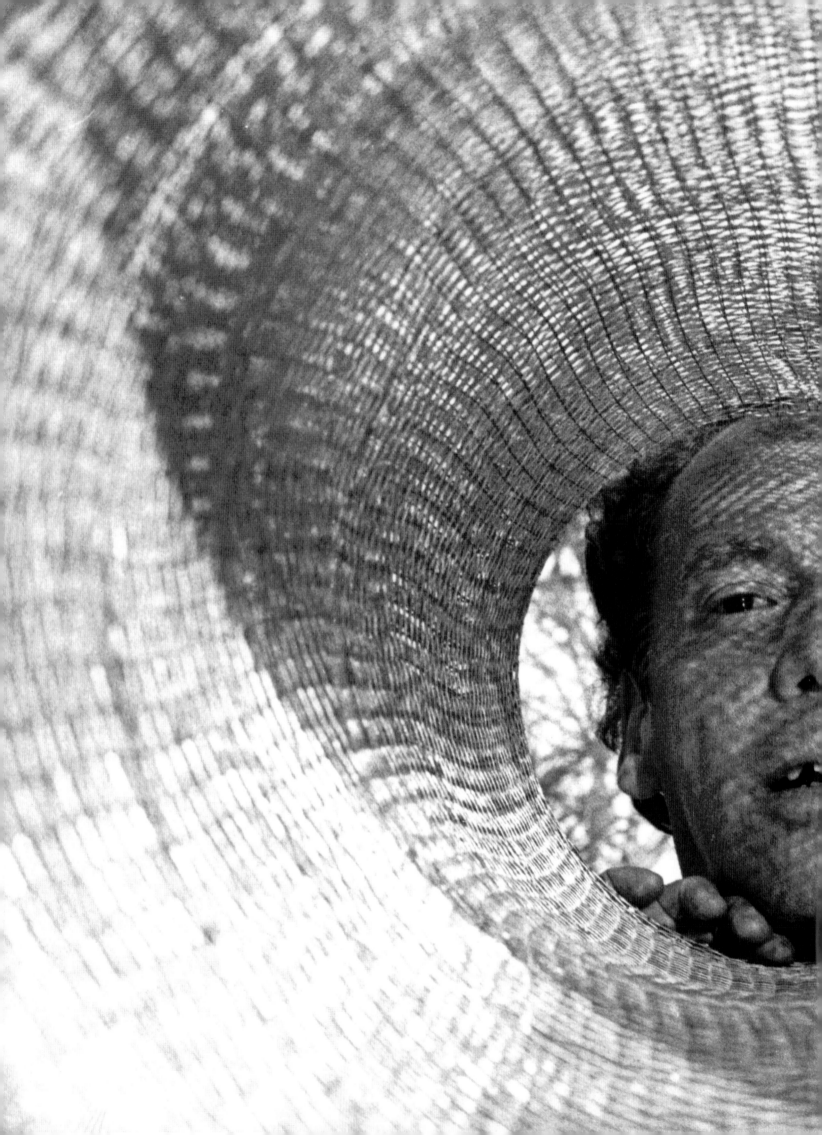

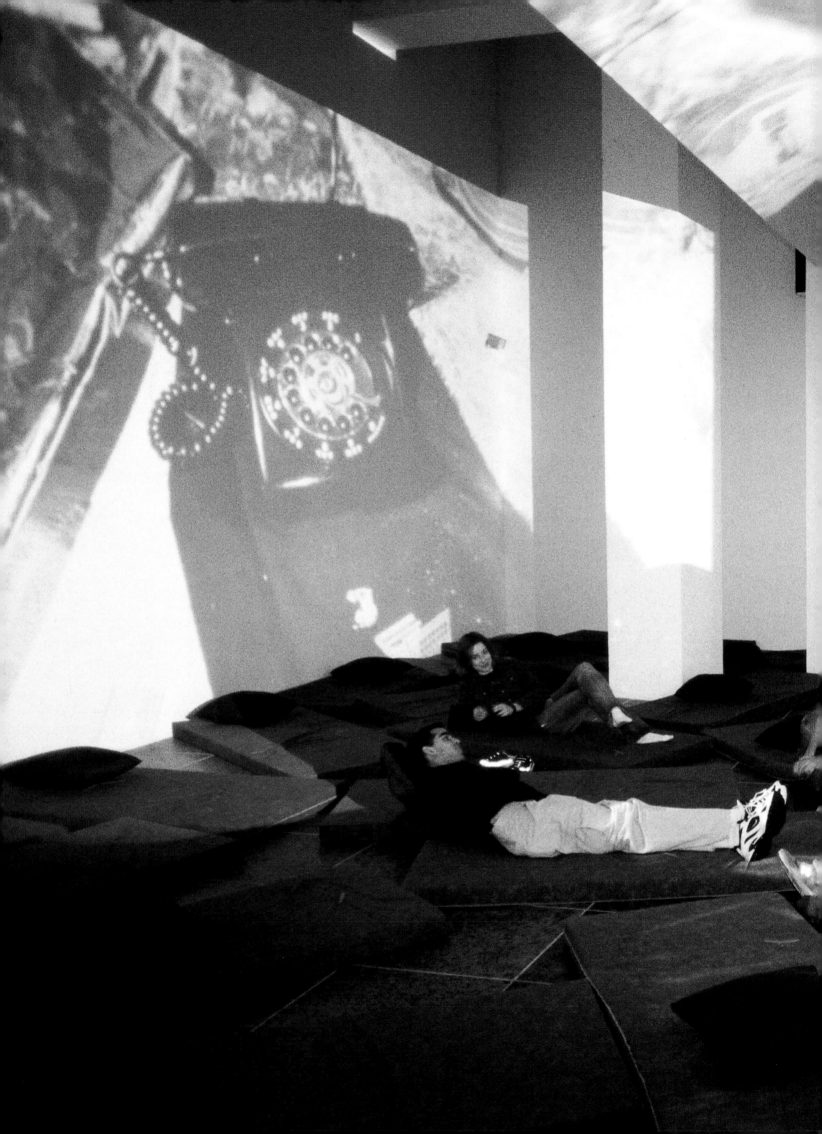

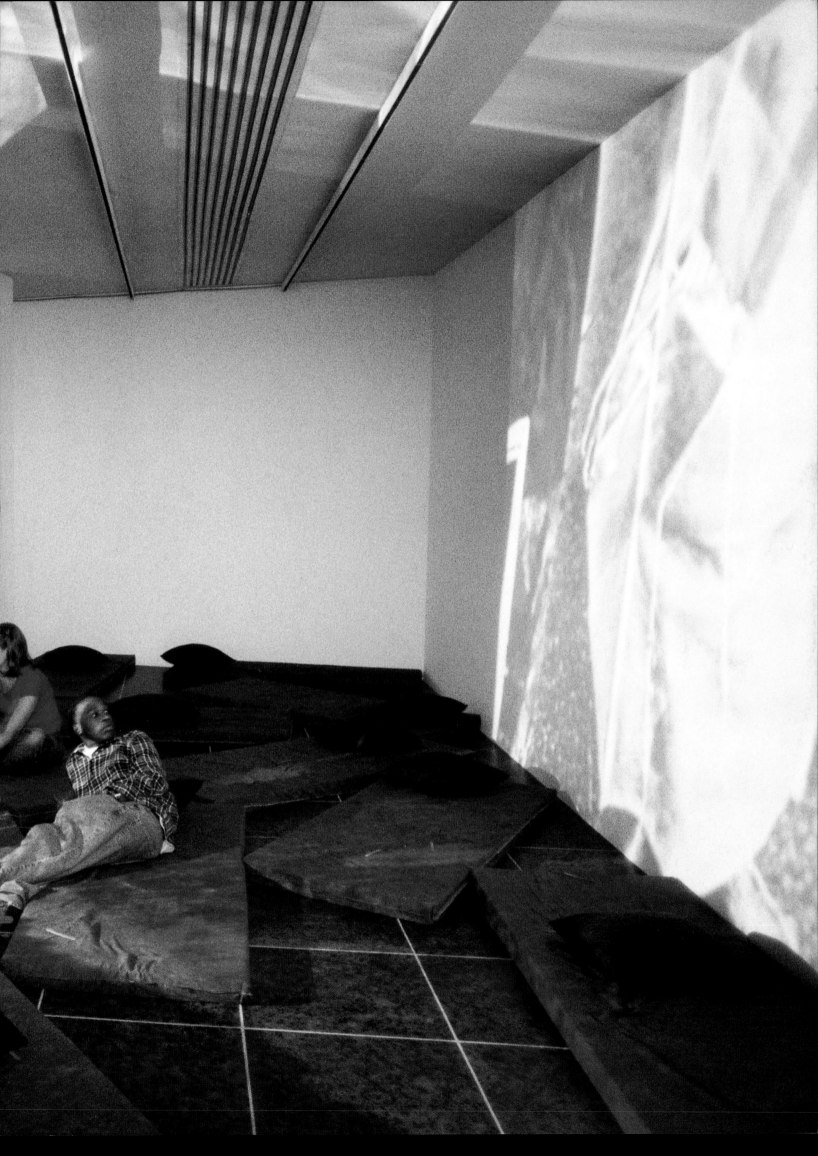

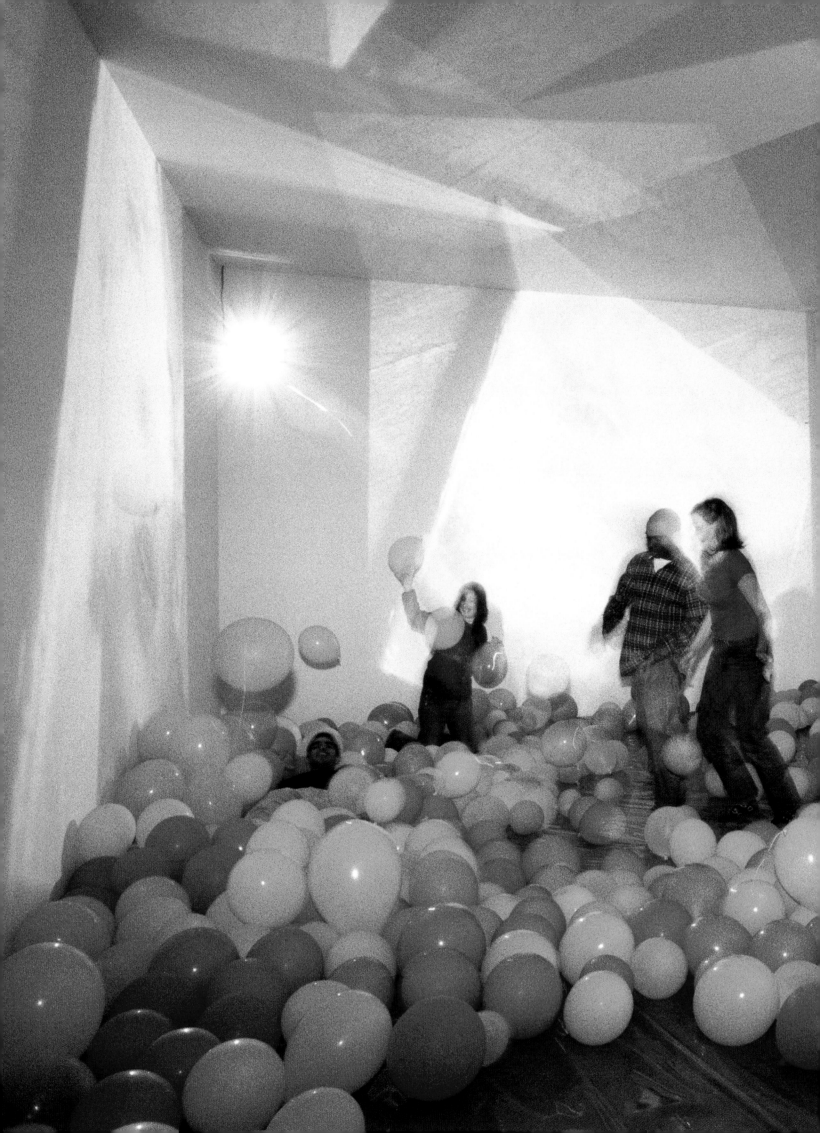

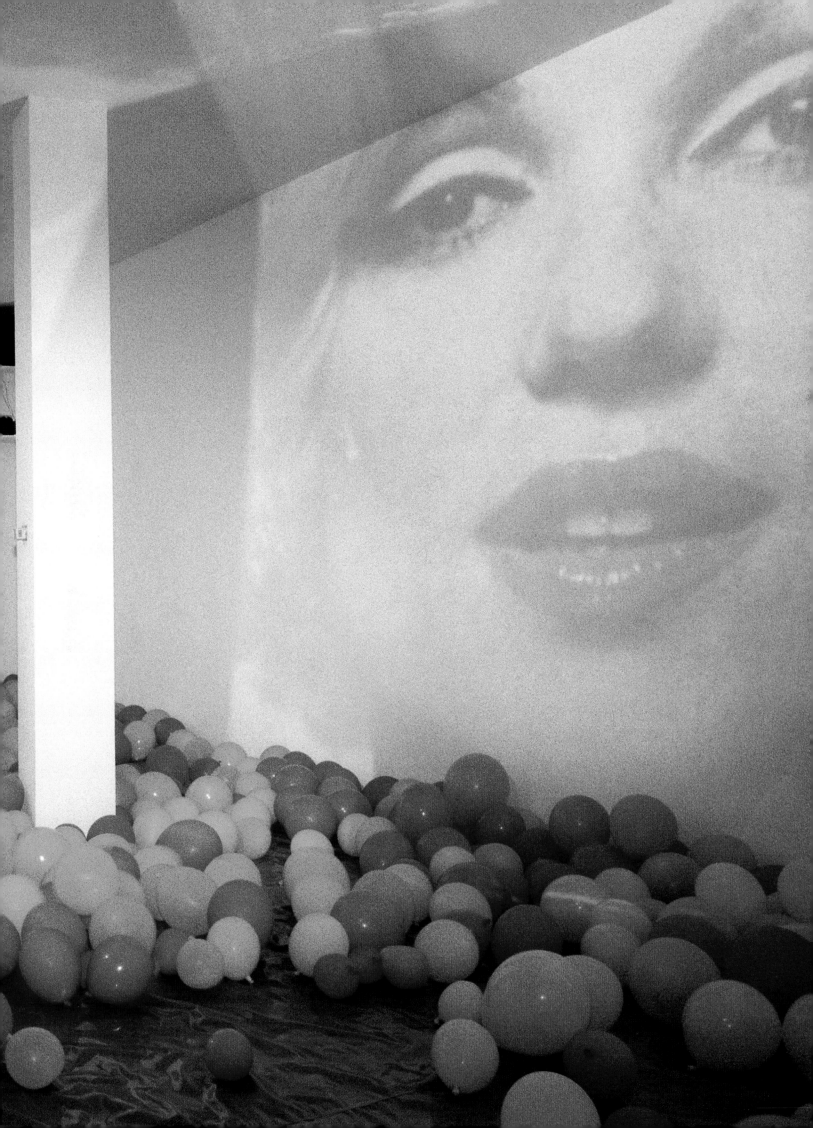

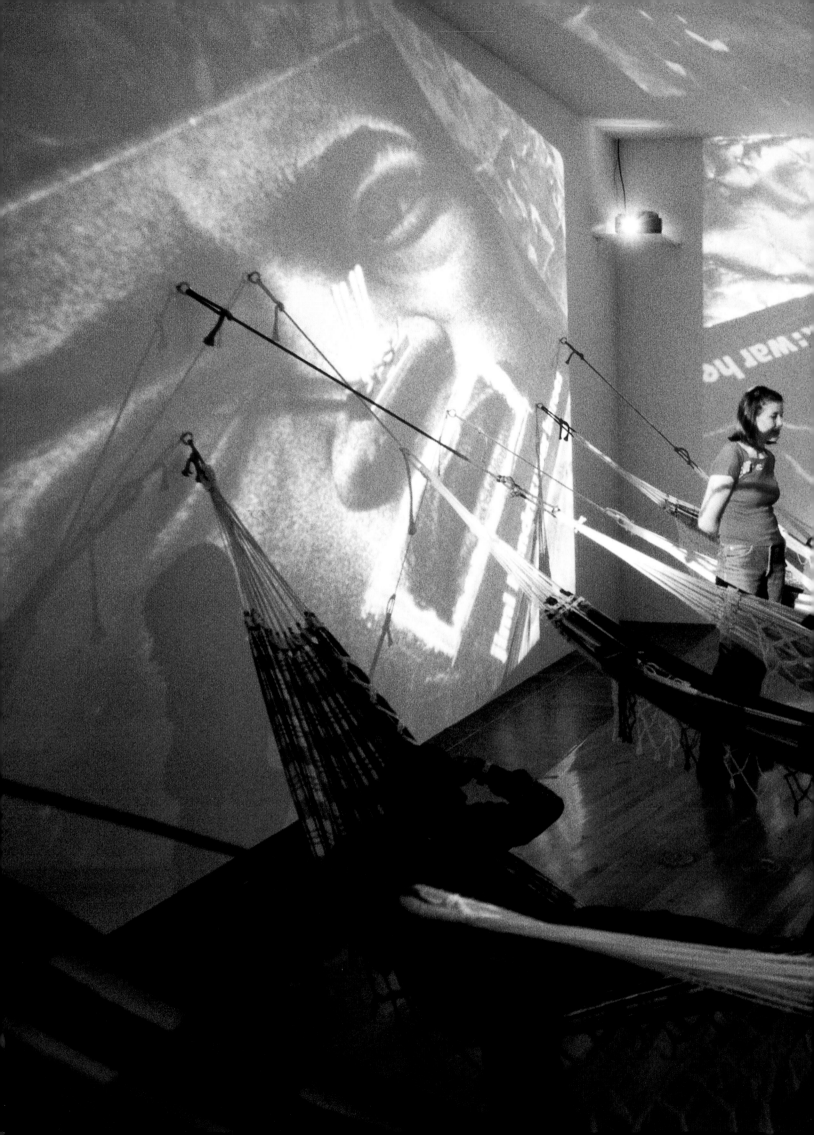

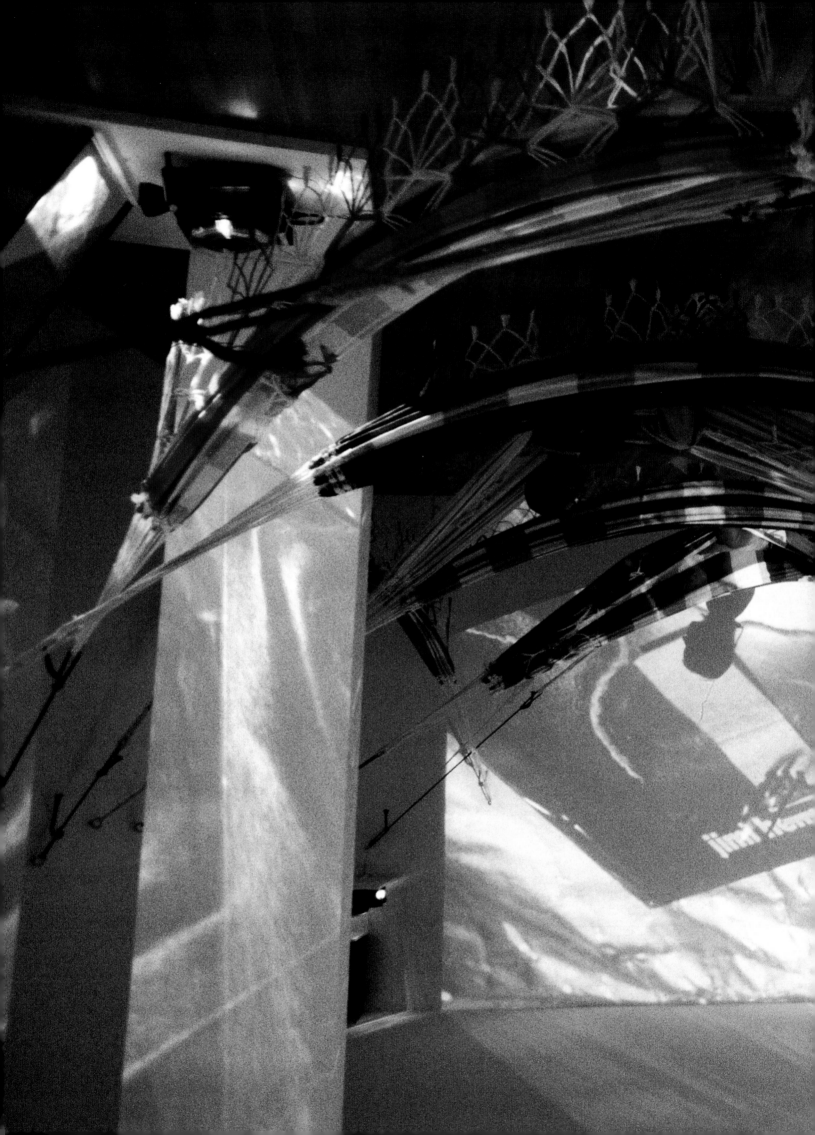

Hélio Oiticica
Quasi-Cinemas

Cover illustration
Hélio Oiticica
Neyrótika, 1973
Slide from series
Courtesy Projeto Hélio Oiticica

Introductory image sequence
Hélio Oiticica during the filming of
Ivan Cardoso's *HO,* 1978
Photo: courtesy Ivan Cardoso

Hélio Oiticica and Neville D'Almeida
*Block Experiments in Cosmococa,
Program in Progress,* 1973
CC1 Trashiscapes: slide series,
mattresses, pillows, nail files, and
soundtrack
CC3 Maileryn: slide series, sand,
vinyl, balloons, and soundtrack
CC5 Hendrix-War: slide series,
hammocks, and soundtrack
Courtesy Projeto Hélio Oiticica and
Neville D'Almeida
Installation views, Wexner Center
for the Arts
Photos: Richard K. Loesch

Carlos Basualdo

Hélio Oiticica
Quasi-Cinemas

Kölnischer Kunstverein
New Museum of Contemporary Art
Wexner Center for the Arts

in association with
Hatje Cantz Publishers

Table of Contents

Directors' Foreword

As an exhibition and a publication, *Hélio Oiticica: Quasi-cinemas* is a project that reflects the vibrant, pervasive internationalism of the contemporary art world. Three collaborating institutions from the United States and Germany have joined together to research and present Brazilian artist Hélio Oiticica's works related to cinema, which he developed during an eight-year stay in New York City. Curated by Carlos Basualdo, who hails from Argentina but is now based in Columbus, Ohio (while also participating on the curatorial team for Documenta 11), this endeavor clearly has global reach. It also spans over two decades in the making: although the *Quasi-cinemas* were conceived in the 1970s, only in the last few years have they begun to generate significant critical response.

Oiticica's work has attracted considerable attention over the last decade, but the full implications of his *Quasi-cinemas* have rarely been considered. This is doubtless a result in part of practical considerations; experiments with enveloping projections and sound-image combinations, the *Quasi-cinemas* aimed to critique and reconfigure the relationship between artwork and audience in radical and inventive ways. Few of the works were exhibited publicly during the artist's lifetime, and the first challenge this project set itself was how best to present recreations of those chosen for this exhibition. Thanks to the generous participation of Neville D'Almeida, Oiticica's long-time collaborator, we believe we have captured the spirit of creative ambition so evident in their original coproductions.

A second challenge was to examine and express these reconstructed works and other *Quasi-cinema* proposals in the format of this volume. As Basualdo, the Wexner Center's chief curator of exhibitions, writes in his catalogue essay, «the obsessive level of detail in his notes contrasts brilliantly with the generosity of the themes explored.» The catalogue reflects both sides of this contrast in copious extracts from Oiticica's writings, many of them previously unpublished. Essays by Basualdo, New Museum senior curator Dan Cameron, and film historian Ivana Bentes investigate the place of these works in the context of Oiticica's own oeuvre and that of Brazilian culture in the 1960s and 1970s. They also reveal Oiticica to be central to the discourses that continue to shape our understanding of art's making, its dissemination, and its reception. Indeed, it strikes us that Oiticica takes his place alongside Andy Warhol and Joseph Beuys in their insistent integration of the passive, the performative, and the immersive.

Each of our institutions is committed to the kind of provocative and wide-ranging innovations Oiticica's *Quasi-cinemas* represent, and we welcome this opportunity to set this work before new audiences.

We take pleasure in adding the Whitechapel Gallery in London—where, in 1969, Oiticica showed his work for the first time outside Brazil—to the exhibition tour, and the itinerary may yet include other venues that will bring the project to additional viewers.

We are enormously grateful to BrasilConnects and its President Edemar Cid Ferreira, and to Stiftung Kunst und Kultur des Landes NRW (the Arts and Culture Foundation of North Rhine-Westphalia) and Stadtsparkassse Köln, for generous sponsorship of the exhibition. We express additional appreciation to our respective trustees for their unwavering support of such ambitious endeavors and join Carlos Basualdo in his thanks to those mentioned in the acknowledgments that follow. We're honored to recognize all who have brought this project to fruition and believe it has been well worth the wait.

Sherri Geldin
Director, Wexner Center for the Arts

Udo Kittelmann
Director, Kölnischer Kunstverein

Lisa Phillips
The Henry Luce III Director, New Museum for Contemporary Art

Acknowledgments

Many individuals and institutions have assisted enormously in realizing this project and publication. I begin by echoing the directors' gratitude to BrasilConnects and its President Edemar Cid Ferreira and Curator Nelson Aguilar, and to Stiftung Kunst und Kultur des Landes NRW and Stadtsparkassse Köln, for their significant support of the exhibition.

The talented staff at the Wexner Center for the Arts and our gracious partners at the Kölnischer Kunstverein and the New Museum of Contemporary Art also have my appreciation for their skill and vision in realizing *Hélio Oiticica: Quasi-cinemas*. Additional thanks go to Markus Hartmann, his associate Christine Müller at Hatje Cantz, and designer Saskia Helena Kruse, for their cooperation and careful attention in preparing this catalogue.

Others who have assisted with advice, research, illustrations, translations, and numerous small and large responsibilities related to both the exhibition and the catalogue include Mónica Amor, Fernanda Arruda, Artur Barrio, Ivana Bentes, Francesco Bonami, Júlio Bressane, Ivan Cardoso, Corina Crosetti, Catherine David, Chris Dercon, Gloria Ferreira, Marian Goodman and Lane Coburn of Marian Goodman Gallery, Sheila Glaser, Brian Holmes, Claudine Kaufmann, Pascal Bejean and Frederick Bortolotti of Labomatic, Paris, Reinaldo Laddaga, Lisette Lagnado, Ricardo Ribenboim, Waly Salomão, Angeline Scherf, Luisa Strina of Galeria Luisa Strina, and Octavio Zaya.

Finally, on behalf of everyone associated with this project, I offer sincere gratitude and appreciation to Cesar Oiticica of Projeto Hélio Oiticica and to artist and filmmaker Neville D'Almeida, Oiticica's partner in creating several of the featured *Quasi-cinema* projects. Without their generous cooperation both the exhibition and the catalogue would have been truly unimaginable.

Carlos Basualdo

Hélio Oiticica
Neyrótika, 1973

Slide series, soundtrack
Courtesy Projeto Hélio Oiticica

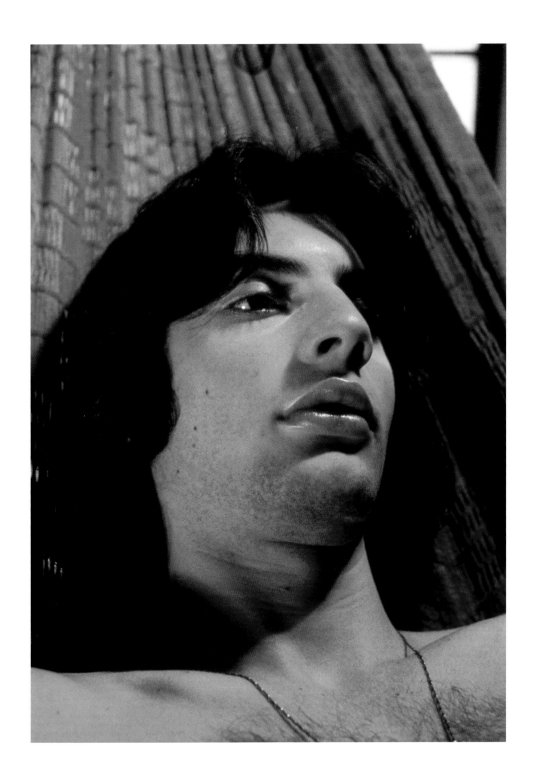

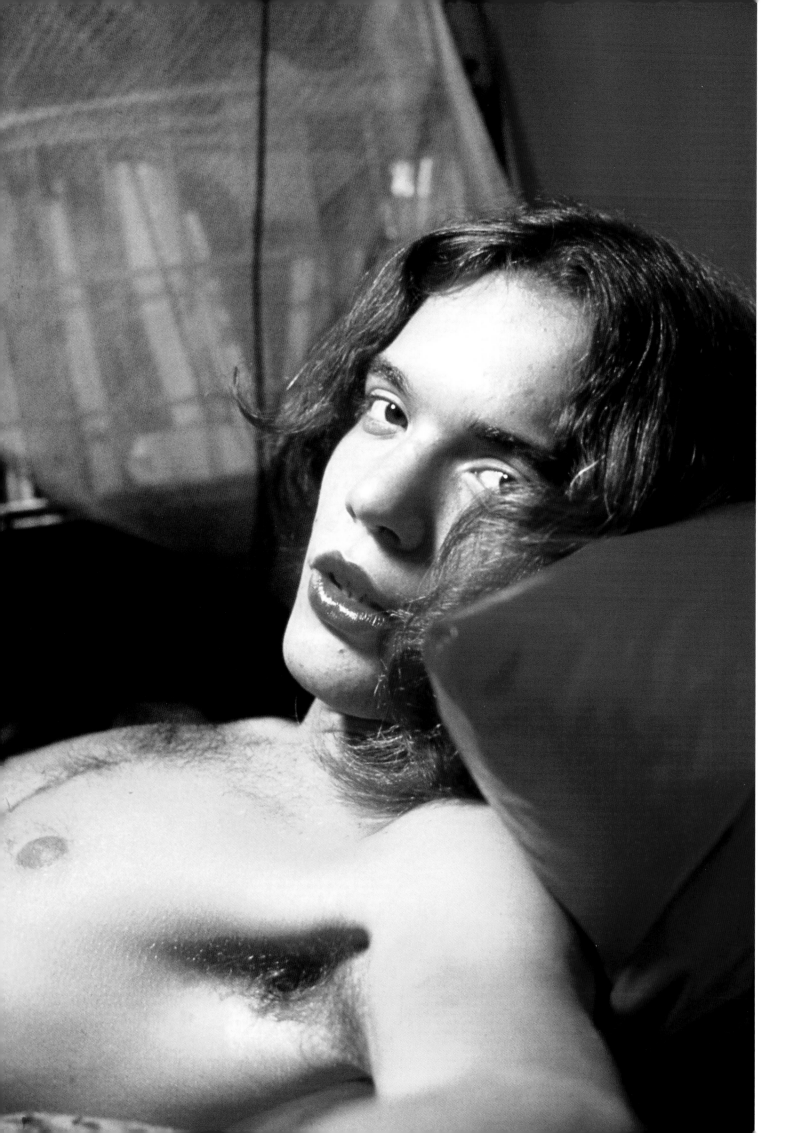

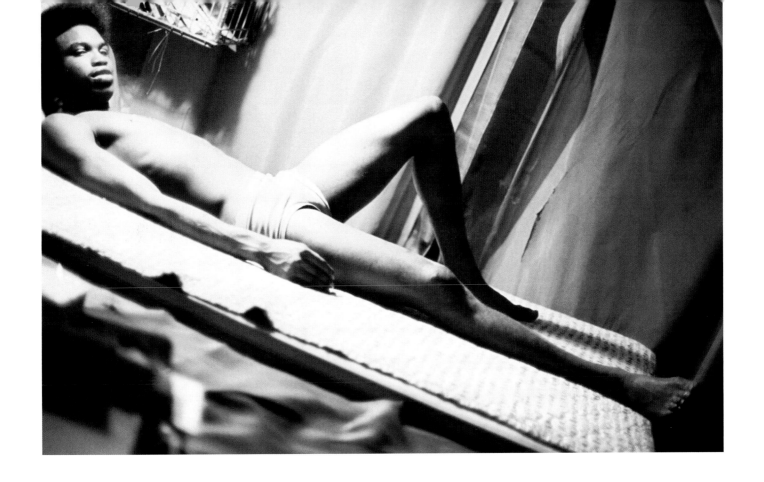

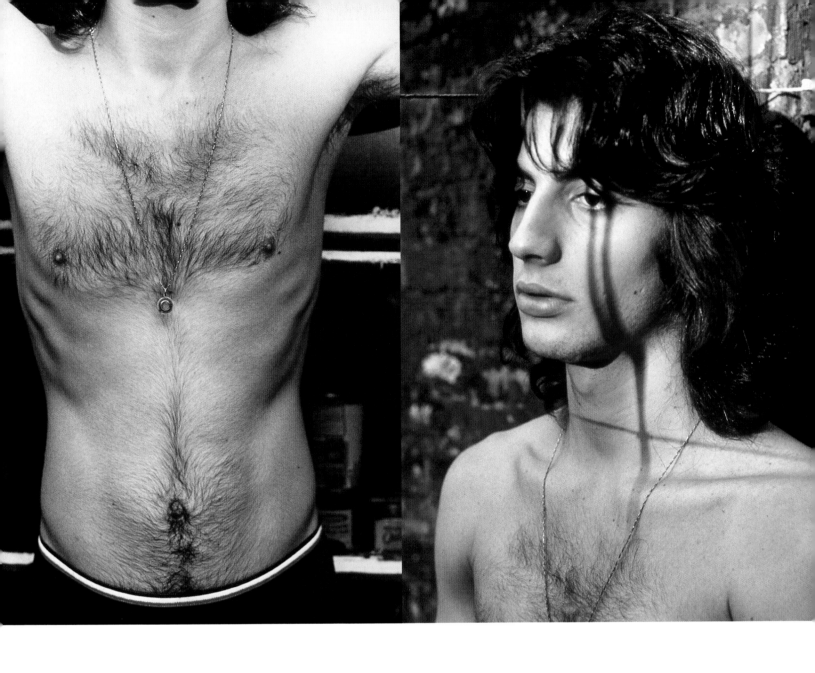

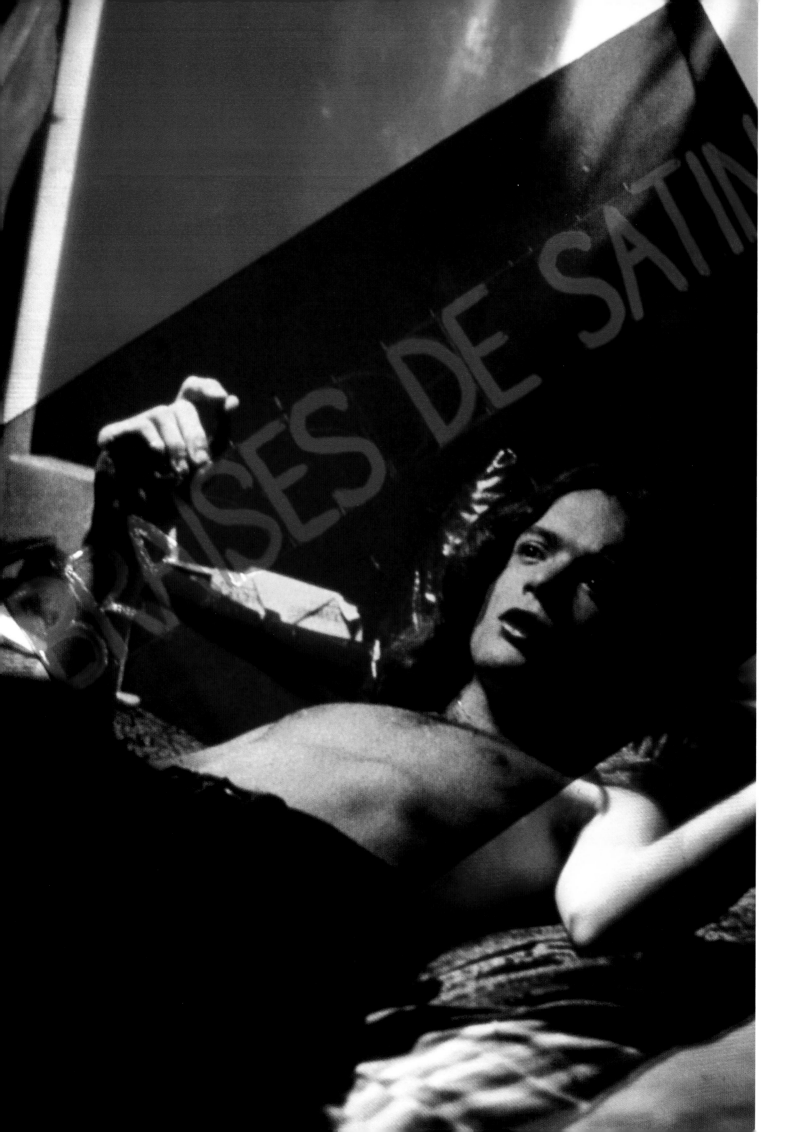

Hélio Oiticica
Helena inventa Ângela Maria,
New York 1975

Slide series, soundtrack
Courtesy Projeto Hélio Oiticica

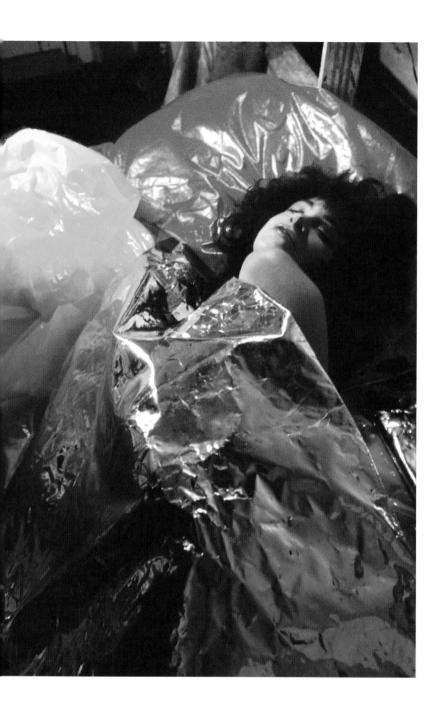

Through the Glass, Darkly
Dan Cameron

Even for viewers who pride themselves on their knowledge of artists who have been overlooked or underrated during their time, the place of Hélio Oiticica in the annals of the art of the twentieth century poses an original dilemma in the practice and theory of art history. When Oiticica died in 1980, his work was appreciated by a small coterie of followers in Brazil and in other parts of the world. However, it was not until more than a decade after his death, when an exhibition of his work was co-organized by the Jeu de Paume in Paris and the Witte de With in Rotterdam, that the international art world began to get a clear sense of the scope of his contribution. Although that exhibition ended up traveling to several museums, and initiated a wave of curatorial and scholarly interest in Oiticica that has ranged from Documenta to the Havana Bienal (among many others), it could probably be said that most viewers in the U.S. would be hard-pressed to describe just how pervasive Oiticica's influence has become, and why. Despite this lapse in the dissemination of knowledge, the range of artists today in whose work a trace of Oiticica's influence can be detected is incalculably broad.

In discussing something as ephemeral as influence, which even in the best of circumstances is comprised of equal parts conjecture, projection, and myth-making, one is usually referring to a process that is conscious on the part of at least one principal: either the one who influences or the successor. What is unique in Oiticica's case, however, is the fact that most of the transformations that have taken place since his death, and in which his work might be said to have played a part, took place without his being aware of their gestation, and concerned the work of artists who to this day may never have heard of him. Put another way, several of the most significant paradigm shifts in art-making during the past decade—the repositioning of the spectator and redefinition of public space, the role of cultural

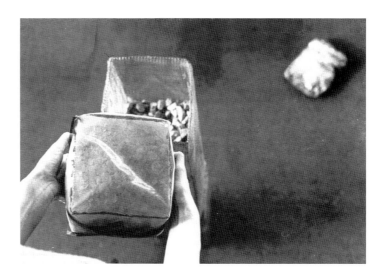

Hélio Oiticica
Bólide Vidro 13 [Glass Bolide 13],
1964–65
Photo: Guy Brett

issues and identity, the integration of art and everyday life—were absolutely key to Oiticica's undertaking. As artists and institutions have struggled in recent years to produce new values out of the changed demands on art objects and their surrounding discourse, Oiticica's art has understandably moved into sharper focus. On the one hand he was far ahead of his time in articulating the need for artists to reaffirm their place within society as a whole, while on the other he seems almost prescient in his exploration of principles that would not become art world currency until decades later. The hypothetical dimension of the argument in favor of Oiticica's work is largely based on conjecture: if the world at large had known of his work, he would have become much better recognized. And yet, since most of the ideas he proposed did not become standard practice until after his death, he can also be said to have possessed an unusually prescient understanding of the degrees to which many forms of art-making would come to seem irrelevant as the century drew to a close.

One of Oiticica's key beliefs revolved around the principle that art's relationship to established social hierarchies was artificial and unhealthy. As he witnessed his country's gradual transformation from a passive source of enormous colonial wealth to a republic struggling to achieve some measure of democracy, Oiticica was drawn, as many have been before and since, to the overwhelming tragedy of Brazil's incessant struggle against poverty. An integral part, personally and artistically, of the Tropicalism movement of the late 1960s and early 1970s, whose name he is credited with inventing, and which raised popular culture to a higher level of political importance than had previously been possible, Oiticica became determined to raise the bar even higher. In his works of the 1960s, he created a standard of expression that required the active participation and validation of the residents of Rio de Janeiro's harsh *favelas* in order to be designated completed artworks. Drawing upon a lack of material wealth as a kind of philosophical advantage, Oiticica went further in challenging the established bonds between the vanguard artist and the social elite than any other significant artist in recent memory. When compared to works made around the same time, with similar intentions, in Europe and the U.S., what may strike viewers as the most compelling feature of Oiticica's art is the thoroughness with which his art corresponded to his analysis of society. While such developments as Arte Povera in Italy seem to have been predicated on the rising hegemony of the U.S. in global affairs, and whereas Minimal artists in the U.S. may have wished for their work to communicate a camouflaged protest against the escalating war in Vietnam, none of these artists ever came close to directly addressing the cultural situations that so deeply distressed them.

With Oiticica, however, the connection was not merely visible, but also acutely felt. A partial explanation for the depth of his commitment may be found in his artistic evolution during the 1950s and early 1960s, when he, along with Lygia Clark and Lígia Pape, devel-

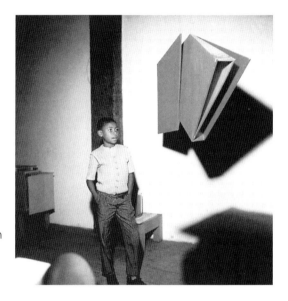

Mosquito of Mangueira and *Relevo Espacial* [Spatial Relief], 1959, at a 1964 exhibition, Galeria G4, Rio de Janeiro
Photo: Pedro Oswaldo Cruz

oped out of a late-Constructivist approach to working a new movement, New Objectivity, that extended the predominantly abstract concerns of the former into a more highly charged confrontation with the inequities of class and social justice in Brazil. The earlier work, which had brought Oiticica's name to the forefront of the Brazilian art scene, also seemed to inure him from the notion that his work was veering towards an area that could only be described as non-art. Despite the radical appearance of his *Parangolés*, for example, and the way that they are meant to be worn as dancers' costumes, Oiticica's particular genius with regard to color and planar design ensured that no one could claim that these works were, in the strictest visual terms, anything but art. In fact, the evolution from plastic artist to social sculptor, which echoes the growth of Joseph Beuys's ideas along similar lines, seems to be in keeping with the European abstractionists of the 1920s and 1930s, in whose idealistic projection of pure planar geometry into modern life the roots of Oiticica's early abstract style can be easily identified.

One of the lesser-known aspects of Oiticica's artistic development has to do with the nearly ten years that he spent living in New York during the 1970s, at which time he experimented with the incorporation of cinematic principles into his art. Like many before and after him, he glimpsed the promise of art's eventual democratization within the media of film and video, and his forced distance from the immediate concerns of Brazilian life and politics—the country was at the time in the grip of a military dictatorship that would last another decade—enabled him to undertake his experiments free of some of the direct burden of his commitments. Another important factor spurred on Oiticica's rapid artistic growth during this period: the peculiarly liberationist atmosphere that enveloped New York's cultural intelligentsia at that moment. The war in Vietnam was still raging, but the tide of public opinion had turned in favor of anti-war protestors. The civil rights movement had exploded into a multitude of competing projects of vastly different degrees of radicalism. The women's movement had just begun in earnest, and the quest by gays and lesbians for respect and dignity was drawing unprecedented amounts of media attention. More so than at any time in the immediate past and future, the New York art world projected a contagious air of freedom and experimentation, and Oiticica's ability to separate himself artistically from the work he had already produced was certainly a crucial factor in the quantum leap that took place upon his eventual return to Brazil in 1978.

What has been missing until now from most narratives of Oiticica's art is a detailed examination of the work produced during this extended sojourn, and the place it holds within the entirety of his oeuvre. In particular, the exhibition at hand treats a series of works entitled *Quasi-cinemas*, and, within that context, a smaller group called the *Cosmococas*, which, loosely described, are room-sized installations in which projections of 35mm slides, audio tapes, and accumulations of (usually) natural materials are presented within a

Mosquito of Mangueira wearing *Parangolé P4 Cape 1*, opening *Plástica Bólide 1* [Plastic Bolide 1], 1966
Photo: Hélio Oiticica

space that has been architecturally modified through lighting, seating arrangements, and, in one case, the suspension of hammocks from the ceiling. On a purely formal level, it is not difficult to extrapolate from certain of the *Cosmococas* to the larger environment-scaled installations that Oiticica had begin carving out of exhibition settings at the end of the 1960s. But their unique place, and by extension their importance, within late-twentieth-century art has to do with Oiticica's rapid-fire assimilation of the tools and vocabulary of the then-nascent experimental video art movement into a mode of investigation that is technically primitive, structurally open-ended, and bracingly intimate. Some of these developments would constitute an important part of Oiticica's investigations from that point forward; others would wind up becoming a brief foray into the most experimental ideas of the time. Surprisingly, however, all of these factors ended up becoming thoroughly absorbed and synthesized into his already-mature artistic sensibility, making the *Quasi-cinemas* as engaging and, ultimately, as revolutionary as any other accomplishment in Oiticica's remarkable career.

Although Oiticica did not have sustained contact with most of the critical figures in the New York art scene of the 1970s, locating his work within the range of artistic investigation unfolding at that time is essential for understanding the implications of this body of work. Most significantly, the slide-show events organized by Jack Smith in his East Village loft, which unfolded over several hours and required that the audience endure a charged atmosphere in which nothing transpired for long periods of time, were nothing short of revelatory for Oiticica. Not only was Smith's radicalized homosexuality at the core of his presentations, these works embraced a deliberate effort to undercut the smooth flow and slick editing of Hollywood-based entertainment that appealed strongly to Oiticica, who was at that point engaged in an effort to challenge the alienated passivity of the spectator. It is also impossible to discuss Oiticica's art at this time without considering the impact of Andy Warhol. Although by the 1970s Warhol had already developed into a cultural icon, with a fairly obsequious relationship to the powers that dictated social order, his initial starstruck attitude towards celebrity and glamour, and his early efforts to duplicate the Hollywood star system on a miniature, homegrown scale, deeply impressed Oiticica, who made an effort to get to know some of Warhol's «superstars» personally upon his arrival in New York. In addition, Oiticica's «appropriation» of such iconic stars as Marilyn Monroe and Jimi Hendrix, as well as his interest in «found» models, while diametrically opposed to Warhol's infatuation with fame, depended initially on a camp impulse that responded to male beauty and female glamour as a potentially subversive instrument for declaring one's autonomy within a heterosexist social order.

Other artists, with whom Oiticica seems to have had little or no direct contact in New York, nevertheless helped define certain aesthetic issues that made the *Quasi-cinemas* possible. Although he

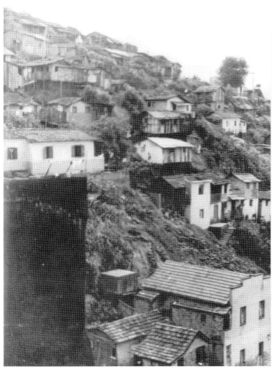
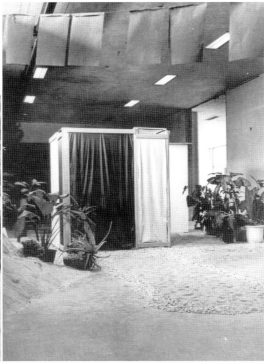

died in 1973, the work of Robert Smithson, who developed a dialectic exchange between the art space of the gallery and the world outside, appears to have provided a fundamental building block for more socially engaged artists like Oiticica, who used a similar mechanism to link the economically dispossessed with society's dominant capitalist ideology. The work of Gordon Matta-Clark, who had begun his dissections of abandoned urban architecture by the time Oiticica produced his earliest installations, is also significant for having transformed an essentially sculptural enterprise into an investigation that carried important political and economic implications. Although the art of Dan Graham may initially be considered as more formally based than that of Oiticica, a fundamental link exists between Graham's desire to employ video technology to liberate traditional notions of the spectator and Oiticica's need to produce environments in which the visitor was both intellectually and physically engaged. Both men, in addition, glimpsed in rock music the potential for a new social order, which collapsed the customary distance between artist and public. Even Oiticica's predilection for using 35mm slides as the basic component in his installations can be linked to the earliest installations of the artist Peter Campus, whose interest in the optics of projection were central to the artistic discourse of the moment.

This presentation of Oiticica's *Cosmococas* and *Quasi-cinemas* comes at a moment when developments within art at a given place and time are no longer understood in the same insular way as they typically have been. The story of the New York avant-garde during the first half of the 1970s, as vivid and inclusive as it may have tried to be, rarely makes mention of the presence of Oiticica, who was, by temperament more than design, very much an outsider. In fact,

Morro de Mangueira [Mangueira Hill], Rio de Janeiro, 1965
Photo: Desdémone Bardin

Tropicália, Penetrables PN2 and PN3, at Museu de Arte Moderna, Rio de Janeiro, 1967

until several years after his death, none of these projects had ever been exhibited in a New York gallery. But to experience the works today, thirty years later, is to come face to face with an aspect of New York's art that many viewers know quite well: the breathless desire to move one's investigations forward at all costs, without consideration of the external reception they might receive. It is a new version of New York's vision of itself, only unencumbered by the formal debates that kept even the most ardent of post-object artists under their spell. Considered somewhat anomalous, until recently, within Oiticica's development, the *Cosmococas* help to make the case that his art was considerably more complex than even his most ardent supporters may have imagined. Certainly, if we try to grasp the import of these installations in relation to developments within Brazilian art in their wake, we run up against an even bigger obstacle, since very few Brazilian artists, even today, have shown much interest in working with new media. In essence, the underlying significance of this project is based on the curatorial view of the museum as a vehicle for championing new viewpoints regarding art history. For if Helio Oiticica's work represents one of the last major artistic paradigms of the twentieth century, and if the *Cosmococas* and *Quasi-cinema* installations characterize the culminating phase of his development, then it is necessary to conclude that the definitive history of the art of the past fifty years has not yet been written, and may never be. If and when this does come to pass, however, the future appreciation of Oiticica's experiments into form, intangibility, and the newly liberated viewer will doubtless reach a much wider and better prepared public.

Dan Cameron is senior curator at the New Museum of Contemporary Art, New York.

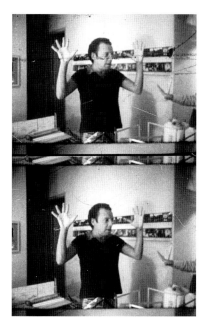

Hélio Oiticica during the filming of
Ivan Cardoso's *HO*, 1978
Photo: courtesy Ivan Cardoso

Waiting for the Internal Sun:
Notes on Hélio Oiticica's
Quasi-cinemas[1]
Carlos Basualdo

1 The title of this text is a quotation from Oiticica's essay «The Possibilities of Creileisure,» originally written for the *Revista de Cultura Vozes* in August 1970 and reprinted in the catalogue of the exhibition *Hélio Oiticica*, co-organized by the Galerie Nationale du Jeu de Paume in Paris, the Projeto Hélio Oiticica in Rio de Janeiro, and Witte de With Center for Contemporary Art in Rotterdam, English/Dutch ed. (Paris, Rio de Janeiro, Rotterdam: 1992). The full phrase reads «…in *Area Bolide 2*, where one lies as if waiting for the internal sun, the non-repressive leisure,» p. 136.

2 «9—WORLD as an *experimental field* signifies: experimental as an exercise for a kind of behavior-fulfillment that at least tends to a notion of *leisure as pleasure opposed to the everyday of leisure as programmed desublimation that sustains periods/ hours of alienated work/production*.» July 28, 1973, NTBK 2/73.

3 While preparing this essay, I consulted several of Oiticica's notebooks from the period 1970 to 1974. The nomenclature used by the artist to classify them consists in an abbreviation of the word «notebook» and an identifying number followed by the year; for example, NTBK 2/73 would indicate the second notebook completed in the year 1973. Oiticica maintained this nomenclature consistently; in the case of exceptions he noted the color of the notebook separately, as an additional classificatory element. Quotations from the notebooks and other writings by Oiticica in this essay maintain his own sometimes idiosyncratic capitalization and spelling.

Hélio Oiticica in Babylonests, one of the «environments» in his apartment, 81 Second Avenue, New York

9—Mundo com *campo experimental* significa: experimental como exercício para um tipo de comportamento-plenitude q ao menos tenda a uma estrutura de *lazer como prazer oposta à atual de lazer como dessublimação programada q sustenta períodos-hora de trabalho-produção alienado*—Hélio Oiticica[2]

It is no accident that several of the relatively rare studies of Hélio Oiticica's work begin by relating the curious combination of vocations within his family circle: his father was an entomologist and amateur photographer; his grandfather was a philologist and militant anarchist. Beginning in this way may just be a logical reaction from anyone who has found the time to look carefully into Oiticica's profuse textual production: piles of notebooks filled with poems, plans for installations and performances, outlines for texts, essay after essay structured according to a logic that is sometimes strictly rational, sometimes wildly erratic. The obsessive level of detail in his notes contrasts brilliantly with the generosity of the themes explored—notes on dance, the consumption of drugs, cinema, and rock music—followed by exacting descriptions of the materials used or needed for the creation of his works, of the way they are to be presented, and even considerations on the possible commercialization of some pieces. For decades, and fundamentally for the almost ten years he lived in New York City, Oiticica composed the multiple volumes of an encyclopedia that painstakingly links his life and his thought, again and again, to the point where they become inseparable. The metaphor of an anarchist philologist's grandson, born to a photographer enamored of the inexhaustible categorizations of entomological taxonomy, becomes irresistible when one must account for the order of a thought and practice that, in the words of his friend the poet Haroldo de Campos, constituted a genuine and systematic attempt «to organize delirium.»

To date relatively few of Oiticica's texts—carefully compiled in successive series of similar notebooks—have been published.[3] This may be why he is commonly identified as an artist who, operating from the contradictory foundations of an education powerfully influenced by the modern tradition and an interest in Brazilian popular culture, produced a synthetic body of work in which the constructivist inheritance became a tool for investigating forms of life ensconced within the precise disorder of the organic architecture of the *favelas*. The literature on Oiticica has centered fundamentally around what can be described as his contribution to the tradition of late constructivism, perhaps for the simple reason that this is the most visible phase of the artist's work. From 1955 to 1969 Oiticica carried out a series of paintings, sculptures, and installations, which, with the commentaries that frequently accompanied them, represent

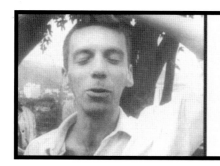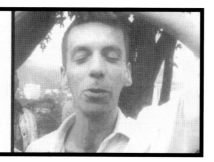

a radical assault on the constructivist tradition of the postwar period
and an ambitious attempt to reinterpret the fundamental postulates
of the modern tradition in its entirety. Oiticica succeeded in realizing
only a tiny fraction of the projects he planned from the outset of the
1970s to his tragic death in 1980. Yet to consult his unpublished
writings is to understand that this last decade of his life and work
was certainly as fruitful as the preceding ones, and that the intellec-
tual discoveries of this period may even oblige us to reconsider the
totality of his previous works. In part, these years can be described
as a period of intense reflection, not only on his existential circum-
stances and future projects, but also and especially on the body of
his earlier work. What emerges from the texts is no longer the con-
crete artist who forces art to fulfill its modern promise, extending
it into the world through the viewer's active participation, but rather
the inventor of ways of life, reconfiguring his work on the basis of
a systematic consideration of the relations between the different
regimes of labor and the subjective formations to which they give
rise. At the center of this effort of intellectual reordering in Oiticica's
late production one finds his relation to cinema, and the series of
works in which the artist addressed the cinematographic image,
works that were given the collective name of *Quasi-cinemas*.

The earliest occurrences of the term *Quasi-cinema* (or *Quase-
cinema*, as it is written on numerous occasions) are found in two
letters that Oiticica drafted in April and June of 1971. In a letter to his
friend the Brazilian poet Waly Salomão, dated April 25 of that year,
Oiticica mentions a performance/work he had seen in New York by
the North American underground filmmaker Jack Smith: «…it began
at ten-thirty, three hours later, and he spent half an hour on the first
three [slides] alone: he moved around the screen in such a way that
the slides were cut upon projection, and he shifted the placement
of the projector to give each one just the right cut: the rest of the
slide spilled over into the environment: incredible; the expectation
and anxiety that overcame me were worth it: it was a kind of quasi-
cinema, for me just as much cinema as you can imagine: the same
complex simplicity that you could feel in godard: more than that,
in my view: the images, the duration of each slide on the screen,
etc., was brilliant and extremely important: sound tract of AM radio
music… Latin malagüeña music, incredible things, noises: telephone
cars in traffic, etc.; it ended at one in the morning: I went away
transformed!»[4] Almost a month later, in a letter to his great friend

4 Letter to Waly Salomão, March 25, 1971, archives of Projeto
Hélio Oiticica, quoted in the brochure of the exhibition *Hélio
Oiticica e a cena Americana* [Hélio Oiticica and the American
scene], held from December 11, 1998, to March 28, 1999,
at the Centro de Arte Hélio Oiticica in Rio de Janeiro.

5 These and numerous other quotes appearing in this text have been excerpted from the volume of correspondence between Oiticica and Clark, compiled by Luciano Figuereido under the title *Lygia Clark/Hélio Oiticica: Cartas 1964–74* (Rio de Janeiro: Universidade Federal de Rio de Janeiro, 1996), p. 204.

6 Quoted by Sylvie Pierre in *Glauber Rocha: Textos y entrevistas con Glauber Rocha* [Texts and Interviews with Glauber Rocha] (São Paulo: Papirus Editora, 1996), p. 253.

Lygia Clark, Oiticica repeated: «…I went to a slide projection with soundtrack, a kind of quasi-cinema, which was incredible…Jack Smith is a kind of Artaud of cinema…»[5]

However, Oiticica's interest in cinema can be traced much farther back. In 1968 he took part in a full-length film by Glauber Rocha, *Câncer*, described by Rocha himself as «an underground film shot in 16mm.»[6] With its improvised dialogue and prolonged static shots, *Câncer* was destined to become one of the precursors of the Brazilian underground cinema known as *udigrudi*. Some of the most important filmmakers in the movement became part of Oiticica's circle of friends, among them Júlio Bressane, Rogério Sganzerla, and Neville D'Almeida, with whom Oiticica collaborated on the con-

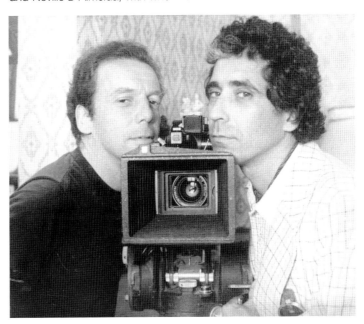

ception of what would be the most important series — or «program,» to use one of his favorite words — of the *Quasi-cinemas*, the *Cosmococas*. Oiticica also participated as an actor in various other creations, among them two 35mm films by his friend Ivan Cardoso, *Dr. Dyonélio* (1978) and *O Segredo da Múmia* [The Mummy's Secret] (1979). Cardoso would go on to shoot what appears to be the only medium-length film on Oiticica carried out before his death, *HO*, also from 1979 and the last film in which Oiticica participated.

In 1969 Oiticica wrote the screenplay of what could be described as the first of his *Quasi-cinemas*, three years before the term appeared in his correspondence, and four years before the elaboration — in close collaboration with Neville D'Almeida — of the first *Cosmococas*. The work in question is titled *Nitro Benzol & Black Linoleum*. The project is dated September 9, 1969, a time when Oiticica was in London, where he had traveled the year before for the presentation of his solo exhibition at the Whitechapel Gallery (the show was held from February 25 to April 6, 1969). Numerous elements of this first project foreshadow the *Quasi-cinemas* of the seventies, and particularly the *Cosmococas*: the work consists of an

Neville D'Almeida and
Hélio Oiticica, 1978
Photo: Ivan Cardoso

41

installation or series of installations, accompanied by films integrated to a structure that could be described as an improvised performance prop. At the same time the audience, abandoning the role of passive spectators, would become part of the work through a series of actions such as inhaling bottles of nitro benzol or essence of jasmine, consuming Coca-Cola or exchanging pieces of cloth. One of the sections of the text, *Idea 8*, proposes the creation of a dark environment with mattresses and carpets spread out on the floor, exactly the same configuration that would be repeated in the first of the *Cosmococas*: *CC1 Trashiscapes*, projected in collaboration with D'Almeida in New York in March 1973.[7] The work also considered the inclusion of soundtracks, and, unlike the other *Quasi-cinemas*, the performance of actions with strong sexual content.

7 Hélio Oiticica, «Nitro Benzol & Black Linoleum,» manuscript dated September 9, 1969, archives of Projeto Hélio Oiticica, Rio de Janeiro.

In 1969 Oiticica was doubtless under the spell of experiences such as the realization of *Parangolé Colectivo*, a multifaceted performance carried out in Rio de Janeiro in 1967 with the collaboration of Lígia Pape, Pedro Escosteguy, Rubens Gerchman, and samba dancers, and the active participation of the audience; or *Apocalí-popótese*, a multidisciplinary action funded by the Diáro de Noticias and carried out a year later, in August 1968, where his *Parangolés* [8] were presented alongside other works/events including Lígia Pape's *Huevos* [Eggs], Antonio Manuel's *Urnas s Calientes* [Burning Urns], and Rogério Duarte's *Dog Act* — filmed by Raimundo Amado and Leonardo Bartucci. Oiticica refers to the event in a long letter to Lygia Clark dated October 15, 1968, where he quotes the Brazilian critic Mario Pedrosa describing it as «…something more important than a happening, because of the truly open feeling of the experiences…»[9] The North American composer John Cage apparently took part in the participatory performance. Five years later, Oiticica and D'Almeida titled one of the *Cosmococas* (*CC4 Nocagions*) with a direct allusion to Cage's name and art, and Oiticica later wrote in his notebooks about the possibility of inviting him to witness a hypothetical presentation of the work.[10] The notion dominating both *Black Linoleum* and *Apocalípopótese* is that of creating a participatory environment, in which the works/actions of the different artists were integrated into a totality open to the active participation of the viewers. These kinds of practices could not fail to be perceived as extremely provocative in Brazil in the late sixties, on the eve of a crackdown by the military dictatorship that had taken over the government of the country in 1964.

8 The *Parangolés* were capes, tents, or banners destined to be worn or used by the audience. For a more detailed discussion of the position of these works within Oiticica's oeuvre as a whole, see my essay, «Some Supplementary Comments on the Parangolé,» in *L'art au corps* (Marseilles: Museum of Contemporary Art, 1996).

9 *Lygia Clark/Hélio Oiticica: Cartas 1964–74*, p. 50.

10 NTBK 1/73.

In a certain sense it could be said that 1964 marked the culmination, in Brazil, of a long decade that began in 1951 with the first São Paolo Biennial and reached its high point in 1959 with the inauguration of Brasilia, the new, ultramodern capital city built from scratch in the country's central highlands. It was the decade of «developmentalism,» a political, economic, and social model that arose under the auspices of the Security and Development Doctrine of the Kennedy administration in the United States and consisted of an attempt to establish local consumer markets in what was initially

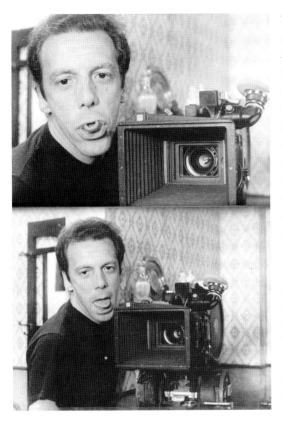

to be a democratic framework. The project's intention, at least in part, was to neutralize the emergence of an organized Left in South America, thus ensuring the subcontinent would remain within the northern power's sphere of influence. In Brazil as in other South American countries (Argentina perhaps the most notorious example), the democratizing phase of developmentalism would conclude with the military dictatorships of the sixties. Nonetheless, the growing cultural effervescence of Brazil in that decade — appearing in the creation of an initially independent cinema movement, «cinema novo,» and a powerful current of innovation that extended to theater, the visual arts, literature, and above all popular music — would inevitably enter into conflict with an increasingly authoritarian government, which from 1967 onward began to openly breach the civil rights of its citizens.

Although Oiticica did not actively participate in politics, his closest circle soon begin to suffer attacks from a toughening military dictatorship. The year 1968 saw the censorship of a concert by Caetano Veloso, Gilberto Gil, and the Mutantes — creators of the «tropicalista» musical style, whose name was inspired by an installation presented by Oiticica in the Museum of Modern Art in Rio de Janeiro the year before. The reason was the inclusion of a banner by Oiticica himself, with the inscription «Be an outlaw, be a hero.» In 1970 the critic Mario Pedrosa, a great friend of Oiticica and the promoter of an entire generation of artists in Brazil, including Clark and Pape, was placed in preventive detention. Gil and Veloso ended up in exile in London, a route followed by other friends of Oiticica (Clark, for professional reasons, had been based in Paris since the late sixties). In 1970, Oiticica was invited to participate in the exhibition *Information* at the Museum of Modern Art in New York. Upon return from his stay in New York, he was informed that he had been awarded a Guggenheim grant. In a letter to Clark dated August 2 of that year, Oiticica wrote: «When I arrived here [Rio de Janeiro], imagine what happened: I received the news that I had won the Guggenheim grant, which will make it possible for me to live in New York for a while... I love that city and it is the only place in the world that interests me.»[11] A few months later Oiticica would travel to New York, where he was to live and work — often in extremely precarious conditions — for over seven years. He returned to Rio de Janeiro only in February 1978, and just two years later, on March 15, 1980, he died in the San Vicente Hospital after suffering a severe stroke in his apartment in Ataulfo de Paiva, in the carioca neighborhood of Leblon.

On numerous occasions in his correspondence with Clark, Oiticica mentions his intention to carry out works in relation to cinema. In December 1969 he wrote: «I have read a lot and have a complete plan to create a film and a ‹piece,› which I don't know when I will begin, despite the fact that they are extremely simple.»[12] And in 1970, before traveling to New York, or more precisely, upon his return to Rio de Janeiro from London: «I have plans for my film, and

11 *Lygia Clark/Hélio Oiticica: Cartas 1964–74*, p. 161.

12 It is possible that Oiticica may be referring here to *Nitro Benzol & Black Linoleum*, conceived just three months before in London (where he wrote this letter to Clark). Ibid., p. 128.

Hélio Oiticica during the filming of Neville D'Almeida's *OS 7 Gatinhos*, 1977 Photo: Ivan Cardoso

may film many sequences-episodes here before leaving, then bring the material to complete it there: no editing, dubbing and all that shit from academic cinema; it's all going to be direct; Luis Fernando, a friend of mine, wants to produce the thing; it will be in 16 mm; there are lots of episodes, it keeps growing, that's why I don't think I can do it all now, but I can do a serious and major part of it; and that's why I'm working on a few things to make money: the cover of Gal [Costa]'s record album and the film by Fontoura» (letter to Lygia Clark, August 2, 1979).[13] In a conversation with the author in Rio de Janeiro in April 2001, Neville D'Almeida referred to the fact that his collaboration with Oiticica began precisely at this time. According to D'Almeida, together they formed the project of shooting a film titled by D'Almeida *Mangue Bangue*, whose subject was suggested by Oiticica. «Mangue»—a word that usually describes a backwater is the name of a red light district in the city of Rio that, according to D'Almeida, Oiticica visited regularly to see several of his friends from the Mangueira *favela* who used to worked there. «Bangue» [Bang] is the onomatopoeic form of a gun detonation. Oiticica had suggested D'Almeida «make a film about ‹Mangue.›» Because of Oiticica's travels, the film was finally carried out by D'Almeida alone, and Oiticica only had the chance to see it later on in New York. He devoted a number of texts to discussions of *Mangue Bangue*, which appears as a veritable precursor to the *Quasi-cinemas*. It's important to note, as another comment on the political situation in Brazil at that time, that although *Mangue Bangue* was entirely filmed in Brazil, D'Almeida developed the footage in London, since in his own words it would have been impossible to do it in Rio with the powerful censorship existing at the time. In NTBK 3/73 Oiticica wrote about the filmmaker: «NEVILLE D'ALMEIDA… He is an exile par excellence…» He saw *Mangue Bangue* for the first time at a private screening he organized at the Museum of Modern Art in New York, on March 9, 1973 (at 11 AM, as he notes with customary precision).

In *Mangue Bangue,* Oiticica saw the overcoming of cinema as one of the languages of the fine arts and its transformation from a cinema-language into a cinema-tool, that could be included in «a type of language that remains as process.»[14] In one of the commentaries he devotes to D'Almeida's film, doubtlessly among his sharpest and most speculative texts, Oiticica refers to the possibility of producing complex structures through artistic work—what he calls «mosaics»—in which the various constitutive parts and phases coexist in a relation of pure simultaneity.[15] The «mosaic» would be the result of an aesthetic quest in which the dialectical negation allowing for the move from one phase of an artist's work to the next does not take place with any kind of finality. Therefore each phase is not exclusively a preparation for the following one—even if it makes it possible—and can exist on its own: «mosaic-fragment that directs and annuls the effect of ‹aesthetic conquest› of the forms-fragments-language they represented in the past, and elevates them to the status of a new language.» To which he adds:

13 Ibid., p. 163.

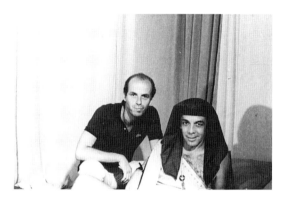

14 «Mangue Bangue,» NTBK 2/73.

15 The point of departure for this characterization comes from his analysis of the structure of *Mangue Bangue*. Oiticica describes the shots as organized in «blocks»—a short time later he would use this very word in the title of the *Cosmococas* —and the blocks as arranged in nonlinear sequences that he calls «mosaics.» He would then extend the concept to account for a truly experimental logic of artistic practice.

Hélio Oiticica and Ivan Cardoso in Ivan Cardoso's film *The Mummy's Secret*, 1979 Photo: Eduardo Viveiros

16 «Mangue Bangue,» NTBK 2/73.

17 Ibid.

18 An earlier text by Oiticica about a super-8 film by Ivan Cardoso («Nosferato,» published in *Navilouca* in 1972) contains a discussion that has several points in common with Oiticica's later texts on *Mangue Bangue* in terms of a critique of linearity and conventional narrative. See «Ivampirismo: O Cinema en Panico,» by R. F. Lucchetti and Ivan Cardoso (Rio de Janeiro: Editora Brasil-América [Ebal] and Findação do Cinema Brasileiro), 1990.

«…the concreteness of the process as mosaic-process is given in what I call experimentation.»[16] The analysis of *Mangue Bangue* allowed for an extremely precise formulation of the concept of «the experimental» that had appeared long before in Oiticica's writings. The experimental could be formalized through the open structure of the «mosaic,» and the filmic image would be Oiticica's chosen element for the completion of this quest: «…what does MANGUE BANGUE have to do with all that?: as a ‹product› the film shows that it is not a product (or culmination) of creative affluence (like GODARD/PICASSO/STRAVINSKY) but *a fragmented proposal of necessary-language that resulted in the thin leavings and the flip gratuitousness of the pleasure of filming*… yes the work is meta-critical of cinema as language: the non-verbal quality oscillates and shows futility as the solution to forms defined as image-photo or audio-visual: it is NON NARRATIVE-NON PHOTO-SOUND-IMAGE-QUASI-CINEMA CINEMA…»[17] The «remains,» outside any teleology, nonetheless acquire meaning in the open totality of the mosaic. It is worth pointing out that in Oiticica's text, the critique of a dialectic that would lead to the gradual overcoming of the various phases of artistic work is carried out in the name of an affirmation of the inherent «uselessness» of the distinct phases/fragments that constitute the work as a process («gratuitous frivolities»). Oiticica's text can be read as an explicit critique of any type of productivist reading of the artistic work. In the terms of the working structure that Oiticica calls the «mosaic,» it is not a matter of achieving any kind of finality; on the contrary, the artistic work becomes precisely an affirmation of the remainder and the «uselessness» that attack the very notion of the product as a final, objectifiable result.[18]

Whereas *Mangue Bangue* was originally planned as a film to be carried out by D'Almeida and Oiticica together and finally was completed by the former because of Oiticica's absence, *Cosmococa* was initially intended to be the title of a film planned by D'Almeida as a kind of continuation of *Mangue Bangue*. A visit by D'Almeida to Oiticica in New York finally transformed the film project into the title of a «Program in Process»: the *Block Experiments in Cosmococa*, of which a total of nine were programmed by Oiticica. In his notebooks one finds detailed instructions for the realization of six of the nine *Cosmococas*, as well as preliminary notes for the scenario of a seventh, *CC8*. The first five were conceived in collaboration with D'Almeida; *Cosmococa 6* was carried out together with Thomas Valentin. In his notebooks, Oiticica noted careful instructions for

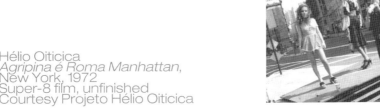

Hélio Oiticica
Agripina é Roma Manhattan,
New York, 1972
Super-8 film, unfinished
Courtesy Projeto Hélio Oiticica

public and private performances of *Cosmococas 1, 2, 3, 4,* and *5*. In his book *Hélio Oiticica: Qual é o Parangolé?* the Brazilian writer Waly Salomão recalls having taken part in one of the private performances of the *Cosmococas* — in October 1974 — in the loft where Oiticica was living, though without indicating whether it was the loft at 81 2nd Avenue (#4), where the artist lived until the end of that year or the one at 18 Christopher Street (#14) where he then moved.[19] A year later, Oiticica completed *Helena inventa Ângela Maria*, with the participation of Helena Lustosa who later acted in a series of shorts by filmmaker Ivan Cardoso. Finally, in 1975, Oiticica would shoot the slides of his last *Quasi-cinema*, *Norma inventa La Bengell* with the participation of the Brazilian actress Norma Bengell.[20]

Recently arrived in New York, Oiticica plunged fully into his interest in cinema. In May of 1971 he was finishing a film course at New York University, had a super-8 camera and an editing table in his possession, and was ready to complete a film titled *Brasil Jorge*, which was considered lost until part of the footage was found in Rio de Janeiro in November 2001, almost as this book was going to press. A number of shots, also from this period, were gathered in what finally became *Agripina é Roma Manhattan*, an unfinished work with the participation of the visual artist Antônio Dias, Cristiny Nazareth, and the transvestite Mario Montez, whom Waly Salomão describes as «an actress invented by Jack Smith and Andy Warhol in homage to the Mexican icon Maria Montez.»[21] Oiticica relates in a letter to Clark (May 14, 1971) that since his arrival in New York he had met «many of Warhol's stars»[22], and it was precisely during this period that he saw the projections of Jack Smith. Warhol, Godard, Kenneth Anger, and Smith became the strongest influences on Oiticica throughout this period, in contrast to the experiments in the field of experimental cinema carried out by North American artists of the time, such as Paul Sharits or Hollis Frampton.[23]

In a telephone conversation with the author, Brazilian filmmaker Júlio Bressane described having been present in Oiticica's loft at a projection of the fragments finally brought together in *Agripina*. According to Bressane, Oiticica was supremely interested in the possibility of seeking an original way to conceive the filmic image. His technical knowledge, however, was extremely limited. In Bressane's judgment, Oiticica's sensibility magically compensated for his lack of experience with the medium. Although for Bressane *Agripina* is less a fully realized work than a tentative collection of attempts and fragments, still the filmmaker recognizes moments of extreme originality and beauty in the piece, in response to which he himself completed a full-length film in 1972. The title of that silent black-and-white film was *Lágrima-Pantera-Míssil*; Oiticica referred to the work in another letter to Clark, dated January 24, 1972: «…I'm crazy to see a film that Julito Bressane made here [New York], with parts here at home (I also appear as part of a gang planning an attack on a bank…)»[24] A reading of Marshall McLuhan

19 Waly Salomão, *Hélio Oiticica: Qual é o Parangolé?* [Hélio Oiticica: Which is the Parangolé?] (Rio de Janeiro: Relume Dumará/Rio Arte, 1996), p. 105. In a telephone conversation with the author on July 31, 2001, Salomão reiterated his uncertainty about the place where the private projection of the *Cosmococa* that he witnessed in 1974 was held. The most striking impression Salomão recalls about this meeting was the fact that Oiticica was extremely cautious about showing the work, as though it were an initiation rite (as Salomão puts it), or «like Empedocles on the edge of Etna.» Salomão understood this attitude as a strategy destined to preserve the «artistic secret» from the curiosity of his colleagues, but also as a result of the «explosive character» of the material used to carry out the work. As this book was going to press, the curator of Projeto Hélio Oiticica, Cesar Oiticica, reported to the author that a collection of super-8 footage including shots of Oiticica and D'Almeida performing a private screening of the *Cosmococas* had just been found in Rio de Janeiro.

20 In a phone conversation with Ivana Bentes, Mrs. Bengell would remember that she was introduced to Oiticica by D'Almeida in New York and that the pictures were taken in one session in his loft.

21 Salomão, *Hélio Oiticica: Qual é o Parangolé?*, p. 21. In his article «The Banana Diary: The Story of Andy Warhol's ‹Harlot,›» in *Andy Warhol: Film Factory*, ed. Micheal O'Pray (London: British Film Institute, 1989), Ronald Tavel writes: «Mario Montez is a creation of Jack Smith. He formulated him at his Cinemaroc Studio, first as Dolores Flores; and, later, when his development became undeniable, as Mario,» p. 84.

22 *Lygia Clark/Hélio Oiticica: Cartas 1964–74*, p. 202.

23 In «O Quasi-Cinema de Hélio Oiticica,» a text published online in the net magazine *Odradek,* the Brazilian critic Glória Ferreira also cites the film *Scorpio Rising* by Kenneth Anger as one of the influences on Oiticica during this period. This information was confirmed by Neville D'Almeida in a conversation with the author.

24 *Lygia Clark/Hélio Oiticica: Cartas 1964–74*, p. 219.

25 *Lygia Clark/Hélio Oiticica: Cartas 1964–74*, p. 202, p. 220.

26 Ibid., p. 73. (letter to Lygia Clark, November 8, 1968).

27 Hélio Oiticica, «Mundo-Abrigo,» text excerpted from NTBK
2/73 and dated July 21 of that year. Published by 110 Arte
Contemporânea, Rio de Janeiro, 1989, p. 17.

28 Waly Salomão, *Hélio Oiticica: Qual é o Parangolé?*, p. 67.

Hélio Oiticica during the filming of
Ivan Cardoso's *HO*, 1978
Photo: Eduardo Viveiros, courtesy
Ivan Cardoso

and contact with Quentin Fiore must be added to the intellectual dialogue and friendships with Rocha, Bressane, and D'Almeida and the influence of Warhol, Godard, Anger, and Jack Smith. It was in the relation to this referential universe that the *Cosmococas* were conceived in 1973.

Yet already by 1972, Oiticica's optimistic vision of New York had darkened. The «only city in the world that interests me» had transformed into an «infernal island» that «lives off slave labor» he wrote in a letter to Lygia Clark, January 24, 1972.[25] Oiticica began to have ever more serious problems with his legal situation in the country and had to work «in whatever exploitative job they wish to offer me.» He finally found a night job as a translator, but his living conditions became increasingly precarious. It is no accident that the relation between the different regimes of labor and the forms of subjectivity that inevitably result from them came to be a recurring theme in his writings. Oiticica's work had explored the possible relation between constructivists structures and forms of life since the late sixties, with installations such as *Tropicália* in 1967 and then *Eden* in 1969. Yet in this first phase, his investigation was organized fundamentally around an extremely precise exploration of the question of the viewer's participation in the work. Oiticica shared with Lygia Clark the desire to develop participative works, less «works» in the traditional sense than «proposals» to be fulfilled by the audience members, who thus took an active role in the work. In 1968 Oiticica wrote to Clark: «I believe that our great innovation comes precisely in the form of participation, or better, it is in this sense that we differ from what is proposed in hypercivilized Europe or the United States.»[26] Actions such as *Apocalípopótese* in 1968 or the project of *Nitro Benzol* seem to point further in this direction. And yet the question of the viewer's participation in the work seems gradually to be reconfigured from the early years of the seventies onward, in the form of an investigation into the relations between subjectivity and labor. In the words of Oiticica himself, the finality of this process would be the invention of «a structure of leisure as pleasure opposed to the current one of leisure as the programmed desublimation that sustains hour-periods of alienated work-production.»[27] The language clearly originates from a reading («an anything but moderate interpretation,» notes Waly Salomão in his book on Oiticica) of *Eros and Civilization* by Herbert Marcuse, a book Rogério Duarte had introduced to Oiticica in the late sixties.[28] But it is fundamentally through meticulous experimental work with the image Oiticica succeeded in conceptually formulating what constitutes nothing less than a radical critique, no longer of the materiality of the artistic object, but of the modes of production that configure the experience of art in postindustrial societies. This investigation of the image can be clearly traced from *Tropicália* on but acquires all its magnitude during the early years of the seventies, when Oiticica's interest in cinema finally transforms itself into a constitutive part of his work. From this moment onward, Oiticica begins to understand the filmic image as the analytic instrument that will allow him to con-

stitute an experimental practice destined to reconfigure the relation between creative pleasure and alienated work. All the *Quasi-cinemas* turn around this problematic, and perhaps it can be asserted that the *Cosmococas* were its most precise and potent formulation. In all the *Quasi-cinemas*, Oiticica maintains elements springing from the open participative structure present in his actions from the late sixties, such as *Parangolé Colectivo* and *Apocalípopótese*: All the works combine slide projections with a soundtrack and environmental elements that in many cases constitute a direct reference to earlier works by the artist (in one of his «index cards» Oiticica uses the word «capullo» [cocoon] in reference to the hammocks included in *CC5 Hendrix-War*; one might read in this an allusion to, or parallel between, these projects and his *Parangolés)*. The radical difference in relation to his earlier works no doubt consists in the kind of images that these works incorporate, and their use.

The grandson of an anarchist, Oiticica had always idealized the figure of the outlaw, with which he undoubtedly identified his own position as an artist. A work of 1966, *Box Bólide Caixa 18*, is in fact a homage to Cara de Cavalo, a popular hero, an inhabitant of Rio's *favelas* killed by the police. «This homage is an anarchist attitude against every kind of armed force: police, army, etc. I make poems of protest (in capes and boxes) that have a more social meaning, but this dedication to Cara de Cavalo reflects an important ethical moment, which for me is decisive, because it reflects individual rebellion against any kind of social conditioning. In other words: violence is justified as a means of rebellion but never as a means of oppression.»[29] It is possible to understand this fascination as a reaction against the figure of the artist as the «superior designer,» to which Ronaldo Brito refers when he describes the reception of Max Bill and Swiss concrete art in Brazil in the fifties.[30] At the close of that decade, Oiticica (along with Lygia Clark and Lígia Pape) had been part of the neo-concrete movement, which had defined itself precisely as a reaction to the excessive rationalism and mechanicalism of the Brazilian concrete artists. In this context, Oiticica's romanticism can be defined as an archaism that paradoxically seeks to set itself against the complete instrumentalization of the figure of the artist implicit in the postulates of Swiss concretism — and which, a few decades later, would return again on an international scale with the gradual transformation of artistic production into one of the branches of a cultural industry fashioned on the model of the spectacle. The romantic recuperation of the figure of the outlaw — and Oiticica's recurrent identification with such figures as Antonin Artaud, Arthur Rimbaud, Jimi Hendrix, and Jack Smith himself — is for the artist nothing other than an attempt to resist the instrumentalizing tendencies of late capitalism in the sphere of artistic production. In Brazil during the military dictatorship, these trends had taken a violent and repressive form, exercised in the name of nationalism — and in favor of the large monopolies — against individual freedoms. In New York, Oiticica had confronted the opposite face of this repressive violence: the violence of alienation, which he described

29 Hélio Oiticica, catalogue of his exhibition at the Whitechapel Gallery (London: 1969), p. 6.

30 See Ronaldo Brito, *Neoconcretismo: Vértice y Ruptura do Projeto Construtivo Brasileiro* (Rio de Janeiro: Funarte, 1985; reprint, Cosac & Naify Edições, 1999).

Hélio Oiticica's *Parangolés*
Stills from Ivan Cardoso's film *HO*, 1979

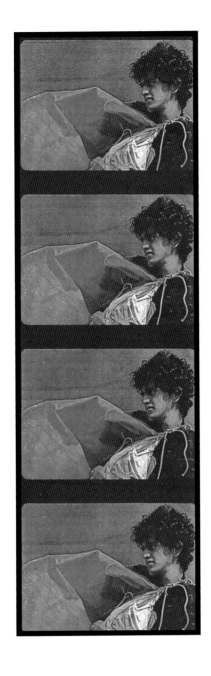

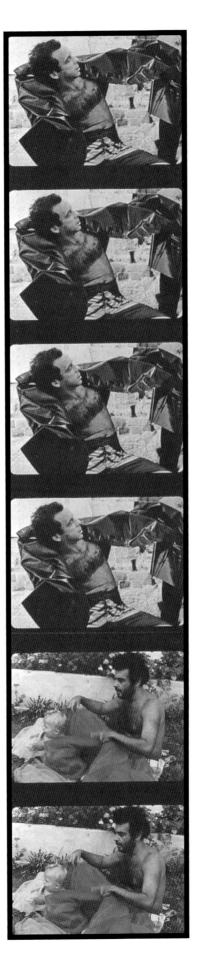

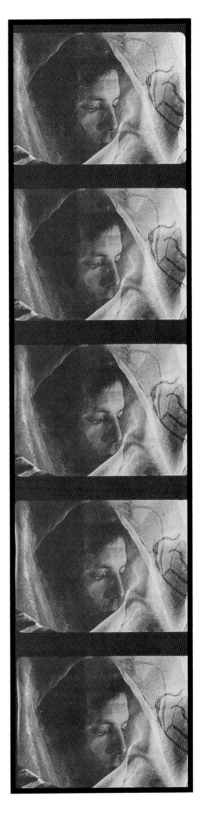

so well by noting that the entire city seemed to subsist through the work of «slave labor.» As a response to both, to the one as the opposite face and perfect complement of the other, Oiticica proposed an artistic strategy that consists in the formulation of a work with the image that was ultimately to be created by the spectator, by abandoning his or her traditionally passive role. Through the *Quasi-cinemas*, and specifically the *Cosmococas*, Oiticica sought to situate himself—and his audience—outside the law, understood as the matrix of alienated production. And this, because the very substance from which the works were made, in the case of the *Cosmococas*, was precisely one of the most obvious signs—and symbols—of illegality.

In August 1973 Oiticica wrote in his notebook: «CC-*program* [CC is the abbreviation of *Cosmococa*] with NEW york: I was never sick of NEW YORK as i thought; it was simply that an old and deformed approach was exhausted—US/NYK still has something to give— even getting angry isn't possible—opening and brandishing what can be: would IT be NYK for me as it was PARIS for G. STEIN H. MILLER? Or INDIA for others or AFRICA RIMBAUD? RIO and NYK are clear and firm positions: no dirty shadow of nostalgia exists in that confrontation—.»[31] In March of that year, Oiticica, in collaboration with D'Almeida, had begun to develop the series of *Cosmococas* launched with *CC1 Trashiscapes*. In April Oiticica completed the second of his *Quasi-cinemas*, *Neyrótika*[32], followed in August —again in collaboration with D'Almeida—by *CC2 Onobject* (whose instructions are dated August 12), *CC3 Maileryn* (August 16), *CC4 Nocagions* (August 24), *CC5 Hendrix-War* (August 26), and *CC6 Coke's Head Soup*, created in collaboration—«imagined» collaboration, writes Oiticica in his notebook—with Thomas Valentin. Finally, on December 30, Oiticica began to do notes for the scenario of the eighth *Cosmococa*. Although the original plan contemplated a ninth, this would in reality be the last work of the series recorded in his notebooks. D'Almeida recalls having traveled to New York on two or three occasions in the course of that year; with his presence as a catalyst, 1973 would become the year of the *Quasi-cinemas*. In a tape recorded the following year, Oiticica recalls 1973 as a «period of total crisis.» He then goes on to remark that the *Cosmococas* should not be considered «artistic photography neither cinema» but «a continuation of cinema.» In his notebooks, Oiticica would describe in full detail how the pieces should be shown, both in private and public performances. All the *Cosmococas* would consist of the projection of a series of slides in a specific environment, with the addition of a soundtrack. In the first five pieces, D'Almeida was responsible for drawing the cocaine make-up on the bodies and faces of the images chosen to be photographed, while Oiticica took the pictures—a reversal of roles that Oiticica deemed fundamental to the project.

The artistic problem Oiticica addressed most urgently from 1970 on, concurrent with his ongoing interest in cinema, was how to over-

31 NTBK 3/73.

32 *Neyrótika* would be the only *Quasi-cinema* that Oiticica exhibited publicly during his lifetime. The piece was shown on June 19, 1973 as part of the exhibition «Expo-Projeção 73» curated by Aracy Amaral in Belo Horizonte. According to Amaral, Oiticica's incentive was partly responsible for the actual realization of the show, devoted to exploring the works on new media by a large group of Brazilian artists. See the exhibition catalogue, Aracy Amaral, *Expo-Projeção 73: Som, Audio-Visual, Super 8, 16 mm* (Sao Paulo: 1973).

Hélio Oiticica and Glauber Rocha during the filming of Ivan Cardoso's *At Midnight with Glauber*, 1979 Photo: Ivan Cardoso

33 NTBK 1/73, notes of June 11, 1973 «– the structure of representation is linear – completely linear – which is what constitutes the foundation of the subject-object duality in all its forms.»

34 Heliotapes 3, 1974, one of four tapes published by Projeto Hélio Oiticica.

35 Reprinted in the catalogue of the exhibition *Hélio Oiticica*, p. 136.

36 NTBK 4/73.

come the representative nature of the image – intimately linked, for him, to narration, and therefore to linear logic and subject-object dualism[33] – through work that was itself carried out on the basis of images. In similar terms, when describing a performance by Yoko Ono that he had seen, apparently several times, Oiticica refers to the necessity to overcome the spectacle through the use of the image, noting that «the spectacle in New York just aims at preserving the spectacle.»[34] He then linked the possibility of overcoming the representative nature of the image to a problematization of the relation between alienated work and «desublimated leisure,» where one functions as the tacit support of the other. Breaking the subject-object logic that organizes all narrative would be the indispensable step toward imagining a creative leisure that is able to situate the subject outside the relations of production as defined in late capitalism. In a retrospective interpretation of his works from the late sixties, published in the cultural review *Vozes* in 1970 and titled «The Possibilities of Creleisure»[35], Oiticica reflected on this question with striking lucidity in pages where the influence of Marcuse is particularly clear: «The Whitechapel experience confirmed many things, overturned others, and leads me to the goals ‹of what to think› and ‹of where to go› – first to the revitalization of the first *Penetrables* and *Nuclei* (from 1960 onwards) – then to the definitive transformation of the ‹world of images,› from the abstract-conceptual (derived from the ‹Neo-concrete› concepts), up to Tropicália, where this repertory, of the ‹image› as such, becomes consolidated in the consciousness of itself, in a synthesis, and goes beyond itself towards a new sense where what was ‹open› becomes ‹super-open,› where structural preoccupation dissolves into ‹disinterest of structures› which become receptacles open to signification.» The text comes extremely close to one he devoted three years later to the analysis of the «meager remains of gratuitous frivolities» composing the open, «mosaic» structure of *Mangue Bangue*. In another note of 1973, Oiticica writes of the «ineffectiveness of representation (as a world, a way of life): the reality of ‹being here› in the ‹lived moment› is *more* than its representation. No resolution can or should be sought in a ‹nostalgia for natural life› pre-representation… [a] solution ‹beyond representation› can only be achieved by existential saturation and consequently dissatisfaction with the world of products of that representation, in which the spectator-spectacle relation is fundamental.»[36] But the problem Oiticica poses is extremely complicated: how to use images themselves to overcome the world of the images/representations linked to the spectacle and the «world of products»? The tentative answer that he seems to have come upon, early that same year, comes from his appropriation «for aesthetic ends» of a substance that at once represents one of the most ostentatious signs of consumer culture and its transgressive reverse: the cocaine powder of the *Cosmococas*.

«Because marijuana tribalizes and PRIMA [the name Oiticica uses in his writings to designate cocaine] isolates, the Incas were powerful in their individuality and succumbed to the Spanish because

they were SPARTAN (united in masculine Fraternity to make War);
for me the PRIMA-INCA thing is the future; the SPARTAN thing is
the past,» declared Oiticica in a letter to Lygia Clark dated July 11,
1974.[37] Oiticica wrote abundantly and reflected deeply on the cul-
tural effects and meanings of cocaine. His notes include references
to the book *History of Coca: «The Divine Plant» of the Incas*, origi-
nally published in 1901 by a North American physician, W. Golden
Mortimer. The book can be read as a defense of the coca leaf's
medicinal uses and a condemnation of its instrumentalization and
subsequent illegalization after the discovery of cocaine, one of the
alkaloids present in the plant. Mortimer suggests that the many
beneficial uses of the coca plant, from which the Incas derived a
wealth of long-lasting advantages, were first masked and then
finally totally eclipsed by the excessive importance taken on by the
cocaine alkaloid when it was discovered to be a stimulant — whereas
in Mortimer's assessment that alkaloid is only one of the many
active components present in the plant's leaves. It is not difficult to
imagine that Oiticica could have read Mortimer's writing as a denun-
ciation of the evils brought on by the instrumental use — and abuse
— of what had originally been a beneficial element in native South
American cultures. The discovery of cocaine and its use as a stim-
ulant may have represented for Oiticica a symbol of the violence
inherent in a socio-economic and political context that was able to
subsist only by opposing alienated work to desublimated leisure:
an opposition that entails the reification of subjectivity. In this light,
the illegality of cocaine would be a necessary consequence of its
insertion within the prevailing order of things. In a conversation with
the author, D'Almeida recalls having chosen the title *Cosmococa* for
similar reasons. Coca represents, in his words, the transgressive
symbol of resistance to imperialism. For an artist who never ceased
identifying with the outlaw as a figure of resistance to the instrumen-
talization of artistic work (so increasingly evident after the postwar
period), the discovery of a substance that signified at once the crisis
of this instrumental process and its reversal into illegality and trans-
gression must have appeared barely short of ideal. In the *Cosmo-
cocas*, cocaine would be transformed into an artistic material (on
several occasions Oiticica unhesitatingly compares it to a painter's
pigment), and also into a symbol of exactly what the artist was
seeking to achieve through his works. A sign of the destructive pow-
ers of instrumentalization, cocaine would become a tool precisely
because of the power of its image to position the spectator/par-
ticipant of the pieces in a close complicity with the artist, outside the
law, and thus, outside the logic of the spectacle. Cocaine, a tool
and a sign — «the trash-image of the remains: of the repertory of
representation,» as he wrote in one of his notebooks[38] — was the
substance that would allow him to articulate a work carried out with
images-representations yet able to overcome them. The price to
be paid would be the impossibility of exhibiting the works in public,
their complete exclusion from the art circuit. Twelve years after the
artist's death were to pass before it would it be possible to carry out
the first public projection of a *Cosmococa* in 1992.

37 *Lygia Clark/Hélio Oiticica: Cartas 1964–74*, p. 233.

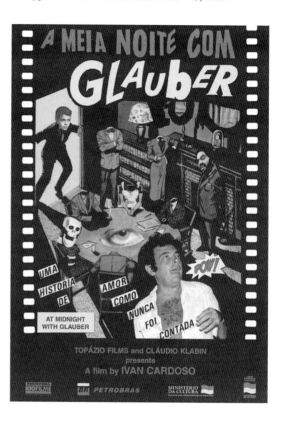

38 NTBK 1/73.

Poster for Ivan Cardoso's film
At Midnight with Glauber, 1979

39 NTBK 1/73, notes of June 11, 1973.

The only way for Oiticica to resist repressive police violence was to configure his position as an artist around the figure of the outlaw; the only way to resist the instrumental violence of late capitalism (and, one could almost say, of neoliberalism) was to appropriate, through a transgressive gesture, one of the most potent signs of its instrumentalizing power and to use precisely that as an artistic material. The «trash-image,» a pure residue that does violence to the very process of value production as value for accumulation, is the tool on the basis of which Oiticica and D'Almeida would organize the program of the *Cosmococas*: «experimental practices of no-wasted space,» as Oiticica writes in his notebooks.[39] Curiously, near the end of his complex aesthetic-existential itinerary, Oiticica seems to effect a premonitory identification of dictatorial militarism with the regime of late capitalism, of Rio in the late sixties with New York as it began to shift in the middle of the following decade. The pertinence of the *Quasi-cinemas* goes beyond the fact that they foreshadow the rediscovery of the filmic image's possibilities in the visual arts during the nineties. Perhaps instead it is related to the fact that these works constitute a laconic, yet marvelously explicit and synthetic, commentary on the tragic paradoxes that make up the political and social reality at the end of the century.

Carlos Basualdo is chief curator of exhibitions at the Wexner Center for the Arts, The Ohio State University.

Block Experiments in Cosmococa, Program in Progress

CC1–CC5 Hélio Oiticica and Neville D'Almeida
CC6 Hélio Oiticica with Thomas Valentin
CC8 Hélio Oiticica

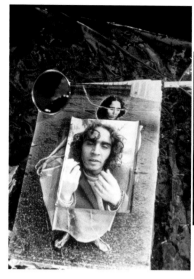

CC1 *Trashiscapes*, 1973

CC2 *Onobject*, 1973

CC3 *Maileryn*, 1973

CC4 *Nocagions*, 1973

CC5 *Hendrix-War*, 1973

CC6 *Coke's Head Soup*, 1973

CC8 *Mr. 8 or D of Dado*, 1973

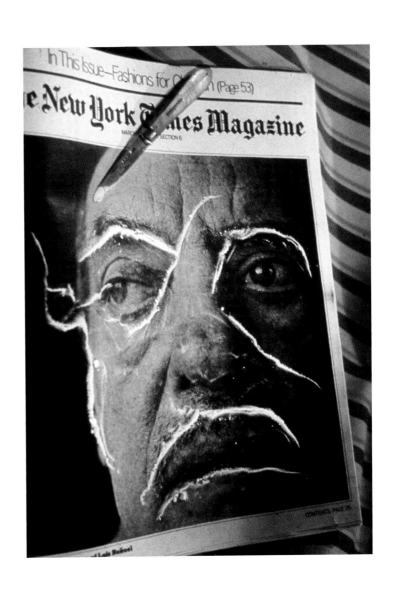

CC1 Trashiscapes, 1973
Slides for installation
Courtesy Projeto Hélio Oiticica
and Neville D'Almeida

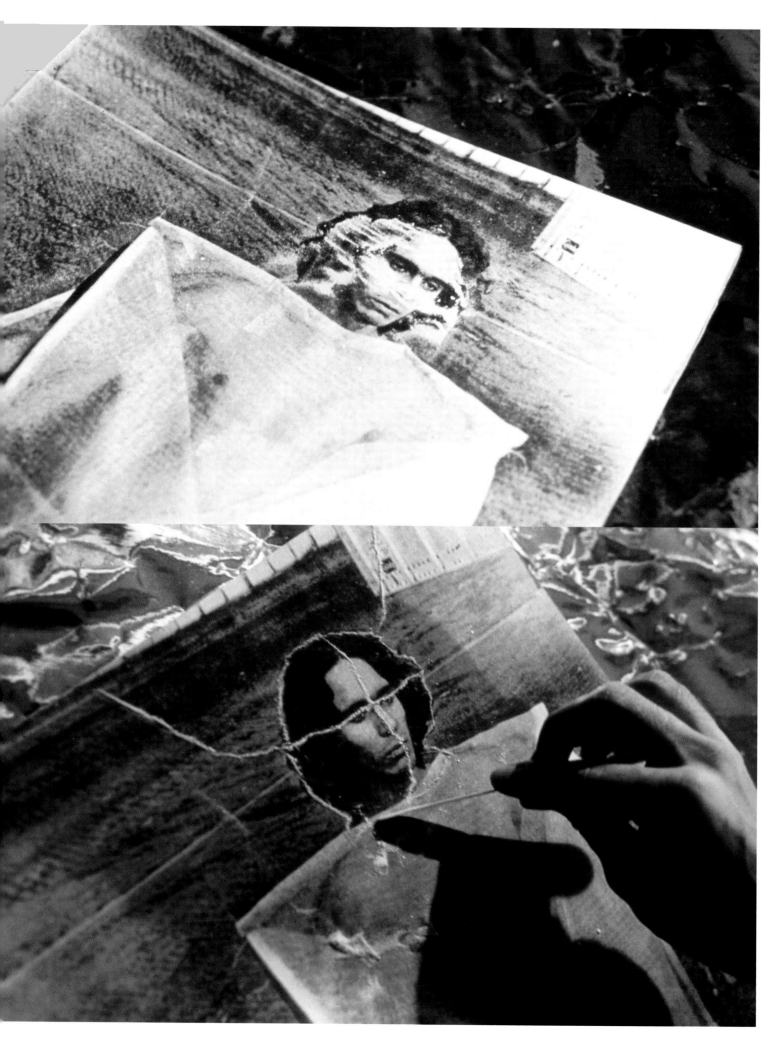

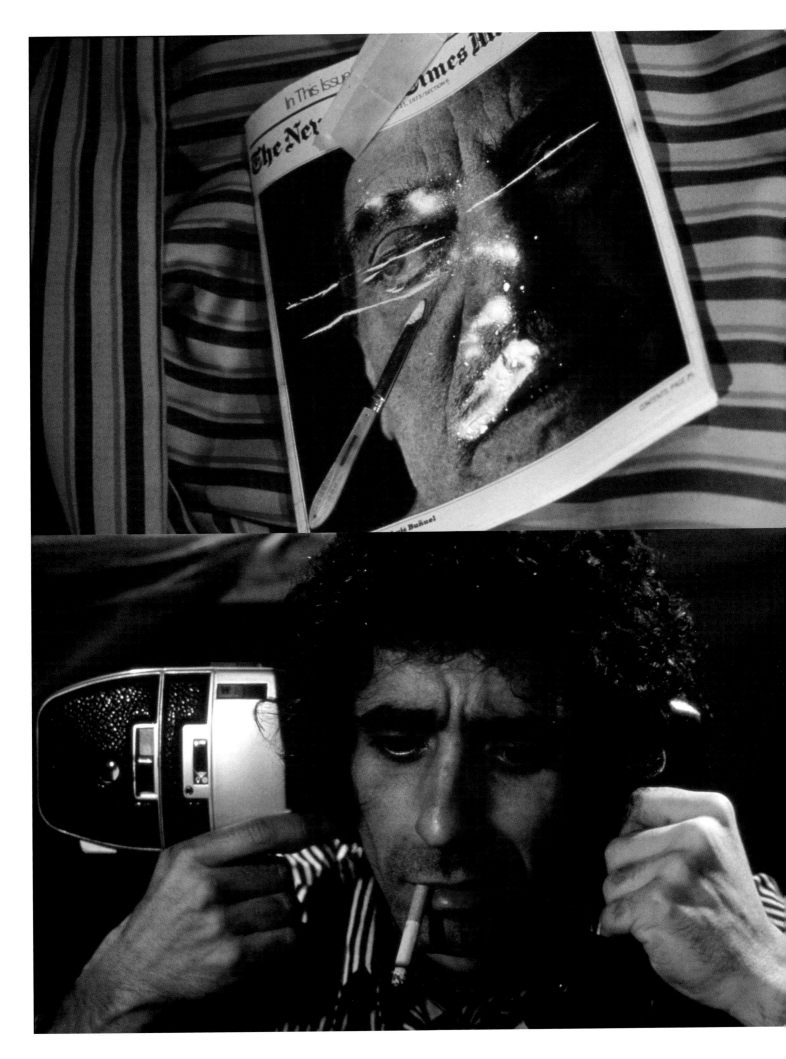

CC2 Onobject, 1973
Slides for installation
Courtesy Projeto Hélio Oiticica
and Neville D'Almeida

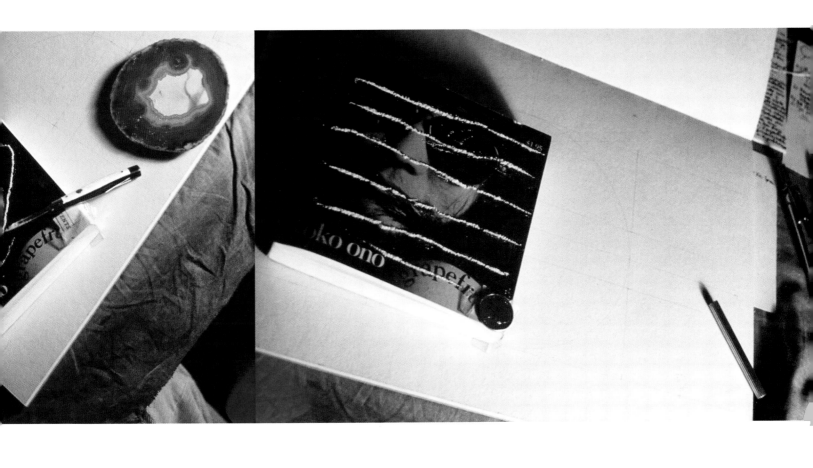

CC3 Maileryn, 1973
Slides for installation
Courtesy Projeto Hélio Oiticica
and Neville D'Almeida

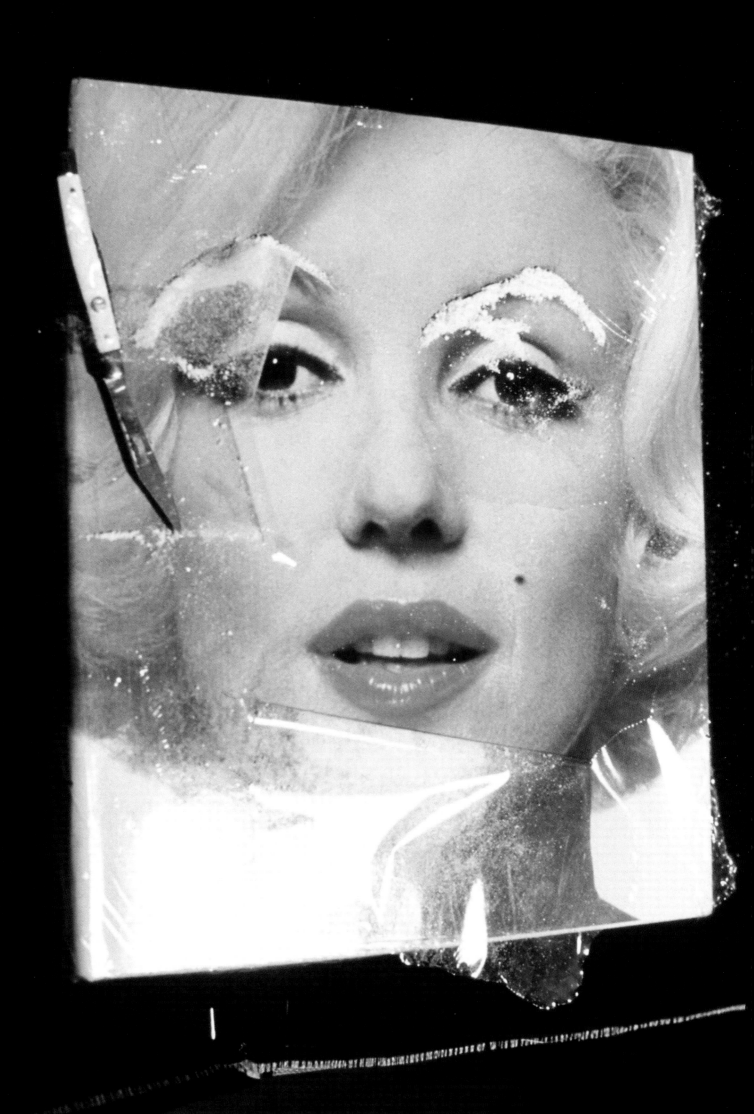

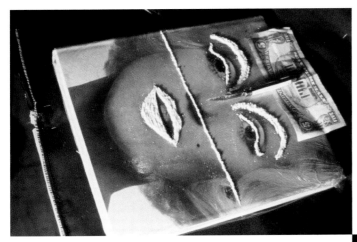

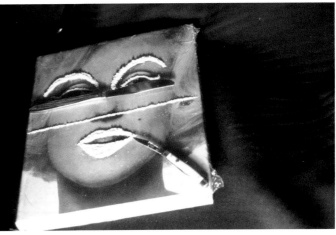

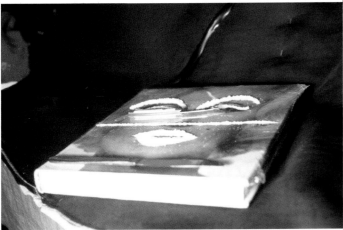

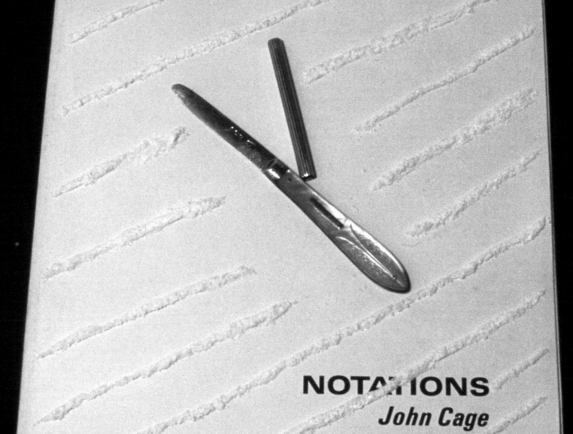

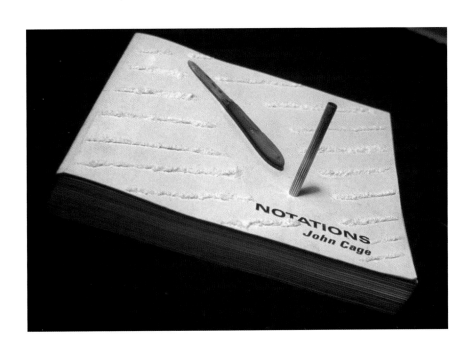

CC4 Nocagions, 1973
Slides for installation
Courtesy Projeto Hélio Oiticica
and Neville D'Almeida

CC5 Hendrix-War, 1973
Slides for installation
Courtesy Projeto Hélio Oiticica
and Neville D'Almeida

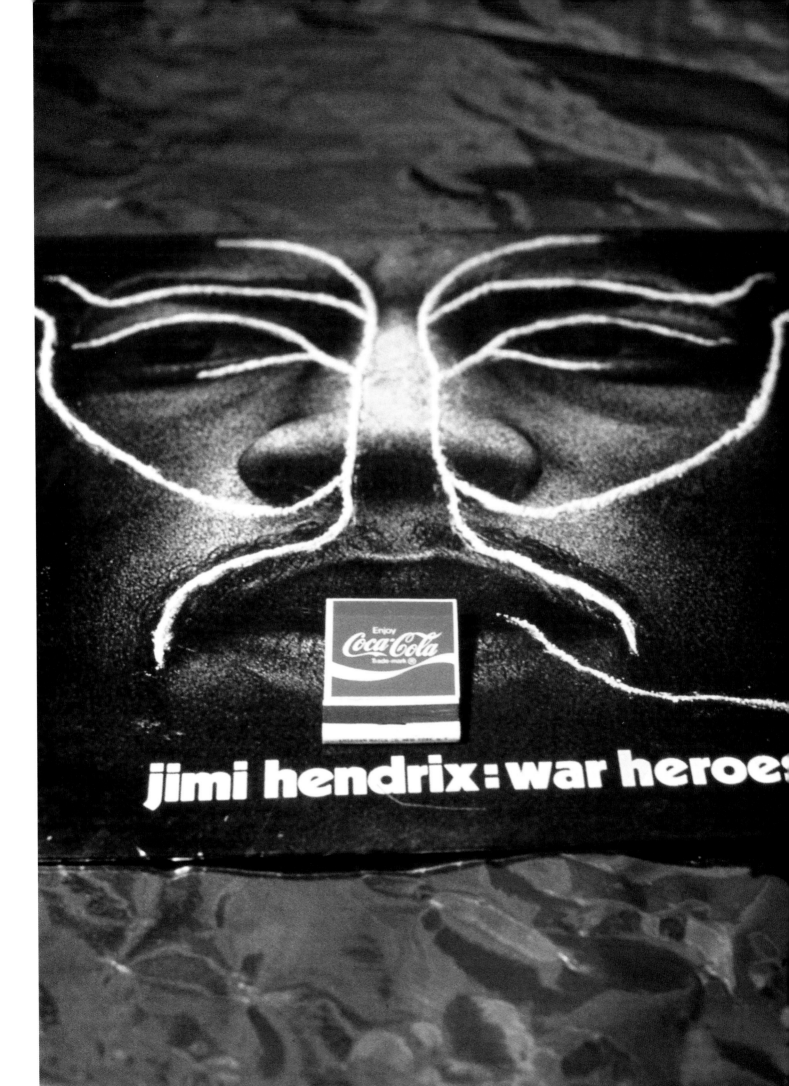

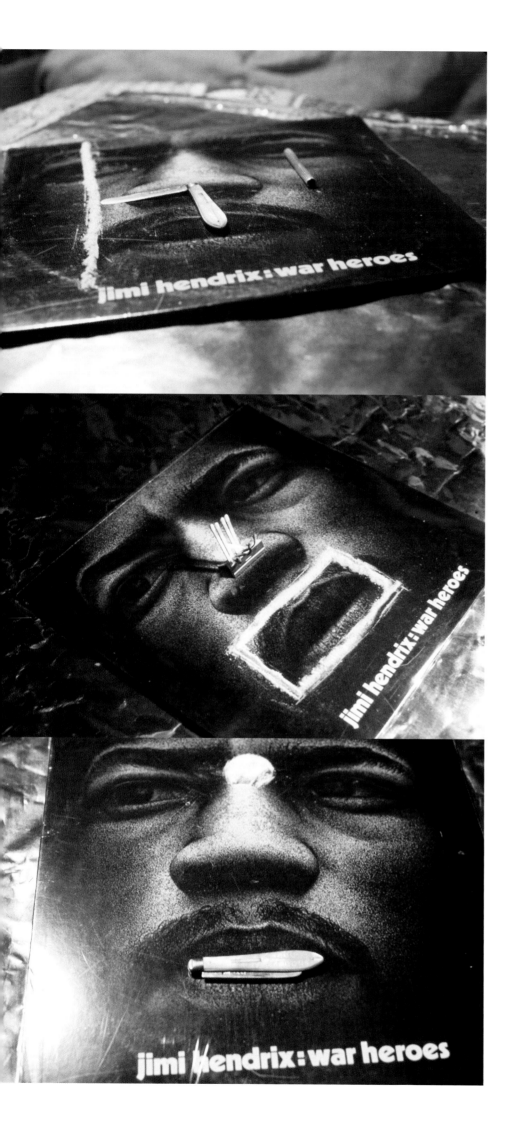

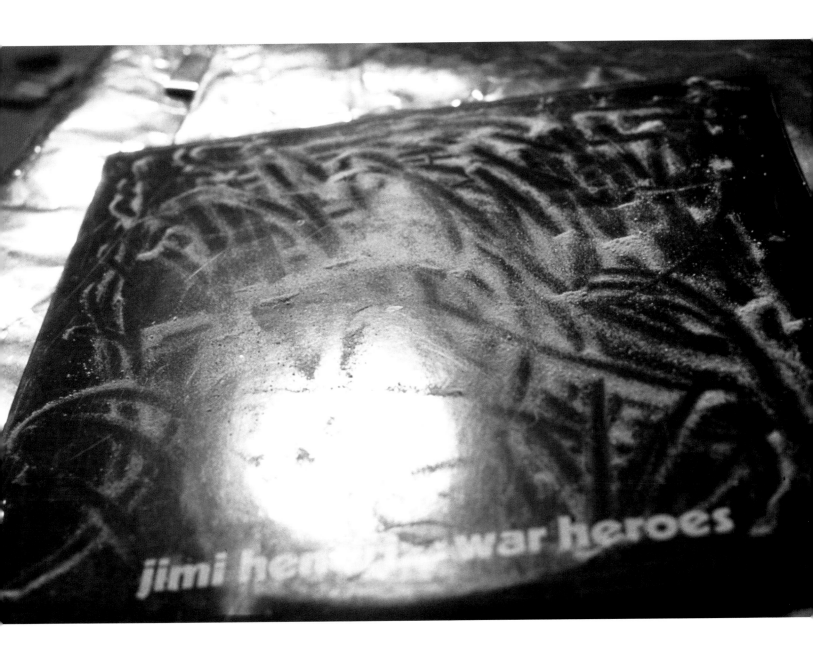

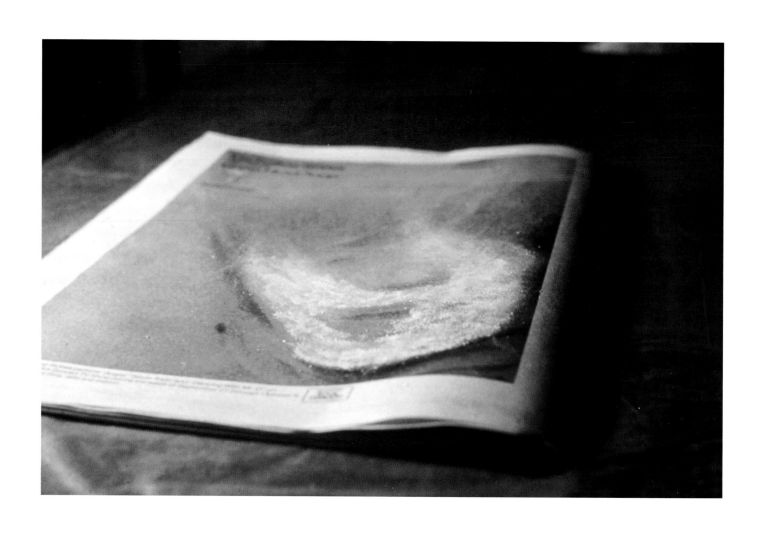

CC6 Coke's Head Soup, 1973
Slides for installation
Courtesy Projeto Hélio Oiticica

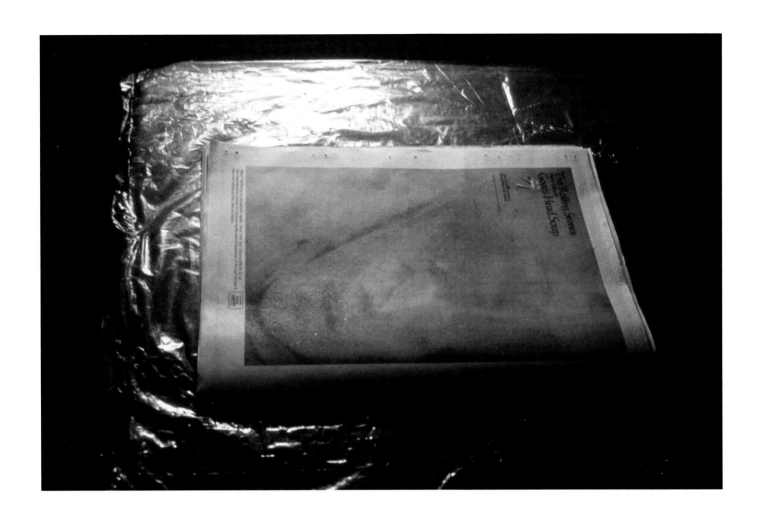

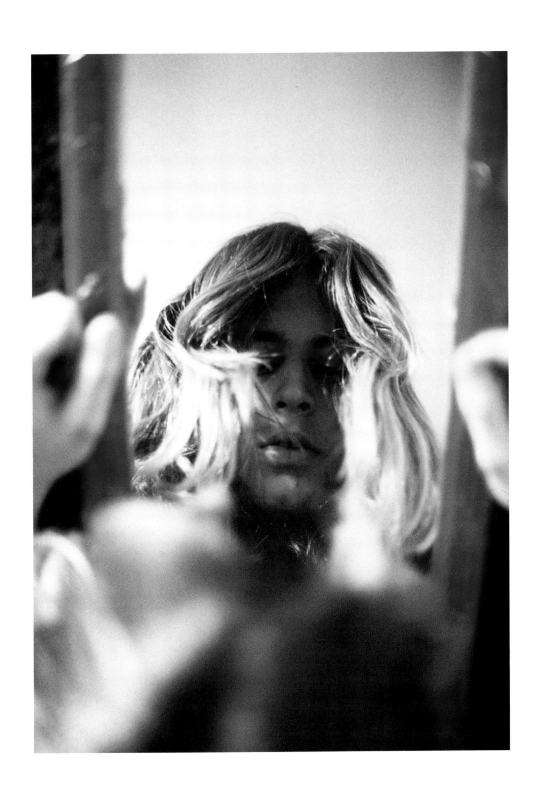

CC8 Mr. 8 or D of Dado, 1973
Slides for installation
Courtesy Projeto Hélio Oiticica

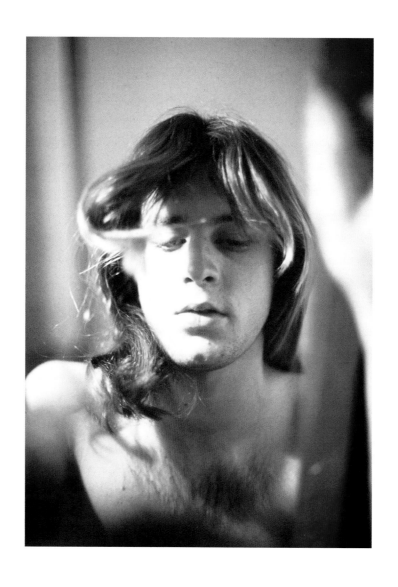

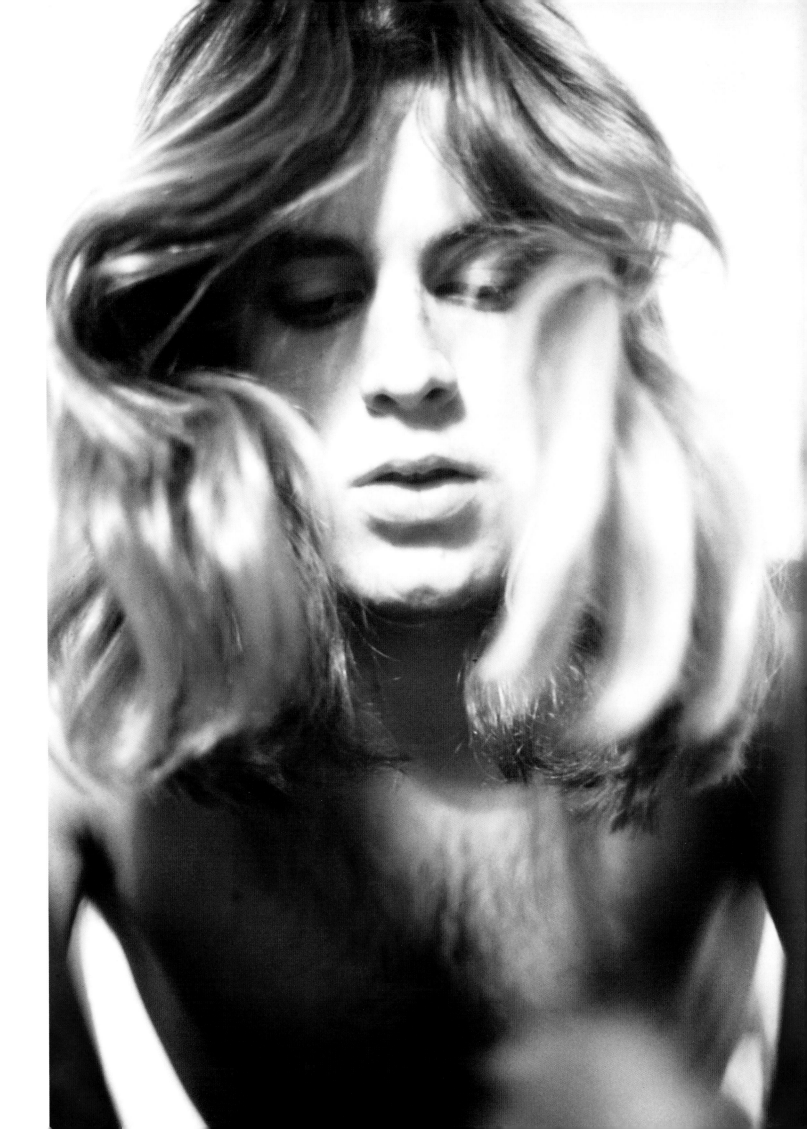

Writings by Hélio Oiticica
Introduction

Since writing—planning, pondering, and imagining—played such a significant role in Oiticica's life and work, it seems a natural choice for his own words to assume equal prominence in this catalogue. Carlos Basualdo made the selections, concentrating on texts that shed particular light on the *Quasi-cinemas* and that are, in most cases, previously unpublished. Fernando Gerheim in Brazil and Kelly Merryman at the Wexner Center provided the meticulous transcriptions. Sheila Glaser rendered English translations that preserve the protean vitality of Oiticica's voice.

In reproducing the texts, we have followed as closely as possible the rhythms of the author's highly individual approach to punctuation and capitalization. But we have not attempted to mimic his specific placements of words on the page, except to preserve occasional pairs, listings, or parallels that contribute to the meaning. For this reason, among many others, we are deeply indebted to Projeto Hélio Oiticica, which not only offered gracious cooperation with access to the original manuscripts but provided digital scans allowing us to reproduce selected pages.

The order of the texts is inflected by both chronology and thematic connections. We begin with *Nitro Benzol & Black Linoleum,* a direct precursor to the *Quasi-cinemas*, and continue with three enormously varied commentaries on Neville D'Almeida's film *Mangue Bangue.* Statements on *Neyrótika* and the *Cosmococas* follow, with the detailed scenarios for seven *Cosmococas* grouped together as «Cosmococa Instructions.» The final section encompasses varied selections from Oiticica's notebooks.

Conceived during Oiticica's 1969 visit to London, this text was written in English. It is transcribed from the artist's manuscript and published here for the first time.

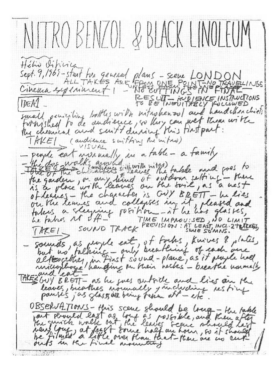

NITRO BENZOL & BLACK LINOLEUM

Hélio Oiticica
Sept. 9, 1969 — start for general plans — scene LONDON
 ALL TAKES ARE FROM ONE POINT — NO TRAVELLINGS
 UNLESS FROM THE ONE PLACE
Cinema experiment 1 — NO CUTTINGS IN FINAL RESULT–
AUDIENCE INSTRUCTIONS TO BE INEVITABLY FOLLOWED

IDEA 1 —
Small peniciline bottles with nitro benzol and handkerchiefs furnished to the audience, so they can wet them with the chemical and sniff during this first part:

TAKE 1 —> (audience sniffing the nitro)
VISUAL
— people eat normally in a table — a family
— the dog walks around

TAKE 2 —> (audience still with nitro)
— one of the characters leaves the table and goes to the garden, or any kind of outdoor setting — there is a place with leaves on the soil, as a nest of leaves — the character is GUY BRETT — he lies on the leaves and collapses in it, pleased and takes a sleeping position — if he has glasses, he takes it off —

TIME IMPROVISED, NO LIMIT
PREVISION: AT LEAST, INCLUDE. 2 TRACKS
SOME 50 MINS.

TAKE 1 —> SOUND TRACK
— sounds, as people eat, of forks, knives & plates, but no talking — only breathing of each one altogether, in first sound-plane, as if people had microphone hanging on their necks — breathe normally and eat —

TAKE 2 —> GUY BRETT — as he goes outside and lies in the leaves, breathes normally, including resting pauses, as glasses being taken off — etc.

OBSERVATIONS — this scene should be long — the table part should last as long as possible, and then after the quick walk out, the leaves scene should last very long, at least some half an hour, so it should be filmed a little over than that — there are no cut-outs in the final mounting.

IDEA 2

AUDIENCE — drinks COKE

(coke would be provided continuously)

TAKE 1 —> VISUAL
26 mins.
— EDWARD POPE rolls in a bed — the bed is in the upper [illegible] bed in the DROWER'S house in the FRONT ROOM — 29, CAMPION RD., SW 15 in PUTNEY — the usual blankets & mattresses should be there — he is sleeping, awake, changing position casually — he gets up, after 5 min. and he dresses a woman's night dress, white — he walks towards the closet, [illegible] in his characteristic way anything — picks up whatever he wants — he sits in characteristic way and stay still (as he does actually) —

OBS: the most amazing filming should go out, depending on the whole improvisation of everything —

TAKE 1 —> SOUND TRACK
CAETANO VELOSO sings ininterruptedly his piece CLARICE — repeats as it ends, but with new words constructed as the needs for the time of image (20 mins.) —

IDEA 3 HOMAGE TO GLAUBER ROCHA

AUDIENCE — the 3 screens project the same thing

[A diagram indicating the placement of the three screens (left, central, right) and the location of the «cushions & audience» accompanies this text.]

OBS: this TAKE to be filmed in MANGUEIRA HILL, RIO DE JANEIRO, by LIGIA PAPE

TAKE 1 —> VISUAL
— In MANGUEIRA HILL, RIO, people in their everyday life — at night — standing around — going in-out, up-down the hill — film near the way leading up towards the BAR DOS COMPOSITORES — towards the end during the day, very light, white high [illegible — hey? bey?], the same casual going on —

time schedule: 30 mins.

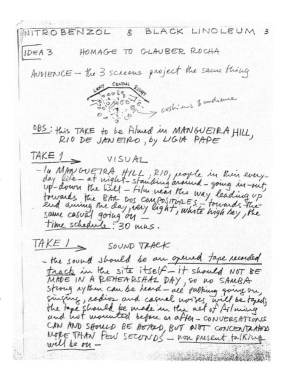

TAKE 1 —> SOUND TRACK
—the sound should be an *opened tape recorded track* in the site itself—it should NOT BE MADE IN A REHEARSHAL DAY, so no SAMBA strong rhythm can be heard—all talking going on, singing, radios and casual noises will be taped; the tape should be made in the act of filming and not mounted before or after—CONVERSATIONS CAN AND SHOULD BE HEARD, BUT NOT CONCENTRATED MORE THAN FEW SECONDS—*non present talking will be on*—

IDEA 4

AUDIENCE: —3 screens *lighted blank*
 —small stage in front of central screen

NO TAKE

scene—in the small stage a couple (man-woman) Kisses during 10 mins. a purple light from a floodlight casts on them—they can be—volunteers from the audience booked beforehand at the beginning

IDEA 5

AUDIENCE: —different kinds of cloth materials are, from one end of the environment, passed around in a chain—the differences between them should be sharp, as for instance: velvet, silk, cotton—in a kind of different size, texture, weight, etc.
 —only the central screen works now—
 —jasmine smell shifts from *odor transmitters* in scattered intervals.

TAKE 1 —> VISUAL
—a girl in a bathtub, naked, full of water, bathes—no soap seen, but she continuously rubs her hand along her long hair, rolls in the water, during 10 mins.—

TAKE 1 —> SOUND TRACK
—to be made in RIO, by LIGIA PAPE, from VELHA GUARDA records—but no singing, only instrumental.

IDEA 6

AUDIENCE: —FLOODLIGHTS cast over the whole audience area, a light similar to the YELLOW LIGHTS OF LONDON STREETS
 —WORD is passed around to slide the couches and mattresses to the sides, by the non circulation areas, and leave a bare central area

NO TAKE
scene with audience people—
to different *blue tunes* from *New Orleans* to more *recent ones,*
people dance during *half an hour.* those who will not dance, sit
around, as in common dance-party.

IDEA 7

AUDIENCE: the 3 SCREENS working

TAKE 1 —> VISUAL
—a man's sexual organs, erected, in profile showing—a girl,
whose face appears not showing the complete head, only eyes,
nose, mouth, chin, sucks the man's prick, during 10 mins., in
profile always.

OBS:—the shot, if not possible for actually filming during the 10
mins., can be mounted repeatedly, in one shot shown continuously
twice—

TAKE 1 —> SOUND TRACK
—local taping of sucking sound

IDEA 8

AUDIENCE: none of the screens are lighted
 no light anywhere
 complete darkness

NO TAKE
scene with audience: during 10 (ten) mins. any strong & quick pop
record plays—in the dark environment people do what they want—
including dance, if possible, for cushions and small mattresses will
be scattered around.

IDEA 9 TITLE: «A NIGHT IN THE OPERA» in homage
 to the MARX BROTHERS

AUDIENCE: —*1 SCREEN* working *for first 10 mins.*
3 SCREENS for *the rest 20 mins* (as [illegible])
—people sit or lie normally on the cushions & mattresses—
—some structures of plastic with air, sensorial objects, or whatever
we can call them, are spread around for people to experience
them—they will be specially invented for this situation and purpose
by LIGIA CLARK—they shall be things that people can experiment
easily with no introduction—they shall be made in series for all films'
projections, as part of the production—

TAKE 1 —> VISUAL

improvised *30. mins.* filming: first, one person is slowly dressing,
out of pieces of clothes, ornaments, anything — after some 10 mins.
the second person appears and starts dressing, aided by the other
one — (people are naked when they first appear) — suddenly a third,
follows same ritual which becomes quicker, and quicker — fourth,
fifth, sixth, seventh, eighth, ninth, tenth, follows faster & faster, and
the increasing gathering and dressing up fills the scene, and devel-
ops in a kind of collective sensual body — rubbing movements, as
a dance — extremely erotic — (this alludes to the famous sequence in
a Night in [at] the Opera — but while that one was a supreme gag,
this one should be increasingly erotic — impersonal: people touch
and rub each other, but not specifically relating as persons, but more
as objects personified —) — this scene goes on in a room with mir-
ror, as a common bedroom or dressing-room —

TAKE 1 —> SOUND TRACK
— talking, conversation, in Portuguese, with background music:
records are put on, changed in back phone-conversation goes on
in [illegible].

first option: conversation with GUILHERME ARAUJO — SANDRA —
DEDÉ — GILBERTO GIL — CAETANO — the records played can
be any, including some of Brazilian pop-music, excluding any
by CAETANO or GIL. — the conversation should be completely
improvised —

second option: conversation in Rio, in Port., taped by LIGIA PAPE,
in OITICICA house, with different kind of people — complete improv-
isation, records in background, etc.

IDEA 10 LIGIA PAPE'S ‹PLEASURE CIRCLE›

AUDIENCE: — FLOODLIGHTS shed purple light making a large
purple circled area on the floor — people gather in the center (around
it) in rows cloning the central bare space — in the center of this
space many kind of ice-cream cups are grouped — people taste
from each cup or continuously from the same started with which are
distributed around — people deposit inside the cups after the cere-
mony is over — the tastes in the liquids in the cups, vary from one to
the other, from bitter to sweet, and with different colors.

NO TAKE
time: 20 mins.
SOUND: tape plays with *drum ritual music*
 tape to be made by Ligia Pape in Rio.

IDEA 11

AUDIENCE: —first 10 mins.: *wind* blowing from apparatus or fans.
—rest of time: strong rock music and *people dance.*
—3 SCREENS

TAKE 1 —> VISUAL
—scene: large room in CERES FRANCO'S house in Paris (58,
rue Quincampoix, 4^ème) —
—*First 10 mins:* CERES FRANCO walks, improvising always, from
different corners of the room, dressed as she always is: in black.

—*remaining time:* at least 40 mins. TIME FREE
complete improvisation-
LEA BOND and JILL DROWER come —
LEA rubs oil in her body continuously, she is in underwear —
JILL has a big german s[h]epherd dog which she pets and rubs
continuously
CERES never stops moving
They should always improvise in those actions and in general
scene — in last 10 mins., movement increases in tension

VARIEDADes
HELIOITICICA
1st ACTIDEA

10 Oct. 1969

(free play)
Scene 1 —> this scene is with complete spectator participation:
INSTRUCTIONS ARE GIVEN BEFORE-HAND TO THE PARTICIPA-
TORS
volunteers, *men*, *10*, one for each sink — close inside the curtain —
dim, almost non-existent light shifts in through the dark passage
from the sink — coupled to the outer-space — the men, each in their
place, reflect in the mirror in the dark; each one masturbates inside
the sink looking for various sensual contacts with their sexual
organs: like water, sponge, the sink itself, etc. When finished each
one eats a banana picked up under the sink (there should be many)
and fill sink with water cleaning the mess.

[The text above accompanies a sketch labeled «SCENARIO» with
«mirror,» «sink,» and «towel» indicated.]

the curtain shifts left-right & vice-v-. (to the floor, so one can stand
between the curtain and the sink — of course making volume on the
curtain, for it shifts tight on the sink —): some *ten* of those open-
cabins, which lead into a darker hallway, then to outer space.

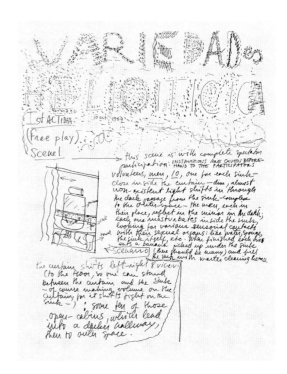

VARIEDADES

Scene 2

—> Microphones displayed equally all around, so the voices can be heard everywhere.

LISP LIP
STICK LIPSTICK
STUCK
 ROCK HUDSON
STOCK BAY
 SOCK
 FROG
 FROCK ISS
 BLISS
 WAY
 |
 ∨

each color indicates an improvised difference of voices: should be characterized by different people: the mirrors will transmit simultaneously the «acting»
action —> different elements *to smell:* for instance: grasses, flowers, powders, metals, things: distributed among ptps. [participants]

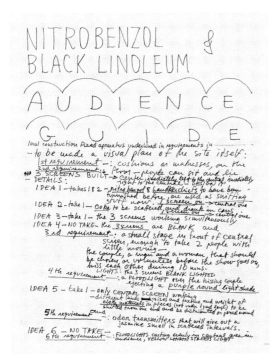

NITRO BENZOL &
BLACK LINOLEUM
AUDIENCE GUIDE

local construction fixed apparatus underlined in requirements in —

— to be made a visual plan of the site itself:
1st requirement —: cushions or mattresses, on the floor — people can sit and lie
2nd requirement —: 3 SCREENS BUILT —> center, immediately left to the central, immediately right to the central — DESIGN IT

— DETAILS:
IDEA 1 — takes 1 & 2 — *nitro benzol* & *handkerchiefs* to have been furnished before, are used as *sniffing* stuff now. *1 screen on* —> central one
IDEA 2 — take 1 — *coke* to be scattered and drank in cans. *1 screen on* —> central one
IDEA 3 — take 1 — the *3 screens* are working simultaneously
IDEA 4 — NO TAKE — the *3 screens* are BLANK and
3rd requirement —: a small stage in front of central screen, enough to take 2 people with little moving — the couple, a man and a woman, that should be chosen or volunteer before the show goes on, kiss each other during 10 mins.
LIGHTS: the 3 screens BLANK LIGHTED
4th requirement —: a FLOODLIGHT over the kissing couple ejecting a *purple round light shade.*

IDEA 5 — take 1 — only CENTRAL SCREEN working

— different kinds: sizes and texture and weight of *cloth materials* in pieces (not under 1 yard large) to be shifted from one end and be distributed or placed around and

5^{th} requirement — : odor transmitters that will give out a jasmine smell in scattered intervals.

IDEA 6 — NO TAKE — FLOODLIGHTS casting evenly in central area in audience

6^{th} requirement — : YELLOW LONDON STREETS LIGHT

IDEA 7 — take 1 — the *3 screens* working

IDEA 8 — NO TAKE — complete darkness for 10 mins.

 pop record playing strong music

IDEA 9 — take 1 — 1 SCREEN for first 10 mins.

 3 SCREENS (after 2^{nd} person enters scene) for the remaining 20 mins. Total: 30 mins.

 — Audience touches & plays with *sensorial elements* by Ligia Clark, passing around from one end

IDEA 10 — NO TAKE — Ligia Pape's ‹PLEASURE CIRCLE›

a) Ice cream cups with different liquids that bear different tastes

b) to taste liquids

c) FLOOD LIGHTS throwing purple light making central big lighted circle area

d) Tape (made in Rio) playing drum rhythms

NITRO BENZOL & BLACK LINOLEUM TIME CHART

IDEA 1 —	TAKE 1	(time free) approximately		20 mins.
	TAKE 2	(time free) approximately		30 mins.
IDEA 2 —	TAKE 1			20 mins.
IDEA 3 —	TAKE 1			30 mins.
IDEA 4 —	NO TAKE	scene on small stage		10 mins.
IDEA 5 —	TAKE 1			10 mins.
IDEA 6 —	NO TAKE	people in audience dance		30 mins.
IDEA 7 —	TAKE 1			10 mins.
IDEA 8 —	NO TAKE	darkness in audience		10 mins.
IDEA 9 —	TAKE 1			30 mins.
IDEA 10 —	NO TAKE	L. Pape's ‹PLEASURE CIRCLE›		20 mins.

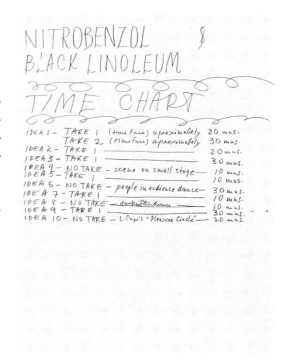

Mangue Bangue

These three texts discuss *Mangue Bangue,* the film by Neville D'Almeida, and bracket in time the *Cosmococas* Oiticica and D'Almeida conceived together. The first one predates CC1 by just four days. They are published here for the first time in English. The film's title is a multifaceted pun on the name of the red light district in Rio.

[from NTBK 49]

mar 9, 73
ho nyk

MANGUE BANGUE at MOMA
11 AM[1]

marcelo
claudinha
neville
ondina quentin
chris kynaston
anne
vera
paulinho
chico

NEVILLE's film
SCRAPSHOTS
fringes fragmentation
riojaneirans

the plastic fades tiling the shower-stock exchange hair shedding flowers vases decorations bed-wall dirtyblue skin on dry skeleton ROGÉRIA and PEPA'S girls peepanties descend-climb eyesarched float astroglobes splitoposcreen: moving from the box to the left through the top to the right water-soap shower-waterfalls stock-vomit black face mud gasometer HENDRIX in DAMIÃO'S non-filmverbosity flower vomited roosterVILinking nevillapproaching glad GLADYS meliesstuff and pattern plan-sound of geometry dislocated between synchronicity and silence SNAPBITS scrotumbites camera tongue-bath from one end to the other gap of touch-vision microplaying mangrovemolecules play-tropics squattedpooheaten there is no margin: animal-environmental limit or script or decoration or situation EXTENSIONS OF THE RIGHT LENGTH

Neville never went along with subliterate pseudocinematics nor with

1 This text was written on the occasion of a private screening of *Mangue Bangue* at the Museum of Modern Art in New York; the names listed at the top of the note are the friends and acquaintances who attended, including D'Almeida, MoMA curator Kynaston McShine, and Quentin Fiore.—ED.

the easy way water with sugar nor did he sit and wait for malediction to get him: Neville is too mocking to put up with the psycho-sentimental little dramas of Brazilian cinema: for that reason his films are not only banned but because they cannot be properly shown (crappy censorship) but are intellectually banned by the curilous pseudomystified cinema of false luminosity and geniality and other characteristic bullshit: NEVILLE was always outside all that and his links to BELAIR were the sadist beginning: he places himself only in the position of an experimenter precise-adventurer linked to the BELAIR filmmakers (the best thing ever made in Brazil in film) and the very new super-8 experimenters like IVAN CARDOSO in the lead: NEVILLE is like the always succulent fruit: for that reason MANGUE BANGUE suggests places paths certain of precise extensions of nonverbalism:

MANGUE BANGUE is not a naturalist document of life-as-it-is or a search on the part of a poet-artist for what's fucked up in life: it is rather the perfect measure of the film-sound gaps-fragments of concrete elements

MANGUEDRIX
with DAMIÃO'S house collagemedia with the environment of

MANGUEPEPA of PEPA the only environmental actress whom it is possible to admire like the flesh of GLADYS bodies that fit together GLADYS-ÉRICO as if all the sappy and idiotic dramas of Brazilian «art» cinema were emptied by the essence of cinema-realizations in the vomit of VILAÇA vomiting years of stupidity and false «cultural» Ipanema cinema It is the finger in the ass after smelling shitbelief sebum of itchy mud of

MANGUE
MANGUEROSE of the queers bigger takes that don't seek out visual images that are the realization of non-situations the cinematic pleasure of making cinema

CINEMANGUEAR non-characters non sentimental non folk-MANGUE so concrete like theOSWALDIAN SANTEIRO or my PARANGOLÉ of nonnarrative montage cut of dislocated planes takes the goal of the realization of cinema verité as long as CINEMA IS THE TRUTH and not a representation of the truth

and what is true, anyway? BULLSHIT

dumping years of the cinema of cute experiments of amateurs the stupid shit of serious people who literally think that cinema is fiction and that therefore cinema-truth would be non-fiction hah hah!

only that NEVILLE is funny is cute without parodic ways that day-to-day sediment of unsentimental humor with no «cult of the image» open to the proximity of open patterns as a relative of MELIÉS a

cartoon super-8 TV non-narrative episodes with vertical cuts silences that are intercut

NEVILLE is good in the zest for living for scraping [escrapear] the germ of feature film

[NTBK 2/73, pp. 10–17]

2 Jul 73

Mangue Bangue: I wrote about Neville's film (see the text of 9 March 1973, nyk) I think of it as I think of GODARD's development what interests me most is not his «cinematic innovations» but the degree to which those innovations devour cinema's reason for being: HAROLDO DE CAMPOS must have experienced the same thing when he says that in Bressane's ESTRANGULADOR DE LOURAS [Strangler of Blondes] the first blonde to be strangled is the language of cinema devoured in its verbalism: but in truth there is something on a less obvious level than the case of THEATER: in extreme cinematic experiences any «innovation» is «devouring» and any attempt to see *beyond* it is the «end of cinema» as an important language: would cinema become a mere instrument? even the idea of cinema as art implies locating or wanting to locate film as a «fine art» which is useless because even in «fine art» the conceit of «fine art» had already ceased to exist which shows that cinema cannot be held as an «art form» but as a *language as concrete as its realized form*: if cinema had been «fine art» it would have remained at the level of projecting photographically beautiful images something to which neither cinema nor photography has adapted because it was not in either's nature: cinema-language identified as a fiction-language parallel to the idea of literature as fiction came and went and ended: will films always be made (?) as pictures—representation will always be painted which does not mean that the importance of the discovery of these stereotyped forms subsists because it doesn't matter that they are made but remain in the detritus of forms saturated with language, etc.: but «innovating» the form of cinema-language takes even more drastic measures: it leads to thinking of something like massaging the heart of a sclerotic cadaver so that he can live a few more hours, or days, or even years; something like the need of a type of language to survive was similar (in that case equal) to the need to live: why? Everything seems to beat against the walls of metaphysics, what to do?: when I say that cinema-language can come to be a cinema-instrument I mean that characteristics of cinema as something as a form and in their palpability: film, images in movement, etc.: it may come to be the instrument of something that incorporates it: TV for example: and that annuls its autonomy as a language-cinema and that consubstantiates it with what is demanded as the major consequence of that language that isn't watertight on a critical academic level: elevating cinema-language to a criticism *in progress* means not only seeing one's *film as*

performed art but also a larger use of cinema as *instrument-language* that is not «applied» or «made use of» for other ends but *incorporated after it is fragmented into a new kind of language that is formed and that remains as a process* all that comes to mind when I think of MANGUE BANGUE: why because for the first time I encountered a film (and the film per se is what made it possible for me) without having to consider through its inherent language-cinema how it «innovated» in that same language: GODARD the most important director since the '60s because step by step he devoured all the conquests of language-cinema incorporating them and step by step annulling himself by negating the preceding stage: I know this belongs to a classic process in the «evolution of an artist» when process is identified with evolution: it doesn't matter and is logical that GODARD-process belongs to a classically defined process-evolution: *negating* in linearity *not seeking a specific end* so long as the evolution from one stage to another doesn't mean trying to «achieve an end» but how to discover what is unknown when that unknown is revealed: negation as a principle is what is still vital be it in a process like evolution or be it (as I would like it to be now) a realized process as *process-mosaic* that is each stage of that process will not be erected as a preparation for the following stage but as a mosaic that made the process itself something of a discontinuous formation and something that is realized as such: the concreteness of the process as mosaic-process is given in what I call experimentation (as JOHN CAGE well says: experimenting no longer means preparing something for a specific result but is already something in itself: a process that is linked more to the behavior of the individual than to the contemplative pleasure of the end product): NEGATING that it always was a point of departure for the artist/creator in any field of human activity is today something that is maintained as an ABSOLUTE NECESSITY—LANGUAGE in any important (or creative, if you prefer) activity

MANGUE BANGUE I think all that because cultural considerations don't matter in that the language cinema in it is given by cinema-fragments or cinema quasi-cinema is made up of clichés or leftovers from other language-forms, etc.: let them be!: because for example or what defines attenuation: for example: cliché/image given/effect taken from the other/etc. it is only the dilution of language when the result as a whole is language-dilution that is, affectedly cultural language interested in «giving meaning to formal and aesthetic conquests discovered by someone else» or in sum «to consolidate them» but if all that takes place as in PICASSO/STRAVINSKY/GODARD: that is it is devoured (it is so obvious that I'll only mention here to remind people—obvious and childish to whoever thinks about the matter) and shaped not as a «collection of fragments» but as *a mosaic-fragment that directs and annuls the effect of the «aesthetic conquest» of the forms-fragments-language they represented in the past and elevates them to the status of a new language*: that has already been discussed shown talked about saturated: but I say it here because as incredible as it may sound it is a

stumbling block when you want to discuss why something is impor-
tant even if it's a banal cliché in one thing and a dilution in another:
the subtle problem of attenuation/banality/etc. is more subtle and
ambivalent when if you want to consider *process* as such instead of
evolution in which A yields B (even if it is more complex—which it
was in the most important cases—where there is multidirectional
overlap ACBJADCH who knows what combinations would be possi-
ble—in linear truth defines a «chain of causal thinking» but of anoth-
er thing—if art criticism and aesthetic philosophy fixed on one thing
in the 20th century it was on banalizing A for B B for C etc. that
is another matter—would that it were!): because today the experi-
mental and rapid freedom in the days of the electric electrified
MCLUHANized global village, etc., launches without the slightest
possible consideration on what is referred to as «aesthetic prob-
lems» of any order of all the fragments within the body's reach
(it can be said) not only as if it were the ideal of psychological-
mechanized immediacy (which in some sense is already part of the
languages of the day) and multi-media (already incorporated) cultural
waste, etc., but as a kind of activity that is structured in so far as
that process is recognized as the only one possible: that is as a
process that is experienced as a process not on a cathartic level
that previously served to demolish old aesthetic positions etc.,
but as a structure of discontinuous form—what does MANGUE
BANGUE have to do with all that?: as a «product» the film shows
that it is not a product (or culmination) of creative affluence (like
GODARD/PICASSO/STRAVINSKY) but *a fragmented proposal of
necessary-language that resulted in the thin leavings and the flip
gratuitousness of the pleasure of filming* (almost a hippie-touristic-
in-the-family home movie) whose only reason for being comes from
having been filmed-shown and proposed as a film because a
greater vital necessity demanded it: the independence of fragment
by fragment is even the repetition of cuts/metacommentaries for
the cockfight show the thin and necessary simplicity of not worrying
about consciously framing cinema-language in terms of formal inno-
vation (even if it ends up being innovative on the whole) but in terms
of the necessary realization that defines the filmmaker's dissatisfied
position with the very language and with what could be the thinking
on that language: maybe the filmmaker as productive filmmaker
would next make something that contradicts all that: it doesn't mat-
ter: what matters is that that work as a situation has to remain a
point that is critical/moving/of language-crisis: even if it is a parody
of cliché-cinema it doesn't matter as a parody that mounts a meta-
critique of language but remains as another fragment in the forma-
tive mosaic: yes the work is metacritical of cinema as language: the
non-verbal quality oscillates and shows futility as the solution to
forms defined as image-photo or audio-visual: it is NON NARRA-
TIVE-NON PHOTO-SOUND-IMAGE-QUASI-CINEMA CINEMA—all
of that can be discussed and each conceptualization leaves the
frustration «why do it then»?—but what would be gratuitous is
played here as a necessity—NECESSITY and NEGATION together
are this work.

[NTBK 4/73, pp. 53–54]

30 Mar. 74

FOR CANNES —> introductory writings on
MANGUE BANGUE de NEVILLE D'ALMEIDA

MANGUE BANGUE is NEVILLE D'ALMEIDA'S fourth film and should
be viewed side by side with the others: his work has from the first
been banned from being in any way viable in BRAZIL, and he is an
exile par excellence: this is perhaps one of the reasons for his immu-
nity in regards to the culturalist obligation that the young Brazilian
filmmakers seem to pursue. I would call MANGUE BANGUE a *limit-
experience*: you don't see in the film any desire to construct a «new
language of cinema» nor the desire to justify an already existing
cinema-language as a means in itself: there is something like an
indifference in regard to the «destiny of cinema»: it is treated as
directly as a «home movie» would be, only without the domestic gra-
tuity and the meaning: at the same time it resists any insinuation
of an «artistic film» (as if there existed «artistic philosophy») and of
«documentary» or «cinema vérité,» etc.: In truth it shows the impos-
sibility and inapplicability of those concepts: MANGUE BANGUE is
a *limit* exactly because it doesn't become fixed in the previous form-
function/cinema and because it doesn't «show a new way for cine-
ma,» it shows cinema as an instrument, which is similar to what
happens with TV: the visual plasticity very super-8 and the montage
as if it were geometric blocks structured in a sort of ‹perpetual [illeg-
ible]› the precise voluptuosity of the takes, a gratuity that reveals
itself as the *pleasure of filming* is a rich and inventive gratuity never
the omission of the author: there is a permanent intent turned to
the cinemagraphic, visually and plastically as if instead of questions
(and questioning itself) on the destinies of a language in cinema,
the filmmaker would focus in block-episodes direct and complete
in themselves, put together as if through a *chance operation*: there
is no intention of creating meaning through the sequencing of the
montage: neither of questioning: he is a limit: and it is so direct that
to a lot of people it will give a sense of insipidity and tedium: as if
asking «what's the point?»: what to say, then, if people shrug and
turn their backs on even the polemics and intriguing experiments of
Godard, how could one hope they would embark on endless dis-
cussions?: well: what is important to the young Brazilians who work,
for the most part, outside of Brazil, is that to «make cinema» does
not mean boring and heavy with «transcendental and deep prob-
lems» or «obligations to cultural ends,» etc.: it's because they freed
themselves from what was weak in *Cinema Novo*: as HAROLDO
DE CAMPOS (poet-critic-director-concretist) pointed out those cine-
matographers had great visual capacity (in terms of training) and
no literary background: the youngest lack neither the facility of the
«artistic-documentary cinema,» nor the weight of «literary cinema»:
a cinema-limit placed as an instrument open to experimentation
NEVILLE D'ALMEIDA began, after MANGUE BANGUE, a series of

[handwritten manuscript page in Portuguese — not legible enough for faithful transcription]

experiments that he called *quasi-cinema*: the cinematic sequence is fragmented in slides, or, rather, in *frames-moments*, in an open game full of accidental incidents with a soundtrack of INSTRUCTIONS for performances (different areas of projection) etc.: MANGUE-BANGUE should not be viewed, however, as an effort to find a «new language of cinema,» or as a metacriticism of valid language-cinema, but as a limit-experience that positions the *finished film* product as an instrument, that is, not as a end-language or as a 7th art, but as an instrument of open experimentation free from the weight of the categorization of art (which in truth still belongs to the old «beaux arts» of the 19th century, when art became an accredited «liberal profession»).

Neyrótika: Non-Narrative

This statement appeared in the catalogue/brochure of *Expo-Projeção,* a 1973 exhibition in São Paulo, where a version of *Neyrótika* was exhibited. First English publication.

NEYRÓTIKA

NON-NARRATIVE
filmed in NEW YORK April/May 1973
80 slides with timer and soundtrack

golden kids of the Babylonests

in the nests or outside
NON-NARRATIVE because
it isn't a little story or
pure photographic images
or something horrible like an «audio-visual» project
because NARRATIVE would be what already was
and what hasn't been for ages:
everything that exists of the aesthetically retrograde
seems to have to do with narrative representation
(like those painters who want to «save painting»
or cinematographers who think that cinema is
literary-narrative fiction)
NON-NARRATIVE is NONDISCOURSE
NON «ARTISTIC» PHOTOGRPAHY
NON «AUDIO-VISUAL»: the soundtrack
is continuous but punctuated by
improvised, accidental interference
in the structure recorded from the radio which is
arbitrarily linked to the slide projection sequence and not used
for emphasis
—it is *play*-invention

NEYRÓTIKA is NONSEXIST
One night I sat Beauty on my knees
—I found her bitter—I cursed her
NEYRÓTIKA is what is pleasurable

Block-Experiments in Cosmococa–Program in Progress

This text from 1973 was originally written in English.

BLOCK-EXPERIMENTS in COSMOCOCA–program in progress
NEVILLE D'ALMEIDA–HÉLIO OITICICA: CC1 to CC5
THOMAS VALENTIN–HÉLIO OITICICA: CC6
HÉLIO OITICICA: proposed to GUY BRETT in LONDON: CC7
HÉLIO OITICICA: CC8
HÉLIO OITICICA: proposed to CARLOS VERGARA in RIO DE JANEIRO: CC9

COSMOCOCA was initially conceived by NEVILLE D'ALMEIDA as a new film project: he invented the name and more than a film project it became—program *in progress*: COSMOCOCA–program *in progress* should then appear in all the references made to the experiments:

emphasis on it being *program in progress–open program* in an effort to show that COSMOCOCA is meant to embrace a much wider spectrum of experiments and as such should not be identified exclusively with these BLOCK-EXPERIMENTS (abbreviated CC followed by corresponding number): they are a first experimental part of COSMOCOCA–program in progress conceived by NEVILLE AND MYSELF the first 5 BLOCKS born of our liaison: alone I would never have the necessity to start: our extended raps on the limit situation proposed by NEVILLE'S MANGUE-BANGUE provided the inertia: these BLOCK-EXPERIMENTS are really a kind of *quasi-cinema*: a structural innovation within NEVILLE'S work and an unexpected field for my longing to INVENT in the light of my dissatisfaction with «cinema language»: not to be contented by the relationship (mainly the visual one) of spectator-spectacle (nurtured by cinema-disintegrated by teevee) and the wide-spread indifference of such notions: the prevalent blindfaith acceptance of that relationship's immutability the spectator's hypnosis and submission to the screen's visual and absolute super-definition always seemed to me too prolonged the pictures changed but somehow remained the same: why?: not even ABEL GANCE's instructions for the role of two screens in some of his films were followed: one screen and be sure the picture has not been chopped up: something had to give: something had to happen: TV HITCHCOCK's THE BIRDS is the first great TeleVising of the natural film sequence to which we were accustomed: then G-O-D-A-R-D: how can anyone muse over the «art of cinema» yet ignore GODARD's meta-linguistic questioning of the very quintessence of filmmaking?: as with MONDRIAN in PAINTING there came to be a *before* and *after* GODARD: in ten years he took to the limit consequences which had never even occurred to other filmmakers: meanwhile within the plastic arts things were much

slower (to the point of no interest even): CAGE continued to open the windows of music to the fresh air of INVENTION: GODARD dissected cinema-language with a checking and multi-evaluation only comparable to TV and ROCK phenomena: the GODARD-STONES SYMPATHY FOR THE DEVIL synthesis was not just one film production (even as film-invention or experimental cinema): in VLADIMIR AND ROSA GODARD disintegrates speech vision is silenced in a CAGEAN way by the insertion of minutes of black leader—the hand-clawed NAGRA repeats the same course in the tennis court to the dry counterpoint of the tennis ball: both HE and the NAGRA emit a disintegrating speech: sticky syllabic: and in MIDNIGHT RAMBLER JAGGER is GODARD: have you heard about the midnight— —within the silence created by the omission of the word rambler the single drumstick blow): have you heard about the boston— (silence-omission-drumstick blow): GODARD—verboclast—unlike the naturalist/romantic who turns to so-called cinema verité (as if cinema were fiction) penetrates the «weft and warp»—the very structure of cinema; joyful the liberation of the spectator from the tyranny of image and language: BRAZILWISE experimentation is far more accessible: some individuals however became increasingly «grave» in their «concern with the destiny of brazilian cinema» and in their quest of «senses» and «significations» prerequisites of their higher ideal—the creation of a brazilian cinematographic industry: as always the cart before the horse (unless one is deliberately going backwards) too much concern: too much searching: sans joie/ sans cocaine: plunging into shallow (uterine) waters: obscure and esoteric literature alongside flashes of insight both fresh and experimental: nevertheless GODARD outpaced all: limit question the raison d'être of a «cinema-language» which is his own: limit taken by him to a limit not crisis but limit: to what boredom and gratuity had «cinema-language» been reduced by the advent of teevee: HITCHCOCK's BIRDS had already announced with his usual genius (blessed fatty) such limit: WITH JOY as we recognize that cinema can transcend this NUMBNESS: spectator paralyzed: how to reconcile such imprisonment with the liberation of BODY with ROCK? long for the JOY and the FRESHAIR as CAGE frees music from the greatest numbness of performance/function ever seen: but seeing is not hearing or is it? MANGUE-BANGUE followed the first less cultural more inventive experiments: why limit? it pulses with pictorial sensuality (feel the color) and fragments into geometrically set episodes within its editing structure as if it were a cartoon strip made into sequence: whatever next? i remember rejoicing in the fact that i was not a filmmaker and consequently avoided those «very grave» problems: i remember being loathe to edit some takes i had of various projects: NEVILLE-I hand-in-hand switched from the project for one more film for CCI at BABYLONESTS: what lightness and sure energy springs from this mere shift: to release «unnecessary-necessités»: to reject that stale so-called professional notion of audiovisual: many factors helped determine CCI's realization on 13/03/73 and that realization which i term quasi-cinema serves to negate the unilateral character of cinema-spectacle.

one—everything started with what I later termed MANCOQUILA-GENS (MANCO(CAPAC) plus MAQUILAGENS MAKE-UP): NEVILLE's invention: a parody of the artist's concerns: the COKE-TRACKS trace the design/pattern upon which they are laid: a demi-sourire at what we used to know as plagiarism: the MAKE-UP is the camouflage: DUCHAMPIAN sarcasm as we consider the inaccuracy and pomp of all those concepts which led to the notion of «authenticity» in the plastic arts: plagiarism is immaterial and gratuitous: could anyone in all seriousness place competition or originality as a main motivation for creative activity? behavior (that is having pride in being supple/light/free) becomes indispensable to anything of interest for those who aim at experimentation: the parody of plagiarism (its ambivalence) is then both subtle and fundamental: the opposite which would be the main feature of «art professional» exists at the expense of INVENTION DISCOVERY EXPERIMENTA-TION and serves to restore plagiarism as an active element in a structure already obsolete: as if someone would copy a text of yours and publish it merely to «keep ahead» of you: it is as if that which had been forgotten—plagiarism—had been unearthed and revived: the COKE copies the surface (uncritical of its plagiarizing) playing playing: (petit bourgeois values lost in discussions who did this or that before…) and to think that some «artists» submit their own work to an evaluation grounded in falsities and infantile class hang-ups: if that which is supposedly superior (presumably the work in this case) can be submitted to such discrepancies then it cannot be the work: it may well be work but it will never be SOMETHING NEW: S-O-M-E-T-H-I-N-G N-E-W…

two—the slides are arranged according to a numerical order shown on their frames: this order is a result of a semi-chance operation the order in the box may or may not be the order of shooting: each slide is taken out of the box in the order that they were put in: mayhap the order is identical… these slides are not mere «photos from NEVILLE's arrangements» but are simultaneous with them… the slides are subject to accidental variations of operator and/or sound-track: THEY ARE FRAMES-MOMENTS: fragmentation of the cine-matic: the hand tracing the coke-track… MAKE-UP that makes itself… single/double-edge razor/blade/knife-edge honed/lick it and see: throughout finished-flat-image: film or photograph it matters not: the «cinematic» of «track making» and its duration are frag-mented in successive static positions as frames-moments INSTA-MOMENTS… crystalline one-by-one not adding up to something but in themselves are something… moments (NOWandNOWand NOWand..............)

 in a
 MAKE-UP
 process
MANCOKE-UP

………yeah: that which is limit in all this and
 that which unites NEVILLE and I and
 that which approximates here and there experiments and
 that which may be considered the predominant element—

the visual—is relative and plays with the whole it proposes to embrace: in short… IMAGE is not the works supreme motive or unifying end:

contemporary artist's experimental positing is not a mere revolt against existing art categories outside the multi-media/more the displacement of IMAGE's constancy and supremacy: that does not mean that the visual has been disposed of: it becomes enriched: it is non-unifying but becomes play-part of the fragmented game which originates in experimental positing taken to a limit: within brazilian experimentation this game of «NEVILLE and I» is akin to ANTONIO MANUEL's KILLED THE DOG AND DRANK THE BLOOD: within TROPICÁLIA (april '67) i included ANTONIO MANUEL's show-table displaying the «flongs» including the above-mentioned piece: some may have wondered about its inclusion and in what way it related to TROPICÁLIA: a «tristesse tropiques» illustration or decay of the newly made? what made me choose this experiment instead of others closer to home? TROPICÁLIA was a limit-tentative (not super realism) probing IMAGE's displacement (visually and sensorially the COMPOSITE IMAGE) through a kind of multi-media salad without the obtrusive dressing of «sense» or «point of view»: the macaws and backyard ambience were as little «realist» or «meta-realist» as were the eyes in the POPCRETE poem of AUGUSTO DE CAMPOS: nothing to do with POP ART or european SUPER-REALISM: as concrete as that which it seemed to evoke: a fragmented foundation of the limits of the nonrepresentational: in ANTONIO MANUEL's flongs we do not detect a supra-realist robustness: contrariwise they are a pseudo-technique a pun on plagiarism: nor were they a sentimental poem on the experienced realities of the tropics: they were the story-newspaper emptied of daily news: the IMAGE-grip is dislocated and a more fundamental element emerges: similarly NEVILLE's MANGUE-BANGUE is not «search work»: it fell straight into my main point: why outline into blocks—cuts cinematic flow? i also can imitate the film sequence through slides which are worked out as FRAMES-MOMENTS and this without any justification defining them as «audio-visual» (a term which i hate: is not everything finally audio-visual and more? so why the isolation of these two senses? does it not indicate an intention to maintain IMAGE's supremacy?): the point is that IMAGE does not have the same function as before particularly relative to cinema: according to MCLUHAN teevee which has a low visual definition opens up a more participatory structure for the spectator unlike cinema which presents itself complete within the super-defined photo-sequence: the super-visual ignoring the fragmentation of reality and the world of things: but IMAGE's effectiveness as a behavior-matrix which immobilized the spectator was not only visual: it was also conceptual: twinsister of applied ideology and discursive demagogy: STALIN and MACCARTHY: a medium trapped within a kind of verbi-voco-visual strait-jacket characterized by idealizing constancies: «star-system» not improvisation: and experimentation which fragmented or threatened the supremacy of existing concepts and verbi-voco-visual orders was considered

subversive and decadent: HITLER towards MODERN ART and ZDANOV-STALIN: yet MAO was not reduced to that: he is the same stock as the chinese individual and not IMAGE imposing itself as immutable: he is fragmented and incorporated into the unity of each chinese individual who in turn identifies with him: similarly the glory and fall of MARILYN MONROE: where IMAGE's supposed unity fragments itself by resisting the stereotype which attempts to define and limit it leading in most cases to frustration and catastrophe: something had to happen...... MAO-MARILYN: TV-ROCK: THE BEATLES: fragmentation leading to another order of identification breaking the univocal habit: today we can laugh at the complacency of maccarthian audiences in the 50's: and we wonder how effectively the unicity of some concepts and «points of view» imposed themselves and how foreign was the audacity of experimentation and how PARIS of latent provincialism became the very hub of experimentation mapping hitherto unknown territories: the world of objects its unity under threat would be transformable (reducible to the atom) but never fragmented in its whole: the implications of cinema as something other than sequential and linear.... so...... verbi-voco-visual constancy?...... yeah...... the skeleton in the cupboard...... and the obstruction.

BLOCK-EXPERIMENTS: slides-soundtrack-INSTRUCTIONS (as flight plan (loosely)): CC abbreviation identifies the series and should be used in the main spine of COSMOCOCA–program in progress experiments:

a) SLIDES: not audio-visual as their programming when put into performance enlarges the scope of the projected succession...... enriched as they become relative within a kind of corny environment: for me JACK SMITH was its precursor: he extracted from his cinema not a naturalistic vision imitating appearance but a sense of fragmented narrative mirror shatters: the slides displaced ambience by a non-specific time duration and by the continuous relocation of the projector framing and reframing the projection on walls-ceiling-floor: random juxtaposition of sound track (records): these BLOCKS the first five of which were programmed by NEVILLE-I replace for me IMAGE's problems consumed by TROPICÁLIA (etc.) by a level of SPECTACLE (PROJECTION-PERFORMANCE) towards which i am attracted through NEVILLE's cinema experience.........

SLIDES: FRAMES-MOMENTS: INSTAMOMENTS are a direct corollary to MANGUE-BANGUE limit: i am driven to insufflate experimentality into forms which seem to remain virtually immutable as SPECTATOR-SPECTACLE: NEVILLE's concern is to grasp environments sensorial plasticity and being above all a «plastic artist» he finds himself driven to....... INVENT IT: the camera work in MANGUE-BANGUE acts as a sensorial glove for touching-probing-circulating: explode then into SLIDES... fragments as consequence ... pretext for ENVIRONMENT-PERFORMANCE and by dint of such experimentation we are united and made to realize that «joint work»

has no more sense than individual work: NEVILLE-I do not «jointly create» instead we mutually incorporate so that the notion of «authorship» is as distant as is «plagiarism»: it is...... JOY GAME born of a monumental hoax: (snorting cocaine from the cover of ZAPPA's WEASELS RIPPED MY FLESH)

«who wants the eyebrows?»

«who wants the lips?»

«... what about the wound?» (to the accompaniment of snorting sounds) SNOW-POWDER: a parody of the plastic arts......... and

b) SOUNDTRACK: records or tape: furnished or suggested: environment incites......... DANCE......... BODY...... and

c) PERFORMANCE-GAMES plus: INSTRUCTIONS for private PERFORMANCE for small number of people indoors or outdoors and for public PERFORMANCE aiming at groupal games-experiments: to follow INSTRUCTIONS is to open oneself to GAME and PARTICIPATION the raison d'être of these CC's; to ignore INSTRUCTIONS is to close oneself and not participate in the experiment: so... where are you at?

three and four—the PRESENCE OF COKE as a prop-element in the first CC's is not obligatory (COCAINVIRONMENT... cocainvironmeans...) nor does it explicate COSMOCOCA–program in progress's INVENTION idea: just another twist in the general hoax and why not? if smelling paint and other shit is part of the plastic art «experience» then why not the shining-white COUSIN so appealing to most nostrils?......... TO PLAY WITHOUT SWEATING... we laugh in the face of the argument that posits that it is the artist's duty to elaborate his inborn talents and to sweat out his very lifeblood «onto the canvas» (... the audience explodes with lahahahaughter): NEVILLE-I are not in favor of sweating: not even when constructing PENETRABLES and NUCLEUS did I sweat: but it really flowssss in JOY-DANCE: PENETRABLES were invitations au voyage to the bitchy pleasantries offered by EDEN... color... sound... languor inside tents... straw... sand: ARTAUD's poetry without blood— ... that which emerges lifting itself above the ground... singing: ZARATHUSTIAN JOY of NIETZSCHE...... NEVILLE invents COSMOCOCA as world-name proposing not a «point of view» but a WORLD-INVENTION program: and from my program-experiment of MARCH THIRTEENTH NINETEENHUNDREDANDSEVENTYTHREE first session-event: the making of CC1) was born the realization of INVENTION-WORLD altering my life and behavior and transforming the wealth of propositions of these work-years into major and radical consequences: COSMOCOCA on CONTIGUITY: OF EXPERIMENTAL WORLD-LEVELS: it is not intended to surround COKE with the so-called deifying-mystical absolutes of lsd: COCAINE neither toxic nor water: the very idea of hallucinogens as «consciousness-expanding» (nothing could be less philosophic or constitute a greater incongruity) sounds phony.

COSMOCOCA is the supreme game-joke in which we play with SIMULTANEITY and CONTIGUITY and the multitude of possibilities of individual experience which lie within the collective-mind of MCLUHAN's GLOBAL VILLAGE: it is not a question of preaching (or its contemporary equivalent «turning on» which should not be «to convert» someone into our own system of beliefs (as a mode of seeing-feeling-living)) it's more a question of mutual experimental incorporation through the play of simultaneous permeating experiences: as in…… DANCING BODIES reeling and writhing never in one place long enough to form a «point of view»: nor is it a spiritual panacea for the «general longings» what madness… each man must choose his own poison… an extension of judeo-christian hang-ups… nobody wants to be saved contrariwise… as ARTAUD says… let the lost get lost: when BAUDELAIRE dedicates odes to OPIUM and HASHISH he is not prescribing remedies he is poisoning us with experience.… he is not preaching or promoting the commerce of the drugs (BAUDELAIRE as pusher… not the first… and certainly not the last)… he was WORLD INVENTING…… yes.… proposing a new and major order… A COLLECTIVE ONE… of participation.… carrying his poetry into new spaces flying by those nets of literary tradition.

NEVILLE-I in another situation within JOY-WORLD… becoming concrete (ROCK OF AGES)… have discovered something in common.… the omniscient generating nucleus of this proposition-program.… THAT WHICH IS PROPOSED IS ALWAYS GIVEN AS PLAY… CHANCE-PLAY… BY THE THROW OF A DICE AND NEVER AS A FIXATION ON EXISTING MODELS: PARTICIPATION AS INVENTION: SCRAMBLING OF THE ROLES: JOYFUL…… WITHOUT SWEAT.

five—the classification of these CC's serves to indicate the openendedness of the BLOCK-EXPERIMENTS: moreover there are other propositions in progress……

VIGIL with/for SILVIANO SANTIAGO: the incorporation through RAP in progress and questionnaire in progress of mutual simultaneous experiences/positings/WORLD: CARLOS VERGARA…… RAP and BODY BEHAVIOR—……CACIQUE DE RAMOS's SKIN DRESS UP…… to open oneself to a superior experimentation… to lead oneself BODYWISE instead of being led by the nose SPECTATOR…… VERGARA… mutant-skin… WITH JOY… as with CACIQUE's CLOTHING-SKIN… which is thrown upwards in dance at the WORLD-STREET…… YOKO ONO… MASK… TO SCRAMBLE ROLES… SITUATIONS… THE WORLD OF APPEARANCES… PSYCHES

MASK PIECE I
make a mask larger than your face
polish the mask every day in the morning
wash the mask instead of your face

when someone wants to kiss you let them kiss the mask
ninteenhundredandsixtyone winter
MASK PIECE II
make a mask smaller than your face
let it drink your wine
nineteenhundredandsixtytwo summer

YOKO...... MASK
SIMULTANEITY
QUENTIN FIORE............... SCRAMBLE-JOKE: laugh at the
seriousness of concepts... at the «grave issues»... only by JOKE
can we SCRAMBLE (inaugurating
then INVENTION-SITUATIONS) WORLD-ROLES: QUENTIN...... tape
RAP...... rapping on what he is and his aims......
SCRAMBLE WITH JOY AND
 WITH BOLDNESS AND
 WITH TRIVIALITY
WORLD ORDERS (...... CONDITIONED BEHAVIOR)
 see you...

GUY BRETT... MY PROPOSITION TO HIM:
 a nail file
 a snake
 shoot the nail file

for CC7: LONDON... GUY...DREAMTIMING... he gave me and
i give him PNI8 SHELTER SHIELD tape record: DID YOUR DREAM-
TIMING TAKE PLACE IN THE PERUVIAN COCAPARADISE?......
hmn?...... and in BABYLONESTS?.........
HAROLDO DE CAMPOS
 ASSOMO DE ASSOMBRO
AUGUSTO DE CAMPOS
 WOODSTOCKHAUSEN

HAROLDO... incorporated through the sister-words all apexes into
Brazilian poesy... apexes of ours... apotheosis......
ROCK/SAMBA/BODY-DANCE/COCA.......................
ASSOMO DO ASSOMBRO of that which JOY raised.........
 with the CAMPOS
 on the FIELDS
 above

AUGUSTO.................. it came to his head while watching HEN-
DRIX......... WOODSTOCKHAUSEN... no SEMANTIC INVENTION
could better capture that which is not limited by motherland or
styles... ROCK OF AGES... HENDRIX definitely incorporated into
brazilian music: «local music» is as senseless as «authenticity/pla-
giarism» HAROLDO...... tape record: ASSOMO DO ASSOMBRO:
would you consider apotheosis as being related to BODY-DANCE
or to ABOVE-GROUND? (which would be the same as having freed
itself from motherland...navel)

AUGUSTO tape record: send him HENDRIX… IN THE WEST…
MONTEREY tape recorded: letter: ninety minutes

CC4 NOCAGIONS: dedicated to the brothers CAMPOS send them
a complete copy of BLOCK EXPERIMENTS
MICK JAGGER
KEITH RICHARD
 the sound of strangers sending
 nothing to my mind
INVENTORS OF THE COUSIN
 sweet cousin cocaine lay your
 cool cool hands
 on my head
MICK-KEITH not only invented the COUSIN but also recognized
her as being……C-O-O-L… C-O-O-L in the same way that AUGUS-
TO DE CAMPOS………………………… says of JOAO GILBERTO
as being………… COOLER THAN THE COOL.
MICK
KEITH
 who else?
NEVILLE-I we sit
 we wait
 we act WITHOUT SWEAT
such a fine entourage from room to anteroom
behind the MIDNIGHT RAMBLER door NEVILLE I

six—DATA
a) on page twenty-nine in CONTRACOMUNICAÇÃO (COUNTER-
COMMUNICATION) it says: DECIO PIGNATARI: (in an interview..
CANNED COMMUNICATION …?)

question:… how do you place work and producer?
Decio: there is no work. even calling it open-work is merely an
attempt to salvage the idea of work. although some people go on
making work mallarmè's un coup de dès (a dice throw) puts the
work in check…it is neither work nor not-work. it is something new.

 …it…is…
 …it…
…IT IS SOMETHING NEW… SOMETHINGELSE…it…is some-
thing…new…it…

DECIO… tape record: rap on if or why COSMOCOCA–program in
progress would have any bearing on THIS…
also on all démarches finding their origins in NUCLEI/PENETRA-
BLES: the margin is not «damnation» but a proof that THIS some-
thing new… founds itself in the ruins of the established.

seven—AUGUSTO's POETAMENOS cries for and its space is
already cinematic with permeable white permeated by
 purple

　　　　orange

　　　　yellow

　　　　green

　　　　blue

　　　　red

nothing could be more congruent with the sense of the
SLIDES… SOUNDTRACK… BLOCK's INSTRUCTIONS… CC…

… today they have the day's freshness… looking ahead… these
flying book plates which are not book… THEY ARE SOMETHING
NEW… i want to insert dias dias into COSMOCOCA. AUGUSTO
angel of the CAMPOS'… each of these plates is as much filmic as
are slides themselves. JOY which is not hedonistic pleasure but
DANCE RAISING ABOVE GROUND.

in his plate: a mor

　　　　(l ove)

　　　　　　　is also

　　　mor (te)

　　　(death)

　　　the core buried within space-enigma:

　　　seguramor

　　　　　　the syllable mor remains

　　　　　　incomplete:

　　　　　　te hides itself but

　　　the suprem(e)(atist) white is more sensual

　　　than the white from

　　　norther northern regions

　　　　　　and even more than

　　　　　　　　　sparkling

　　　CCCoca-white

　　　of kings crowning and glittering

　　　　　　　a lone.

　　　the white in dias dias dias is filmic/multivalent animal but it
conceals within itself the hidden syllable te:

　　　a mor (te)

　　　the white…

　　　…it does not conceal

　　　the white…

　　　…it does not reveal.

eight—PROPOSITION for BLOCK-EXPERIMENTS in COSMO-
COCA–program in progress title—CC9
COCAOCULTA
RENÔGONE
for CARLOS VERGARA
RIO　　　　　　　　　to be sent on MARCH 13,1974
celebrating l year of
NEVILLE-l COSMOCOCA–program in progress

1) Indeterminate number of slides to be made (according to
VERGARA's choice or chance decision) at ST.CARLOS HILL: ZEZE's

house: ROSE's mother: i should send her something as a token-present for RENO's death (CARNIVAL SUNDAY FEB. 24 1947): VERGARA is to invent… whatever: initially i had the idea of a FRAG-MENTED ENVIRONMENT

a COCAINVIRONMENT but don't show the COUSIN…

OCCULTCOCA: photographic definition: discipline yourself to avoid the «typical»: ZEZÉ and whoeverelse is there should appear in the pictures: ZEZÉ -FRAGMENTS: mothershand/motherskin with close-up lenses. OCCULTCOCA: RENÔ GONE: photopauses: SCRAP-EPISODES: sensorial glove camera not acting as «outsider» or «spectator» relative to environment. but TOUCHING: photos of «local» color/slum-romanticism should be constructed as it were architecturally that is with precision.

2) SOUNDTRACK… to be CREATED or MODIFIED by VERGARA: avoid the charm of local sound: if local sound has been recorded use it on some future project along with other requirements.

NOTE… these are suggestions and as such should be considered relative rather than taken as limitations: VERGARA should not use them unless stimulated by them: INSTRUCTIONS here may inhibit rather than open up the game: this TRACK will be VERGARA's OPUS I in the same way that CC6 became my OPUS I: VERGARA will take full credit and hold exclusive rights of the TRACK's profits: after the release of CC9 in the form of a limited edition of ten (sets) the SOUNDTRACK may be released as an independent piece (VERGARA's decision): see INSTRUCTIONS for further details.

3) PLANS: for a) PRIVATE PERFORMANCE
 b) COLLECTIVE PERFORMANCE
a) determine projection items: number of projectors and method of projecting… environment… other types of action—…timing and duration of projection… synthesis of SOUNDTRACK with CAR-ROUSEL-SLIDES… indoors or outdoors.
b) as above…outdoors or indoors.
the very nature of these PERFORMANCES preclude them from the inherent limitations of the «plastic arts» etc…not unlike the work of JACK SMITH the PERFORMANCE-space-situation creates a NEW DIONYSIAC NUCLEUS: MCLUHAN's TRIBE is totally NEW… not a reconstitution of the old one… SOMETHING NEW… selfsame as this PERFORMANCE-NUCLEUS… what may be worth a try… as some sort of challenge… is to use a traditional theatre space and check out in what way stage-audience ROLES are fragmented as they are absorbed into a NEW NUCLEUS-SPACE…… VERGARA should invent the COMPOSITE-PERFORMANCE as specified in a) and b) above and IN THIS CASE THE GAME CONTROLS…… open up a chance-way in which i can participate as INVENTOR without being restricted by my status as a necessary element.

OBSERVATIONS: for VERGARA

Decide who is to keep possession of the original SLIDES... all CC
originals are kept in BABYLONESTS... rubber stamped and signed
by both authors... 10 copies will be made (duplicates of the series)
... with regard [to] CC9 my only credit as author of PROPOSITION...
ORIGINALS can either be kept in RIO or be sent up so that the
duplicates can be made here thereby maintaining some sort of
coherent classification... etc... you will keep the ORIGINAL SOUND
TRACK... i should like to keep CC9 COPY 1 of each of these
parts—rubber stamped: COPY_____and CC_____according
to former sample

ATTENTION... no PERFORMANCE nor INFORMATION nor PRIVATE
EXHIBITION should be released before the publication of the special
fascicle on the BLOCK-EXPERIMENTS... nor before carrying out
plans for the release of the others: any SALE is out of the question
at this stage:

WRITE A PIECE ABOUT THE EVENT... IT'S MAKING...THE PHO-
TOS... IN CELEBRATION: this PROPOSITION for CC9 marks the
FIRST BIRTHDAY of the BLOCK-EXPERIMENTS in COSMOCO-
CA–program in progress and of the making of CC1—...MARCH
THIRTEENTH NINETEENHUNDREDANDSEVENTYTHREE...
NEVILLE D'ALMEIDA... LOFT FOUR—... BABYLONESTS...
TRASHISCAPES... my choice is also meant as a tribute to VER-
GARA who grew and blossomed....... in COSMOCOCA–program
in progress...
directed at
higher levels
voilà

Cosmococa Instructions

The «instructions» for CC1–CC6 are reproduced here from English typescripts provided by Projeto Hélio Oiticica. Portuguese and English manuscripts of CC1–CC5 are on facing pages of «small green» NTBK 1/73. Portuguese manuscripts of the CC6 and CC8 texts are in NTBK 4/73. The texts for CC2, CC4, CC5, CC6, and CC8 are published here for the first time.

CC1 TRASHISCAPES

at BABYLONESTS
81 2nd Ave: #4
NYC

March 13th 1973

slides: 1 to 32: OPEN TIME
photos: by HÉLIO OITICICA
mancoquilagens: by NEVILLE D'ALMEIDA
sound track: a montage of NORDESTE (brazilian northeast) POPular music and the following chance elements:
one—discords using STOCKHAUSEN as a guide:
two—the music of HENDRIX:
three—2nd Avenue streetsounds:
four—male voice reading INVENTED text:
these insertions constitute signals-space-silence-chance timing throughout the composite-sound track.

COPIES: (all duplicates to be made by HÉLIO OITICICA):
2 SETS of 10 COPIES to be produced from the original (marked 0) and marked CC COPY___(from 1 to 10).

PROPS: PHOTO-visuals to include:
one—NEW YORK TIMES magazine COVER showing face of LUIS BUÑUEL:
two—POSTER by HÉLIO OITICICA OF LUIS FERNANDO GUIMARÃES wearing CAPE 23 P30 in NYC:
three—ALBUM COVER of weasels ripped my flesh by ZAPPA and MOTHERS OF INVENTION:
four—cocaine:
five—assorted props at BABYLONESTS including mirror/knife/boxes/money/ashtray etc.

INSTRUCTIONS:

PUBLIC PERFORMANCE
slides to be projected SIMULTANEOUSLY onto two opposite walls:
OPEN TIME:
participants to recline on cushions on the floor and operate metallic
nail polishers which will be provided beforehand:
sound track to start one minute before projection of the first slide:
in a chance relationship with the slide-sequence.

PRIVATE PERFORMANCE
slides to be projected onto a medium sized white screen-surface
alongside a transmitting COLOR TV:
scan the ADS in the daily paper during projections/
sound track/tv transmission:
FM radio (blasting out ROCK) to be situated in the furthermost
corner of the room.

CC2 ONOBJECT

at BABYLONESTS
81 2nd Ave: #4
NYC

August 12th 1973

(note—draft of ground plan-project for performance-set to accom-
pany this text: the original draft may be found on the DI-pad)

slides: 1 to 25 omitting 5 and 6: OPEN TIME
for placement refer to GROUND PLAN-PROJECT in DI-pad
photos: HÉLIO OITICICA on ektachrome hi speed daylight film
mancoquilagens: NEVILLE D'ALMEIDA
sound track: a tape-montage of ONO screams and chance elements
to be made at BABYLONESTS

COPIES: 4 SETS of 10 to be designated CC2 COPY__(A)(B)(C)(D)

PROPS: PHOTO-visuals to include:
one—books: GRAPEFRUIT—YOKO ONO
 WHAT IS A THING—HEIDEGGER
 YOUR CHILDREN—CHARLES MANSON
two—items: knife – paper – silver straw
three—cocaine
four—assorted objects scattered on work surface to include ruler –
pencils – cards etc.
five—drawing pad

INSTRUCTIONS:

PUBLIC PERFORMANCE
(note—the PUBLIC PERFORMANCE of this BLOCK-EXPERIMENT

should be totally unlike the accepted mode of PERFORMANCE nor
should it enter the realm of ANTI-PERFORMANCE which by defini-
tion asserts that which it seeks to destroy: it should be something
else: S-O-M-E-T-H-I-N-G N-E-W as YOKO herself is:
it should be ENVIRONMENTAL PLAY SCRAMBLING the situation
 SCRAMBLING object/function
 SCRAMBLING spectator/
 spectacle
here the participants will be induced into a light and joyful play of
BODY through DANCE rising ABOVE THE GROUND):

the participants sitting/reclining/lying but mostly dancing during pro-
jection-time and interval-time over a floor completely covered with
medium-thick white foam rubber.

(for FINAL DRAFT/PERFORMANCE-SET (with NEVILLE D'ALMEIDA
/APRIL 24'73) refer to DI-pad PLAN):

the slides to be back-projected onto two verticals of central cube
and onto two walls of the square room:
participants to occupy the intermediate area (see DI-pad PLAN for
details of placement and dimensions): the objects (MADE and
SUPPLIED by PROJECT-ADMINISTRATION) will be passed around
manually:
SUGGESTED OBJECT: a white-painted wooden box light/hollow
and scaled relative to the central projection cube: (dimensions to be
specified in PLAN form in the DI-pad PLAN).

PRIVATE PERFORMANCE
four slide-sets to be projected SIMULTANEOUSLY (TIMING and
SEQUENCE as for above) onto white surfaces to be improvised on
location (room/garden etc): perhaps white bedsheets arranged to
create spatial divisions and weighted at the bottom to keep them
flat: perhaps use them to cover furniture/inside or bushes and
trees/outside: IMPROVISE and PROJECT.

CC3 MAILERYN

at BABYLONESTS
81 2nd Ave: #4
NYC

August 16th 1973

slides: 1 to: OPEN TIME
photos: HÉLIO OITICICA on ektachrome hi speed tungsten light film
mancoquilagens: NEVILLE D'ALMEIDA
sound track: tape to be made using NEVILLE's suggestion (APRIL
24 '73) for the incorporation of sounds/music suggestive of SOUTH
AMERICAN ARCHETYPES such as quechua etc.

COPIES: 2 SETS of 10 to be designated CC3 COPY__(A)(B)

PHOTO-PROPS: to include:
one—MAILER's MARILYN in cellophane wrapping
two—cocaine and related equipment (silver knife/straw etc.)
three—scissors
four—electric fan
five—five dollar bill
six—CAPE 24 P31 PARANGOLÉ–HO/NYC/72
seven—assorted chance-props at BABYLONESTS

INSTRUCTIONS:

PUBLIC PERFORMANCE
the floor-surface: thick durable transparent vinyl over sand arranged
DUNEWISE with a low-level smooth area sloping up to a somewhat
higher-level which in turn undulates down then up even higher-level:
this topography to be improvised on location by PROJECT-ADMIN-
ISTRATION in a way that is both INVENTIVE and SKILLFUL:
participants barefoot:
projection-surfaces: in a four walled room (SIMULTANEOUS) projec-
tion on wall abuts projection on ceiling:
participants lie down on sand-vinyl floor-surface and proceed to
roll/crawl at will: (note-anything liable to damage floor-surface (buck-
les/buttons) to be removed before entry):
virgin balloons to be distributed for the blowing-up/letting-down
(with a whistle):

PRIVATE PERFORMANCE
projection-surface: one slide-set onto a screen/surface of white
velvet (real or artificial) or white/thick/shiny vinyl: other slide-set onto
wall spreading onto ceiling and/or adjoining wall and/or floor by tilt-
ing projector: improvise at will: in a way that is both INVENTIVE and
MUSICAL: yes MUSICAL:
underfoot: participant placement-transfer occasionally from basins
of water to floor-surface (bare or carpeted).

CC4 NOCAGIONS

at BABYLONESTS
in the bathroom
81 2nd Ave: #4
NYC

August 24th 1973

slides: : TIMING
photos: HÉLIO OITICICA film: ektachrome hi speed tungsten light
mancoquilagens: NEVILLE D'ALMEIDA
sound track: submit carrousel-slide-set to JOHN CAGE and invite

him to make a piece using the slide-set as a basis for NOTATIONS: see also SOUNDWISE below.

COPIES: designated CC4 copy__(from 1 to 10) each two carrousels: to be made by HÉLIO OITICICA from the original (marked 0).

PHOTO-PROPS to include:
one—JOHN CAGE's NOTATIONS: white cover
two—silver straw (from Tiffany's)
three—two penknives
four—a half burnt joint
five—cocaine
six—blue tissue in water of toilet-bowl

(in connection with the following INSTRUCTIONS refer to plan-project for the PERFORMANCE-set mapped out in DI-pad)

ELEMENTS IN THE NOCAGIONS LANDSCAPE:

one—SWIMMING POOL: pool indicated in plan-project (DI-pad) is the optimum size for the EXPERIMENT: however it may be adapted to any fair-sized pool.

two—ILLUMINATION: GREEN LIGHT DEPTHWAYS DIFFUSED AND SOMETIMES: BLUE LIGHT EDGEWAYS-PERIPHERAL TINT: GREEN LIGHT RUNWAYS IN A LINE BRIGHTLY:

three—PARTICIPANT-SPECTATOR: hereinafter designated SWIM-MER or LOAFER according to activity.

four—PROJECTOR/SCREEN PLACEMENT: two projectors/two screens: for convenience projectors/screens have been designated as PROJECTOR X located opposite SCREEN 2 and PROJECTOR Y located opposite SCREEN 1 at each end of pool: both projectors are below the level of the screens so that the projection inclines upwards to fill the screen: in cross-section (see plan-project DI-pad) the projection triangles intersect midway along the pool's length.

INSTRUCTIONS for PUBLIC PERFORMANCE
before the projection starts: in the BLUE LIGHT that BLUE LIGHT-FRAMES the pool throughout the PERFORMANCE SWIMMERS swim DEPTHWISE and LOAFERS loaf EDGEWISE and CUSHION-WISE:

GIVEN: projector X – projector Y
　　　　screen 2 – screen 1
　　　　carrousel X – carrousel Y (slide-sets)
GIVEN: that slide-sets are identical in TIMING and SEQUENCE:
GIVEN: that slide-set X is staggered exactly one slide behind slide-set Y:

SYNCHRONICITY: Y projects 1st slide:

 Y cuts to 2nd slide: X projects 1st slide

 Y cuts to 3rd slide: X cuts to 2nd slide

and so it goes...

...until Y cuts from final slide: X cuts to final slide

 (screen solidlight for 10 secs then solidblack)

 : X cuts from final slide

SIMULTANEITY: (SIMULTANEOUS GREENLIGHT and RUNNING-
GREENLIGHT)
(screen solidlight for 3 mins then solidblack)

—AT PROJECTION-END (duration of projection to be finalized
but will be approximately 30 mins) SWIMMERS and LOAFERS will
amuse themselves—

SOUNDWISE: four loudspeakers edgewise to pool will play during
projection-time a CAGE-piece—LOUDLY:

item: whether or not to commission CAGE-piece?
 if not—choose a piece from his oeuvre

item: whether or not CAGE-piece (subject to above)
 will continue after projection-end?
 if not—will anything play SOUNDWISE?

item: how [to] determine (NUMBERWISE) optimum attendance?
 —relative to size of location?

item: whether or not to run successive performances in the same
day? if so—at half-hour intervals?
 if so—how [to] control IN/OUT traffic?
 by—no set-schedule (the-show-begins-when-you-arrive)?
 by—a set-schedule (where those not in by performance-start
must wait outside until next scheduled performance)

INSTRUCTIONS for PRIVATE PERFORMANCE

OBSERVATIONS/SLIDEWISE:
one—coke-tracking across the cover of NOTATIONS plus the
cocaccessories combine into a kind of visual-transformable-
NOTATION/MUSICWISE:

two—moreover is the sequence-NOTATION of the slides them-
selves: each slide IMAGE-ined (by means of camera placement/
manipulation/mobility through 360: EVERYWHICHWAY—a filmic
space) with reference (HOMMAGEWISE) to MALEVICH's WHITE ON
WHITE (white coke-tracks on white cover) and to SUPREMATIST
space: not as a SUPREMATIST revival—more as an assertion of its
very existence carried out in a play-chance and candid (PURE-
WHITE) way

three—CHANCE as PLAY
in the shooting of the slides:
in the box-order from the lab:
in the carrousel-order (which may/maynot be box-order):

CHANCE-NOTATIONS
CHANCE-RELATIONS within performance-project

DEDICATION: this 4th block-experiment in COSMOCOCA is
dedicated in recognition of ABOVE-GROUND INVENTION/ATTAIN-
MENTS to TWO BRAZILIAN CONCRETE-POETS and PROSE-
WRITERS and THEORIZERS and above all INNOVENTORS [sic]:
to the SÃO PAULO brothers
the CAMPOS brothers

AUGUSTO and HAROLDO DE CAMPOS

PROPOSITION/GIVEWISE—CC4 COPY 1 (each COPY is an exact
duplicate-set of/and made by HÉLIO OITICICA from the ORIGINAL)
will be presented to DE CAMPOS brothers along with INSTRUC-
TIONS for PERFORMANCE and a PROPOSAL inviting them to con-
tribute—INVENT and/or TRANSFORM the INSTRUCTIONS for a
PERFORMANCE to take place in SÃO PAULO or RIO.

OBSERVATIONS/BLOCKWISE—my work/relationship with NEVILLE
may be compared to that of film director and cameraman: the dif-
ference being that there are just two of us in the whole project: just
two of us INVENTING/EXTRAPOLATING/etc. just two of us in a
multi-structural
multi-valent EXPERIMENTATION which is not cinema nor photog-
raphy nor narrative:

CC5 HENDRIX—WAR

at BABYLONESTS
lower-middle NEST:
81 2nd Ave: #4
NYC

August 26th 1973
from 2AM to 3:30AM:

slides: 1 to 34: OPEN TIME
photos: HÉLIO OITICICA: film—ektachrome hi speed tungsten light
mancoquilagens: NEVILLE D'ALMEIDA
sound track: tapes: any HENDRIX have them all at hand: to be
played before/during/and after slide-set projection: choice of
albums/individual tracks/etc. to be made by PROJECT-ADMINIS-
TRATION.

COPIES: 4 SETS of 10 to be designated CC5 COPY__(A)(B)(C)(D)

PHOTO-PROPS to include:
one—penknife
two—matches: virgin/burning/spent
three—unfinished silver mylar PARANGOLÉ CAPE
four—record album: WAR HEROES–JIMI HENDRIX

INSTRUCTIONS:
PUBLIC PERFORMANCE
participants to occupy hammocks suspended from ceiling structure
and disposed throughout enclosed room-space:
BACK-PROJECTION of SLIDES onto the four canvas walls which
define the room-space:
ENTRY through openings in each corner of room-space:
a sketch-plan is to be made and included in these INSTRUCTIONS
indicating environment-set/distribution of hammocks/projection-
surface walls/etc.
SUSPENDED IN THE AIR: BODYWISE: ABOVE THE GROUND:
HAMMOCKS-HANGING-COCOONWISE:

PRIVATE PERFORMANCE
for four or more rooms (apt. or house: in the case of a house with
a garden use the exterior walls): project each of the four slide-sets
in a different room: start projections as soon as you wake: let co-
habitants each control a SLIDE-SET with the instruction that they be
repeated the whole day along with sound track of HENDRIX tapes
and/or albums: where possible use four SETS of sound-system:
projection-interludes at operator's will: not as: WASTE TIME rather
as INVENTED TIME:
as the day lengthens and the soundsandslides repeat-repeat-repeat
themselves so should the operators direct everything towards
DANCE to the extent of inviting in OTHERS from ELSEWHERE.

CC6 COKE HEAD'S* SOUP

a parody
GOAT'S HEAD SOUP—

at BABYLONESTS
81 2nd Ave: #4
NYC

Sept 25 73

note: joke-title IMAGINVENTED by HÉLIO OITICICA at 7:30 in the
morning—with THOMAS and all that jazz (WRVR FM radio/106.7
dialwise)
(*—it has been suggested that the 'S on HEAD'S is dropped to
increase the ambivalence: COKE HEAD as USER: as the «HIGH»:
sexual reference as in ‹to give HEAD›: etc)

11:40 PM to 1 AM

HÉLIO OITICICA
THOMAS VALENTIN photos/brumaquilagens (MISTYMAKE-UP)
back cover ROLLING STONE
 MICK JAGGER
 poster/page/cover
 GOAT'S HEAD SOUP

COCAMIST
limit not-limit
MICK-photo doesn't disSOLVE into pastel-mark (PASTACHE):
controlled photo-smudge:

COCAMIST

Sept 29 73: slides received and numbered according to box order
from 1 to 26:

FINALIZEWISE-DECISIONS:

slides: 1 to 26 plus a 27th (not-slide) of SOLIDLIGHT:
 EQUAL TIME—to be finalized (1, 2, 3 seconds each:approx.)
with direct reference to duration of…
sound track which will include SISTER MORPHINE (5:34 minutes):
SIDE B/track 3 of STICKY FINGERS:

sound track starts SIMULTANEOUS to 1st slide projection and ends
SIMULTANEOUS to 27th (SOLIDLIGHT) projection:

PERFORMANCE: slides to be projected
 note: prerequisites for PERFORMANCE-area: a goodly-sized
four-walled room—any doors/windows to be same color as walls
and to be kept closed during projection:
projection from above-/and inclined down towards the FOUR
WALLS—where possible covering them:

GROUND-WISE—completely foam-rubbered upon which PARTIC-
IPATORS sit and/or lie BAREFOOTED.

Sept 29 73—later that same day:
5:20 PM:
PLANS for CC6/SOUND TRACK: (SONY stereo tape recorder)

—record/from the album/through microphones/LOUDLY/SISTER
MORPHINE (5:34 mins)
—background (EXTRAneous) noise ain't no problem:(see below)

ASSEMBLE a NUCLEUS of assorted chance-sound/silences—pro-
duced by means of the following OPERATIONS (simultaneous to the
above-mentioned operation):

a) IMPROVISATION/TYPEWRITING—clicketyclack —ANDREAS:
b) IMPROVISATION/RANDOM/WHISssssstling —THOMAS:
c) IMPROVISATION/TELEPHONE-DIALING (how/many/often
 subject to participator) —SILVIANO:
d) IMPROVISATION/FIDDLING-ABOUT (widespread)
 within the tape reception field —HÉLIO:

item: this SOUND TRACK/PIECE is the first tape recorded work (?)
where my intent is to incorporate elements that become SOUND-
TRIVIA: as a homage to JOHN CAGE for was it not him who said

> Music is an oversimplification of the situation we actually are
> in. An ear alone is not a being; music is one part of theatre.
> «Focus» is what aspects one's noticing. Theatre is all the var-
> ious things going on at the same time. I have noticed that
> music is liveliest for me when listening for instance doesn't
> distract me from seeing. One should take music very natural-
> ly. No technique at all. (SILENCE, p. 149)

CAGE: precursor
cursor of the performance
unconditioned
LIBERATOR
brother to everything
principally
THE GIBE

Oct. 1st 73

OBSERVATIONS/re: CC6/SOUND TRACK: (finALSSEMBLY on Sept
29 73 between 10:05 and 10:15 PM at LOFT(Y) 4):

the taping-performance-session ran as PLANned (see above) but
with SIGNificant EXTRAneous elements:

a) the COINCIDENCE of the S-i-R-e-N i-N t-H-e S-t-R-e-E-t (later
confirmed as an ambulance) and the recording start: it could not
sound more PLANned:
(«the scream of the ambulance is soundin' in my ear»)

the actuality of a DANGER—subjectively EXPERI-HEARD/SENSED
through a SIGN/SYMBOL transliteration—combines with the
lyric/context of SISTER MORPHINE: EXPERIENCE becomes a
rounded EXPERI-SENSE:

the RESULTant-tape-piece (assembled hence complete) will re-
OPEN within the context of CC6 as CHANCElement: the semi-/
chance operation the chance/semi-chance operations (typewrit-
ing/whistling/dialing/fiddling-about) are only recognized as such
through the verbal/written description of incidEVENTals of TAPE-
IN-FORMATION:

(TAPE with the SOUND OF IT'S OWN MAKING?): the REPORT of tape-in-formation (by definition REPORT/finished) reveals itself through factual digression(s) and OPENS UP THAT WHICH IS RESULT (the tape) making us change our perception/evaluation of that RESULT: —presupposing that «me-listen/me-talk-about/me-write-about» (REPORT) was the raison d'être of the tape-piece:

PLAY TO BE HEARD:

b) the telephone-dialing (SOUNDWISE) is not audible (TO ME?) on the sound track-tape: «do I hear it/YES/no/yes/no/NO/i…i…I DONT KNOW»

—what we have then is someTHING which is PRESENT-ABSENT within the PERFORMANCE: (note: the possibility that the sound is on a wavelength outside our auditory threshold: yet we may SENSE the signals (SOMEHOW?) and automatically classify them as auditory: «yes…i…hea…r…»: also we may «hear» it by virtue of «knowing …it is in there…SOMEWHERE»

—however for the possibility of the following EXTRApolationS we will accept that the sound is inaudible: (which gives us our first paradox—a sound that is not heard (RELATIVELY-speaking) and hence that is not a sound (again relatively): a NOT-SOUND (nb. chance reference to 27th NOT-SLIDE: also to other STONES lyrics as

«i got silence on my radio/
let the air waves flow…etc» (for radio/read phone)

«the sound of strangers/
SENDING NOTHING TO MY MIND» (for strangers/above)

—as PRESENT-ABSENT it demands the fullest participation (the COOLEST) to «realize/experience» it:

[NTBK 4/73, pp. 4–73]

30–31 dec 73
14 jan. 74 to 13 jan.:

30 Dec 73

CC8 MR. D or D OF DADO [GIVEN]

I —> PHOTOS—SITUATION
CARLOS PESSOA: MR. D —> participant *in*-photos

PHOTOS —> from 1 to 20:23 [10:23 pm] Dec 73 NYK loft 4: bathtub

Special assistance with LIGHT: SILVIANO SANTIAGO
always cite in the written information of CC8 the following except by
OSWALD DE ANDRADE in SERAFIM PONTE GRANDE:
Serafim goes to the window and Narciso sees him,
in the mirror of the waters, the fort of Copacabana.

1—in that series: *block-experience* 8 in COSMOCOCA–*program in progress*: instead of the printed image there seems to be an image (head) reflected in the mirror that is flat on the floor (from the bath in BABYLONESTS: LOFT 4/81 2nd ave./NYC 10003) and turns the ceiling into a background for the reflected face: white ceiling of white walls-planes that meet—

2—in that series *b-e8* (CC8) the coke-powder doesn't appear: it is *the glass-mirror + the light*: the *light* makes-unmakes areas-white light that spills and spills over the reflected image: it is there that the voluntary participation of SILVIANO SANTIAGO comes in, a partici-pation that was alive and important because of the importance light assumes as the coke-trace did before it/area made him (NEVILLE and THOMAS)

3—the image—the reflection is like a head that bends over a lake-glass and the long blond hair of Mr. D has ends that touch (the real ones) on the very reflections: the mirror-glass dilutes and multi-arenas the surfaces-areas-masses: the reflection makes the old coke- make up the surface that reflects and that hides itself in the very illusion of its materiality-area: the reflex that annuls the surface makes it a make up disappeared: she is ambivalent: multivalent: wood of MR. D

4—MR. D is CARLOS PESSOA CAVALCANTI brother of ROMERO
—> D of the blond-ambivalent reflex of the mirror that mirrors
D of Jagger —> what did the egg of COLOMBO give when I said out loud «what should the soundtrack be?»—«now why not MR. D of the STONES?—what more could it be?»—so it was discovered decided —> D of *dado* [given]: whatelse?

5—soundtrack: 4:50—MR. D: STONES as decided by MR. D-CARLOS on 24 Dec. 73 in BABYLONESTS

31 Dec. 73

6—LIGHTS: on 23 Dec. light bulbs of: *150* w
 and *500* w

14 Jan. 74

 on 13 Jan.: of *500* w

7—SESSION 2 to 13 Jan. 74: same place
light: SILVIANO SANTIAGO

Selections from the Notebooks

Transcribed from Oiticica's notebooks from 1973 and 1974, these texts range from expansive, essay-like reflections sustained over days or weeks to cryptic reminders about details related to the *Cosmococas*, *Neyrótika, Agripina é Roma-Manhattan,* and other projects. The sequencing is guided by chronology, but with groups of entries from individual notebooks preserved. The source notebook is listed at the beginning of each passage. The texts are published here for the first time.

[from NTBK 49]

CLOUDS IN MY COFFEE
ho nyk
Feb, 18 73

FOR DANIEL BUT
in the intermingled comings and goings of the always restarted work on CAPA 28 P 35 i listen to records, the radio, TView: PAULINHO DA VIOLA is followed by NOVOS BAIANOS while I write what I have been wanting to write for a month but can't find the time to start — from the arrival-departure of ROSE and TERESA that has changed everything: their visit was too much fun — ROSE, if you guys don't know who she is it's who introduced me 10 years ago to MANGA [cunnilingus]: related to ESTACIO-MANGUE,[1] daughter of OTO firm supporter: her mother, ZEZÉ is also mine: ROSE, all of a sudden showed up more beautiful than ever with a radiant heat cooking up aphrodisiacs communicating without speaking English more than those who arrive already speaking it: ROSE if you didn't exist you would need to be invented: made me forget the tedious beginning of earthly misunderstandings and throw out uninteresting connections: we sambaed, talked about what only we know how to talk about: the elite of naughtiness in a rare encounter as if MANGUE [hooker] and MANGUEIRA [dick] had come to stay here in loft 4 in f*un-city* not always *fun* but *pun*: I only want to talk of ROSE be it only what should be said but what comes to mind in the decisive moment of clear and irreversible decisions (I hope) that I make reeling as if they came from non-dreamed dreams (the clouds in the initial titles of IVAN THE TERRIBLE are time of time or the revelation of focus of clarity: make «a» point with curtains opening in the duration you want) — I think of all that and of ROSE our ten years of friendship without a fight (more profound than [illegible] superficial) and when she knows *of*: she didn't arrive expecting directions from me or complaints asking for comfort or with problems to be solved: if only everyone who came was like that! Alas! new york life would be paradise — no one, only ROSE knows that I have been in another for a long time: besides, I always was in another: while those poor

1 Mangue was the name of Rio's red light district and is still a slang term for «prostitute.» — TRANS.

people without the same perception think I'm here wanting for example «to enter the Brazilian art market» or to compete with sporadic productions (mine, situated as they always are so relatively to what is called *conception-work-end* as *artwork*) from here or from my years in Rio: hear me laugh: ha ha ha — of course such thoughts and conjectures come from people who think in a very narrow way and I don't know why I even bother to air such stupid things: to torment myself? never — I sell well in BRAZIL: thus the goal and the ambition of a little group without: GODAVOMIT: leave me alone — or put on a 7-league shoe to reach me a thousand light years from where they are: that is the truth: I've always been so far away from that from those people that the distance can only be measured in light years

ROSE knows we laughed a lot here me her TEREZA (whom I adore more every day) and my loves in loft 4 while we planned/amusing things: I got out of the subway with CAPA de PARANGOLÉ: it was too much fun and part of training my-PARANGOLÉ here: CAPES are made for specific contacts-happenings with a chance NEW YORK audience: *circumstantial programs* — ROMERO «kid of the year» of the PARANGOLÉ is who acts as a PROPOSITIONER first wearing and giving the CAPE to other people to wear: we filmed (ANDREAS VALENTIN whom I have known since I was 6 when he taught painting at a time that painting still existed, and who filmed in 16mm some sequences of the encounter on the subway of NEW LOTS AVE.): with us were ROSE TERESA CRISTINY ONDINA (daughter of QUENTIN FIORE) LEVINDO (shooting): the principal sequence and where everything functions given that in the subway the situation is limited to circumstances of local time light train in motion and others: the sequence with the two blacks: one was BILLY THE KID with the face of GROUCHO MARX with a cigar and everything: the train turned into a carnival with CAPA 27 P 34 but the graffiti as an invasion of superposed ideograms that glorify and suppress everything that could be called «automatic writing» or «collective art» or the dumb-ass pretension of artists that don't know that painting doesn't exist anymore (show me an important painter after POLLOCK or IVES [sic, YVES] KLEIN and I'll give you a dessert) and that have gotten lost and insist on not leaving me alone not knowing that I was never with them — but thinking of ROSE I ask: what is the relationship *between* the clouds of *CARLY* SIMON and those of EISENSTEIN — mediation of internal time or contestation of approximate realities — while thinking that I'm lying down reading a interview with the new idol-who-doesn't-want-to-be-one LANCE LOUD: it goes like this:

there is a series (it must have already shown up in the magazines there) on TV channel 13 called AN AMERICAN FAMILY in which for 8 months the LOUD family was scrutinized by the presence of a video camera in their daily life: they're from SANTA BARBARA in CALIFORNIA and in that time period the LOUD couple gets a divorce and LANCE the oldest son lives in NEW YORK [illegible]

CHELSEA and is gay (at 14 he dyed his hair platinum blonde in homage to WARHOL) and his mother comes to visit him and runs straight into HOLLY WOODLAWN in the door of the room — in effect LANCE is the true *roll of the dice* [lance de dados] of the LOUD family — of a life without hobbies without worries of an empty hedonism by the side of a SANTA BARBARA pool for the gay world of the lower babylonian astral LANCE maintains a sort of original innocence and freshness mixed with an international gayness of local vintage and AN AMERICAN FAMILY IS an american family — deep right? — it's true but what's great is that reading what LANCE says in the interview (in a gay magazine) is how it is shown, he says what you don't see on the video: he reveals himself to be lost and bitter: but not saturnine: a bitterness that evaporates like a glass of washdown: «I fel[t] that my whole life could be rolled up in a paper ball.»

3 mm and life goes on: one more banal cliché: yesterday I was saying to NEVILLE (my favorite filmmaker): I give myself the luxury of saying silly things: no one is going to take that away from me; that's a privilege: in that slavery continues continued what I searched for above: I went to Buffalo and showed 160 slides I spoke they made a poster SILVIANO SANTIAGO invited ALBRIGHT KNOX received I spoke talking it was great intelligent people in the cold — 4 Fahrenheit — in that time NEVILLE also arrived with his prime prima in preference for me it's a party because I love NEVILLE: MANGUE-BANGUE we're going to see in the MUSEUM OF MODERN ART: KYNASTON MCSHINE (who dared to construct 28 of my NESTS in «INFORMATION» in 1970) is going to shelter him: the seed of MANGUE of ROSE ours mine: NEVILLE knows it's ridiculous to want to explain something in the contested presence of ROSE-MANGUE: if we could live without explaining/things it would be great: of long conversations of long ago/for longer ones now: the plans the stills: those that IVAN sent to BRAZIL those that came from LONDON: I bring NEVILLE up-to-date on my street plans: with ROMERO people CAPES circumstantial situations: NEVILLE brings me up-to-date on his — MARCELO asks if DAMIEN was here — NEVILLE says that in the photo-poster LUIS FERNANDO with CAPE 23 P 30 looks like a Roman — I remember that I met DAMIEN three years ago in MANGUE [Rio's red light district]: I introduced him to MACALE who thought he was cute: I adored him: HENDRIX and screams-jumps-falling on the floor — DAMIEN my love, I have a message for you: find ROSE and she'll tell you what it is — what is hers? NEVILLE was and is the ideal MANGUE [prostitute] filmmaker — why? — neither overly idealistic-aristocrat nor banal naturalist: right-just good-nonsense to be played in the situation that in him is cinema: in that sense circumstantial: saying good-bye to the serious banalities of serious Brazilian cinema to the subliterary bullshit of provincial philosophers: situational *trichs*: lost and found

5 mar [1973]

yesterday we got lost in TIMES SQUARE: we went to see BLACK

CAESAR and we were the only white people in the audience: who said that I'm white? to begin with I'm allergic to white people — but skin color is skin color — we were with NEVILLE MARCELO and the tireless — inseparable — prima: BLACK CAESAR eliminates all the oppressors of the Harlem black: Italians and Jews and devils-breakers get screwed and CAESAR becomes an oppressor — but none of that matters: there is no concern with a thesis or with an ideology: the film is the summation of cliché-cliché of all the motivated black-white fights black on white: in that case we're *underdog* too: LATIN AMERICA, why not! minority of minorities! — I don't know — I don't care: what matters is the cheering of the audience each time a white man is killed by BLACK CAESAR who ends up killing the corrupt policeman (oppressor) white demon screwing with the MAFIA: he kills him with the same shoe-shine box that was the object of his humiliation when he flourished as an adolescent as a flower of HARLEM — the happening continued through the streets of TIMES SQUARE and 42nd that are the continuation of the movies contained in them — THE SUCKERS — JEKYL AND HIDE (with an I and not a Y as in HYDE — (??)) — idiot or sucker? Monday morning: me and CRISTINY playing of AN AMERICAN FAMILY: BILL and PAT LOUD? transvestism of the every day? *rejeuvenation* of old desires.

[from NTBK 49]

Snows

Mar 25, 73
ho
nyk

NEVILLE D'ALMEIDA
Note: 13 march of 1973; two S8 takes in LOFT 4 81 [2]nd Ave. NYC: NEVILLE's proposal/invention: a new project-film would be COSMO-COCA (so as not to refer to the whole name, I'll cite it as CC or PRIMA): 1st 3 mm ektachrome reel — 2nd 3 mm TRIX reel: a series of slides made by me: COCAQUILAGENS by NEVILLE on the cover of the record by ZAPPA-MOTHERS OF INVENTION: WEASELS RIPPED MY FLESH, on the poster LUIS FERNANDO/CAPA 23 P 30 + PHOTO LUIS FERNANDO in SÃO PAULO, cover of the NEW YORK TIMES MAGAZINE (march 11, 1973) with BUNUEL'S FACE —

OBS. (today's): NEVILLE'S films are the first NON SEXIST films of Brazilian cinema: in MANGUE BANGUE the androgynous evocation of the whorehouse of the BALL, of the DAMIEN-HENDRIX collage, of the individual independence of the characters (?) creates a language-cinema conjunction not [illegible] in SEXIST problems of *LOVE as generator of the world* — in COSMOCOCA the COKE or the PRIMA dominates everything that SEX AS A PROBLEM might come of the situations: it exists as the cosmic part of cocainized COSMO:

in that also lies the innovation and complete supercession of tra-
ditional Brazilian cinema (NEW and old) always linked to sexist ego-
dramas usually derived from French or Italian cinema or diluted
American cinema: chauvinist cinemas par excellence —

[Neyrótika NTBK, pp. 1–3]

N E Y R O T I K A

ho nyk
April 11, 73

NON-NARRATIVE
timed slides and cassette sound track

for ARACY AMARAL

EPISODE 1: DUDU
slides taken 1 April, 73 NESTS: LOFT 4
titles to be shot on DUDU's nude body

BRAISES DE SATIN

(RIMBAUD — Délires: FAIM)

NESTS: LOFT 4 done
SLIDE 1: close DUDU
SLIDE 2: lettering BRAISES DE SATIN
 " 3: DUDU — star (photo veins light in his face)

SOUND-TRACK
Recorded off the radio with a SONY tape recorder microphone from
the NEW YORK station WBLS

SIDE A: 5 may 1973 (Saturday)
 from 5: 30 PM
SIDE B: from 7:04 PM

PHOTOS
Data control, etc. of the ORIGINALS
all made in 81 2nd ave. LOFT 4 Babylonests

DUDU — 1 april 1973 – DAYLIGHT Ektachrome with artificial
 light
DIDI —
CARL —
JOAO — 27 april 1973 – Ektachrome: tungsten. light art.
ROMERO — 28 April 1973 – Ektachrome: 1) tungsten. light
 2) daylight art. light
CORNELL — 6 APRIL 1973 – Ektachrome 1) tungsten. light

TAPING being shot: 5 may, 73

2) daylight art. light
1) Day light (1 shot)
2) tungsten. art. light

[NTBK 1/73 #4908, pp. 1–3]

ho nyk
11 Jun 73 —> 12 of June

NOTES:

— the ineffectiveness of representation (as a world, a way of life):
the reality of «being here» of the «lived moment» is *more* than the
representation of it.

— no solution can or should be sought in a «nostalgia for natural
life» pre-representation — [a] solution «beyond representation» can
only be achieved by existential saturation and consequently dis-
satisfaction with the world of products of that representation, in
which the relation of spectator to spectacle is fundamental.

— the structure of representation is linear — completely linear — it is
fundamental to the duality of subject-object in all its forms.

— the duality(s) of the world of representation is (are) only resolved
in the unity of what is the *body*: a *body* whose ecstasy consists in
the discovery of its own realization: the dance breaks into this real-
ization when it is instituted as «art» or «social practice,» but liberated
from the functions that they want to give it[.] it is the maximum real-
ization of the *body* as the supercession of representative structures:
the dance of the body still or in motion: the spectacle that ensues
is not a spectacle for nor is it reversible (someone's dance, or better,
for someone else, or for a collective that visually contemplates what
is given, because what takes place in the realization of what dances
is unique and only that can live): it is *a realization in spite of the
spectacle* in which the fundamental unity of *the individual living body*
achieves functions that only refer to itself, that is, to the subject that
it incarnates as a whole.

— change in everyday spatial arrangements is yet another given in
the «wasted space» that characterizes people's average choices: the
dissatisfaction of living in a world of representations (that are per-
ceptive projections of the unrealized) leads to dispersal and to the
gratuitousness of living space, the environment that delimits every-
one's everyday. what should be proposed: *experimental practices of
non-wasted space*.

— for me the solution to the problem of the *supercession of the
image* or *the production of images* was found in the penetrable
[penetrável] TROPICÁLIA at the end of 1966 and the beginning of

1967: when I say «supercession of the image» I'm referring to the growing and finally final and decisive lack of a need to produce images even if they are non-representational as had occurred from the first participatory proposals, etc. — TROPICÁLIA made me aware of that: it was a penetrable [penetrável] in which the proposal of *sensory images* that did not exclude vision as part of that state *was not an attempt to create a new repertory of images* (whether visual or not visual), but to use those sensory, intentionally banal, images to posit an *elimination of the image as a vehicle of spatio-temporal realization or the realization of the body as discovery* as if, there, I wished through *the self-evidence of the sensory image through the image* (that culminates in a TV hooked up to the end of the labyrinth, and in the participant sitting compulsively in front of it) to propose solutions of non-images, that is, of non-representation: the collection of «imagetic-sensory proposals» presents itself as grotesquely banal and as a mere game to be experienced by who-ever experiments — enters and exits — etc.: today you see that the absence of «serious intentions» or «larger goals» did not exist around the piece-environment: it was as realistic as the garden-image TROPICAL that completed it: not-pop not-aesthetically absorbed but *the detritus-image of the remains of the repertory of representation*: non-environment

[NTBK 2/73, pp. 51–53]]

ho
nyk
24 Jun. 73 just before midnight

COSMOCOCA
by Neville D'Almeida

pre scriptotal ideas
non-script falala-script
fallacy, etc...

7 to midnight

the abbreviation-code of COSMOCOCA is CC which I'd been plan-ning since the pre-stills in loft 4 with NEVILLE

pre-stills pre-paration that become NONNARRATIVE which MARCE-LO will do the soundtrack for (when?) (?)

58 initial shots: 3 mns. color — 3 mins. bl. & wh. done the same day 13 of March of 1973 a Tuesday at 22:30 PM

NEVILLE'S MAKEUP on the ZAPPA MOTHERS OF INVENTION weasels album

12 midnight 25 Jun 73

on the face/cover of BUNUEL in the NYT Sunday mag.
on the poster of L. FERNANDO GUIMARÃES (now dresesd up as
LEONARDO KATZ)

ideas/annotations on MAKEUP [MAQUILLAGEM]

—*fragmentation of the finished*: the line of coke applied to the cover,
face, poster, etc., visually fragments the «unity» of the image/whole
in making it up: cover, face, poster

—*to fragment: non-mask: self-masking*: the MAQUILAGEM referred
to here does not act as a magic-mask: making the ugly beautiful:
making the old young: etc.,: it is not the milennial magic of the ritual
mask that culminates in the collective western use of makeup: to
show itself in the light of day at first makeup hides the age/ugliness
the pore/skin that reveals that the body is undesirable—etc.: in that
makeup—the line of coke the problem is different: the game of
chance without a moral: NEVILLE's makeup is not ritual-makeup:
it is makeup-cum-play

to makeup by NEVILLE

the verb is in the infinitive because it is not the product-makeup but
MAKEUP in process: creating the line by following a visual pattern
like the *plagiarism of the given image* because the makeup-game
the play is like traces of chalk on the blackboard and erasing it as
if it were a «new art» (ha ha ha) when no one believes anymore in art
or in novelties: from the shape of the mouth of the exaggerated
soap-opera caricature of CAPA DE ZAPPA (ZAPA COVER) or the
eyebrows or bloodshot eyes: snort: zzuuuhum and there went the
plagiarism/trace: for whoever looks from the outside it might seem
as if (and it is) what is being made up is the very makeup element
that is the *line of coke*: it is lost plagiaraizing as an additional frag-
ment of the given image: a discrediting of the finished image: the
snorted line clothes/undresses the supposedly finished surface: *frag-
menting the finished=adding the mask-plagiarism or sacred pre-
tense (the finished)*

—*fragmentation of cinetism:* the no that makes the coketrace-
makeup moves gillette/razor/knife or whatever on the flat-finished-
image whether filmed or photographed: the cinetism of «making
the line» and its duration in time all become fragmented in succes-
sive statuesque positions as one-by-one moments-frames that
don't become anything but *already constitute moments* [illegible] in
process

MAKEUP
MANCOquilagem

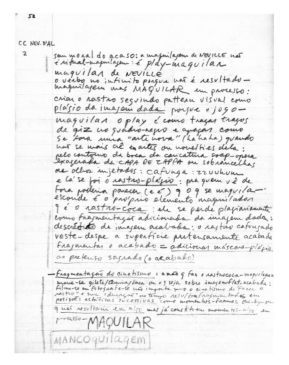

29 Jul. 73

yesterday NEVILLE saw the chance sequence of the 1st EXP.COS-
MOCCOCA: to which a soundtrack will be added — will MARCELO
do it? when? or should I propose doing more than one soundtrack:
as in ÜBER COCA where not only a soundtrack but a recording
and improvisation on the layout of the original text should be done
— NEVILLE intends to and sees that first EXP. COSMOCOCA as
a whole:

moments-frames one-by-one
which I say on the previous page —

SILVIANO SANTIAGO sees in the structure of MANGUE-BANGUE
an approximation to the type of structuring of slides-sound-tracks —

— OBS: the chance arrangement of the slides that make up EXP.
CC1 is important in how it plays with the sequence of MAQUILAR
[putting on make-up]: it is as accidental as MAQUILAR's trans-
formations: it transforms the ultra-visual framing of the MAQUILAR
sequence into a new organic fluency: the linear squared visual
Frame by Frame flows in a sequence that is not governed by a
«sequential logic» structured as such: it is the accidental nucleus
of open proposals: these are not photos just to be photos: nor
sequences with an end in sight: not settling on a definite order for
the slides is important: it's a game of positions on the soundtrack,
a game of projection (they play with the spectator/environment/
circumstance position/etc.) —

[NTBK 2/73, pp. 53–55]

12 Aug. 73

P —>
PROPOSAL — to ask for statements from the following people about
MANGUE BANGUE and to include those statements as elements for
COSMOCOCA in a situation that I won't define for now:

SILVIANO SANTIAGO QUENTIN FIORE ANDREAS VALENTIN
ME KYNASTON MCSHINE GEORGE QUASHA
MARIO MONTEZ

NOTE: suggest that these statements not be placed either as an
«impression» nor as a «discourse/aesthetic judgement» but as syn-
thetic statements of what the film might be in the most concrete
sense — which would eliminate the process of «comparison» «defi-
nition» «interpretation» etc. —

Ins. —> INSERTION/with no definite place/: tapes in progress [ME]
of ANNE (see carton) 1 — LOOKING EAST

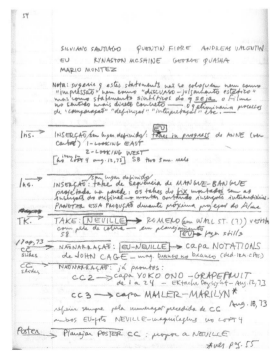

2—LOOKING WEST
[ho item 1-LOFT Aug. 12, 73] S8 two 3 min reels

Ins. —> INSERTION/with no definite place/: a take from a sequence of MANGUE BANGUE projected on the wall; the takes of the *fix* in a montage that doesn't have the original insertion —> to do the montage by cutting intermediary insertions—PROJECTING THAT PRODUCTION *during the next projection of the film*

TK —> TAKE: NEVILLE —> ROMERO (in WALL ST. (?)) dressed with snakeskin—in planning stages
S8
ME —> make stills

17 Aug., 73

CC slides
NON NARRATIVE: ME-NEVILLE —> cover NOTATIONS of JOHN CAGE—makeup white on white (of d. IRM. CPOS.)

CC slides
NON NARRATIVE: already ready:
 CC2 —> cover YOKO ONO-GRAPEFRUIT
 from 1 to 24 Ektachromes. Day light—Aug. 12, 73
 CC3 —> cover MAILER-MARYLIN*
*see page 55

Aug. 18, 73
Always refer to it according to the numbers preceded by CC
both
ME—photo
NEVILLE—makeup in LOFT 4

Poster
Planning POSTER CC: propose to NEVILLE

24 Aug. 73

CC—*program*: anticipated forms of possible concretizations —>
mode of presenting the proposals/program:
1—NON NARRATIVES: slides in a carousel
 timing—sound track

25 Aug. 73

2—BOX-*planks* NON NARRTIVE:
 collection CC1 for example
 CC2

etc.

in planks of slide for slide
in a positive print —

1st OBS.: make a *design* of the box and the format of the planks

*a) includes text
*make it: include excerpts from those pages of NTBK 2/73

2nd OBS: inquire of LEANDRO about possibilities —
the best way to:
print (and how)
the paper to be used

[The following note, on p. 55, completes the reference indicated by the * in the entry from August 17. — Ed.]

*Note: in respect to CC3 —> MAILERYN
is the definite name:
for the performance-exhibit of that episode: (slides-timing-s. track)

there is the following instruction:
1 — *spectators seated on cushions* in a room with *sand on the floor*

2 — *the projection on 2 walls* demands *2 projectors and 2 collections of slide-carousels.*

[NTBK 3/73, pp. 1–2]

17 Aug 73
midnight

1 — on 12 august: photos *CC from YOKO ONO'S book GRAPE-FRUIT

2 — on 15 august: NEVILLE presents me with the book MAILER MARILYN

3 — on 16 august at 11: 30 in the morning I began the photos (ekt. 125 ASA) BOOK MARILYN that are finished at night between 21 and 22 [9 and 10 pm] with NEVILLE — the cellophane that is still on the book is taken off then

4 — from 11 to 12 I open the book and examine it page by page and this book-object still seems invincible to me: not-nostalgic: it is everything you could want of *concreteness* photo-book-reporter SYNTHESIS: in the era of nostalgic-conservation MAILER extracts MARILYN as a whole from that: MARILYN as ROCK is not nostalgic for itself

those four times mark what I see and I want it to be the beginning
of a new stage that is permeated with those in motion: a stage-
program in which the presence of NEVILLE and what I see and am
with him comes to count in what I call a program-CC:

I see FREDDIE KING on the 13th now: who is the drummer? And
why is it that when I lift my gaze to MARILYN I fall into his mouth-
body-drum set?

YOKO ONO–GRAPEFRUIT in the chance series of 24 slides:
HEIDEGGER — WHAT'S A THING? MANSON — *your children*
SARTRE — BEING AND NOTHINGNESS

YONO —
FRUIT — GRAPE-APPLE trace
the cover — the mask that MASKSCOKE!
skull-cape
in those as in the ones I did today: PHOTOS: I want the clarity of the
same to be dry *crystal*: that nothing be left over: without remains

CC-*program* reconciles me with NEW york: I was never sick of
NEW YORK as i thought; it was simply that an old and deformed
approach was exhausted — US/NYK still has something to give —
even getting angry isn't possible — opening and brandishing what
can be: would IT be NYK for me as it was PARIS for G. STEIN H.
MILLER? Or INDIA for others or AFRICA RIMBAUD? RIO and NYK
are clear and firm positions: no dirty shadow of nostalgia exists in
that confrontation —

cities as situations: RIO — *block* was built as a germinal situation
in the '60s —> US-city work-US work-city, etc. — the shock of
LONDON was precisely having to place the city as a block-US: the
WHITECHAPEL experience was a big deal because of the violence
of having to create a total environment that developed in a fragmen-
tary way in a RIO-*block* situation: what occurred cannot be reduced
to the «reconstruction of experiences in retrospect»: what occurred
was discovered and…

*CC ABREV. FOR COSMOCOCA: program NEVILLE-ME

[NTBK 59, p. 1, original text in English]

Aug. 27, 73

CC program

General:
1) concerning *timing*: in the slide projection of BLOCK-UNITIES, the
timing will be *accidental* on a whim depending on the care and
place and people involved —

2) NTB 2/73 p. 58
in DECIDE list: answers and decisions
A) Piece by CAGE ends as projection ends.
B.) JOHN CAGE to be consulted.
C.) Delineate instructions according to the situation of exhibit in specific cases

pag. 62
*NOTE:
decision: the buyer would receive in the INSTRUCITONS sheet, INSTRUCTIONS only for private use — PUBLIC PERFORMANCES would be strictly forbidden —

pag. 63
Attention
decision: the BLOCK-UNITIES can only be sold when the specific B-U has been PERFORMANCE [PERFORMED] at least once.

[NTBK 59, pp. 18–19]

pages
72/73 — coke dream:

when I first read these pages I immediately contradicted within myself what the concept seems to say in terms of the reference in the text: that it would be synonymous with something like *make believe* for example:

today I see that even if it is in some way that (with which I, obviously, vehemently disagree) it is not only that:

it is simply more superficial:

and functions as follows:

because for MILLER coke dream identifies itself with what would be aspirations to such states as *«christmas on Earth» peace adaptation harmony communion*: dreams common to the geniuses who live them as if they were realizable: they are in charge of the potential of those dreams: and that keeps them from living them and in that they are akin to the supreme naysayers who reject Nirvana until all men can realize it with them: thus that dream is not what is presumed to be *make believe*: it is closer to something more Nietzschean
dream — intoxication
dream — drunkenness

: 2 conditions of the artists that are privileged and cannot be rescinded:

gifted keys

potions that make them hover above everyday problems: without time or ménage:

but Miller's superficially plucked definition (or whatever it is!):

why?:

it's that coke dream that brings us closer to Nietzsche — *dream* and we know that *dream* is supra-real and not «illusion» and so that when it invokes aspirations of *communion harmony peace* (naively cited!) it cannot do so without what is terrible also being invoked:

the *dream* is so vivid that it keeps it from being lived (which doesn't mean that it has been renounced!) dare to aspire to the supra-real and to hover above the trivial but since that also brings what is DIONYSIAN —> all that is glimpsed in that dream —> with him —> and that in the final analysis refers to the statement of the DIONY-SUS-god —> YOU, IT WOULD BE BETTER IF YOU HADN'T BEEN BORN —

[NTBK 4/73, pp. 55–60]

31 Mar. 74
1:40 AM
ho
nyk
BABYLONESTS

seeing now the beginning of a HITCHOCK film (considered to be minor) UNDER CAPRICORN (1949) I thought about something that could perhaps be COSMOCOCA — *program in progress*

in the beginning of UNDER CAPRICORN HITCHCOCK places inserts-takes of *live maps* while he succinctly recounts the history of the discovery of AUSTRALIA — the rise of SYDNEY — the importation of slaves — and the *frames-live-maps* follow one upon another: the first that appears is a centralized flagpole with the English flag and the colors applied in the watery marks of a projectionist of urbanism — the presentation of ADS in the beginning has a map of AUSTRALIA as a background — after that magisterial sequence the insert-takes that seem to mix live action and animation

that the action per se begin[s] (dialogue, actors) with the same quality of color and that it submit[s] all live action to the series in an initial sequence:

what does all that have to do with COSMOCOCA — *program in progress*?:

weird?:

NO!: it's that all of a sudden I saw that in that sequence-scheme at the beginning of this film is not only the beginning of the structure of the film (magisterial as it is!) but also a scheme — or simply SCHEME — of all of HITCHCOCK'S work before and after this film:

I know that there are one thousand other situations — moments — in HITCHCOCK'S films that are more fully realized — supreme — but they don't matter in this case: inserts — insert-takes (that's what I call them — I don't know if it's what they're called) reveal in their suc-cinctness–in the brevity of the sequence — SCHEMES — open possi-bilities — the
unfinished program synthesis

grandfathers: STRIKE and POTEMKIN: EISENSTEIN
heir: GODARD
:and COSMOCOCA because
it comes to mind:
well:

it's a dream awake —> and I say here —> DREAM WHICH IS ESSENTIAL and not a reference with a moralist air like HENRY MILLER when he makes reference to a COKE-DREAM as if to dis-miss the argument —> DREAM is as REAL as: the CONCRETE REAL-RES-THING — :

so it is:

a dream and something that formulates COSMOCOCA —*program in progress* with more precision: the *fragments-insert*s that make up the montage of the SCHEME at the beginning of UNDER CAPRI-CORN are similar to what the PROGRAM IN PROGRESS should be: not a collection of fragments but *fragments-BLOCKS* that are wholes that are juxtaposed as an augmentation and not as a logical linear sequence —> MY DREAM is that those fragments that in the film refer to HITCHCOCK total individual-creator in COSMOCOCA incorporates discontinuously and at the same time is fed by what I'd call the EXPERIMENTAL CAMP in what I define as BRAZILIAN EXPERIMENTATION: the existence of such a camp is real and strong: like time it will show itself to be stronger than what is in PARIS (unsurpassed): BRAZIL is more important than PARIS but less lim-ited culturally and less provincial: as MARIO PEDROSA says BRAZIL is a country CONDEMNED TO THE MODERN: ignorance ends up minimizing the cultural (even if it's true that it brings the negative with it) — :

well:

in my initiatives of appropriation/absorption/togetherness of frag-ments that are structured in BLOCKS and PROPOSITIONS I seek the non-limitation of homogeneous groups or casts: I direct myself to what comes to me in my head: what is open and not content

with the «made»: the JOY of discovering (oneself) WORLD building
WORLD: that has nothing to do with the majority of *groups-pro-
grams* in which the relation of individual components remains as a
relation of the debt of a debtor to the lender: less and delimited:

but my dream is that COSMOCOCA is changed in each fragment
and ends up forming a kind of GALAXY of INVENTION of individual
powerful manifestations:

LIGHT THAT INTENSIFIES:
MORE LIGHT
MORE COOL THAN COOL:

CALL ME HELIUM by Hendrix: with PARANGOLÉ: which was/is
the PROGRAM IN PROGRESS also: I sought to wrench from THE
EXPERIMENTAL FIELD as POTENTIALLY MYTHIC AREAS that
have as immediate effect the experiments with the BODY and the
AMBIENTS culminating in the DANCE which is more more than
everything:

in COSMOCOCA that limitation of AREA doesn't exist:

there is JOY in EXPERIMENTATION that rises collectively and frees
us from the dull weight of non-invention:

something unused and luminous like that idea that you may have of
the arrival of the year 2000:

COSMOCOCA overcomes the era of isolating the MYTHIC because
it opens/and opens/to/the/GAME: to CHANCE OPERATION:

[Index Cards, «small green» NTBK 1/73]

CC1 24 April 74

soundtrack: NEVILLE —> supplies tape of music from the north-
east — open
fine — HO —> montaged with the *NEVILLE-tape* the *definitive-tape
montage*

CC2 24 April 74

— set.: (COLLECTIVE PERFORMANCE) — decision made with
NEVILLE: square-canvas-internal wall: use 2 walls as back projec-
tion — square room: 2 others with back projection too — partici-
pants in the same area as the 1st proposal

— sound track: ONO screams: make a tape-montage —

136

CC3　Apr 24 74

—sound tracks: get (search) disco-sound-NEVILLE: south america archetypes quechuva/etc. —

CC5 [undated, probably April 24, 1974]

—soundtrack: to freely choose some piece of HENDRIX with the time left *open* to begin before—continue during
«proj.»—after

—PERF. col.—participate in hammocks that will be hung so as to be occupied SUSPENSION IN THE AIR—back projection on 4 walls—hammocks attached to the ceiling—BODY MOVEMENT—HAMMOCK-AIR—*PODS*

[NTBK 4/73, pp. 95–96]

28 Jun. 74

Notes for PHOTO-RECORD SERIES:
on: cardpiece should be recorded on 2 sides:
*a) PHOTO:
 b) text:　　　reference and INVENTION

*a) PHOTO:　　CRISTINY [at] PIER 42 in NEW YORK: 6 Jan. 73 (negative 29 A 30)

bleeding
PHOTO: HO for NON NARRATIVE *Agripina*
as part of the film—NYK slides-sound program AGRIPINA is ROMA-MANHATTAN
SOUSANDRADIANO of WALL ST. INFERNO

TODAY'S OBSERVATIONS: when this photo was made it aimed with precise planning and vision at what I wanted in a given situation: CRISTINY-AGRIPINA (without placing «the characterization of character» but more a poetic relation established for me VIA-SOUSANDRADE as a departure) with the SEA (HUDSON RIVER there) seeking to avoid the touristic piers —> here it's a matter of the extreme-limit like the RIVER of PIER 42 in MANHATTAN: that encounter[s] PLATFORM FLOOR-CEMENT/SEA (RIVER) is straight: of classic precision: and what makes it more special and *eventful* is the horizontal-vertical exactness CRISTINY-AGRIPINA in the *gaze toward/through* the *SEA* that is masked by the windblown hair:

LOOK IN THE DIRECTION OF THE SUN THAT TURNS METALLIC GLINT-REFELCTING ON HER: light and shadow are not molded in measures and volumes: they become geometric in clear areas with defined planes: the photo —> I see it in a larger sense as SIMUL-

TANEOUS CONTINUATIONS OF DEFINITE ELEMENTS: there is no
intention-relation: there are multiple openings: *poetic* however

—> same [28 Jun 74]: 9:40 AM

bu button no button
eye eyeing eye
(o) (o)
meta/isol mirror
vertigo finca
hour straight-zone
turn turning
xoxo
xo
x
xoo

H.O. and Cinema-World
Ivana Bentes

1 Hélio Oiticica, «*Crelazer*» in Hélio Oiticica et al, *Catálogo Hélio Oiticica* (Rio de Janeiro: Centro de Arte Hélio Oiticica, 1996), p. 132.

2 *Crelazer,* a proposal to turn leisure and laziness into inventive states. Ibid.

Hélio Oiticica in Ivan Cardoso's film *HO,* 1979
Photo: Eduardo Viveiros
© Ivan Cardoso

The works by Hélio Oiticica grouped under the rubric «quasi-cinema,» a term he formulated in the 1970s, are inscribed in an original quest to break down all compartmentalized forms of expression — painting, sculpture, photography, cinema. They do so in the name of an expanded experience of art that would destroy any claim to artistic purity («purity is a myth,» he says) and celebrate the coupling of art and a world that gives birth to hybrids.

This aesthetic becoming of life and the world is linked directly to the ascension of mass culture, with its power to create and dilute signs, processes, images. Oiticica never stopped confronting and problematizing this aesthetic-mediatic hyperactivity, posing the following questions, which run through all his work: «Who is or who could be a creator?»[1] How can we create «states of invention» that are open to everyone?

The works grouped under the concept of «quasi-cinema» — *Cosmococas, Neyrótika, Helena inventa Ângela Maria* [Helena invents Ângela-Maria], *Agripina é Roma-Manhattan* [Agripina is Rome-Manhattan] — are a formulation of those concerns. They can be thought of as part of a historical line that begins in the cinematic vanguards of the 1920s, runs through «expanded cinema» and the experiments in various media of the 1960s and 1970s (experiments that brought the plastic arts closer to cinema, to photography, to super-8), arriving at today's hybrids such as video installations and investigations of Internet art and virtual reality.

But Oiticica's singularity and radicality lie in his capacity to convert these «historic» formal and conceptual questions — regarding non-narrative, multimedia, interactivity, pop art, anti-art, Happenings, performance — into vital and original experiences, triggered by the years he spent in New York between 1970 and 1978. Oiticica gave «local» responses to structural questions, with proposals that were rigorously and minutely conceived in texts and notes that fill hundreds of notebook pages, many of which have yet to be published or, in some cases, are published in this catalogue for the first time.

For Oiticica there is no separation between the conceptual and the lived experience. The product of his «newyorkaise» derives directly from underground drug culture, risky homosexual behavior, inventive leisure (as in *Crelazer* [2]), and odd jobs (Oiticica worked nights in New York as a translator) but also from a sensitivity plugged into the hyperproductivity of urban media: cinema, rock, radio, TV, all of American pop culture, the iconography of Hollywood, the glamour and celebrities that fascinated Oiticica.

left Hélio Oiticica in Ivan Cardoso's film *Dr. Dyonélio*, 1978
Photo: Eduardo Viveiros

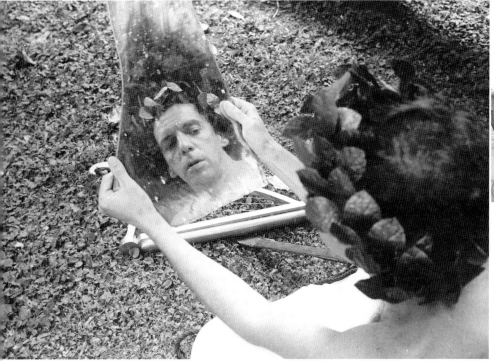

Hélio Oiticica in Ivan Cardoso's film *Dr. Dyonélio*, 1978

The contemporary body living in a cinema-world, the mediatized city that continually excites and stimulates all the senses with images, sounds, and sensations, is one of the bases of «quasi-cinema.» The artist competes with the media, feeds on it, turns urban culture into a new skin. Inside these experiences, how can one «isolate» art, compartmentalize it, keep it out of the streets and public spaces?

The works grouped under the name «quasi-cinema» are an original means of posing that question. They postulate a «cinema» that speaks to the body, just as the experience of watching TV or rock concerts does. The audio-visual spectacle sets off corporeal reactions and creates a feeling of disquiet: fragmented images, sensory stimulation, «dirty» sound environments that incorporate breaks and interference, an excess of «disintegrated» stimuli that break down established classifications, eliminate distance, and create a flux of serial images and sounds that are felt and experienced in the body before any verbal reaction can be formulated.

«How do you release the BODY in ROCK 'N' ROLL and remain in the chair of the numb-cinema?»[3] «Do you inhabit the chair-prison?» asks Oiticica, and limit yourself to the traditional contemplative relationship before an artwork in a gallery or museum? All of Oiticica's work is an unfolding of these questions, but the *Parangolés* (1965), *Tropicália* (1967), and *Quasi-cinemas* (1973), stand out as radical moments that problematize the relationship among the environment, the image, and the body.

The *Parangolés*[4] — banners, capes, tents — function as structures similar to clothes (to wear or dance in); the participant «wears» the work, is on display, sees and is seen. The superimposed fabrics

3 Hélio Oiticica, «Bloco-Experiências in Cosmococa» [Block-Experiments in Cosmococa], in *Catálogo Hélio Oiticica*, p. 177.

4 Oiticica's best-known works, the *Parangolés* are structures for dressing, dancing, running, exhibiting: capes, banners, tents, «layers of colored cloth,» like clothes that become a second skin. The spectator wears the work and becomes, according to Oiticica, «a participant,» transforming his own body into a «support,» in a ludic experience that constitutes an «expressive act.» See «Anotações sobre o Parangolé» [Notes on the Parangolé] by Hélio Oiticica for the exhibition *Opinião 65* [Opinion 65] at the Museum of Modern Art in Rio de Janeiro in 1965, in *Catálogo Hélio Oiticica*.

and plastics trumpet slogans/warnings/statements: «I AM POS-SESSED, I EMBODY REVOLT, FROM ADVERSITY WE LIVE.» These projects embrace the specular dimension of exhibiting one-self, inspired by the makeshift aesthetic of beggars and street people who transform blankets, plastic, cardboard, newspaper, and boxes into a second skin that protects them and makes them unique.

With *Tropicália*, «an extremely ambitious attempt to create our own language that would go head-to-head with the international image of Pop and Op,» Oiticica gave a name to what would come to be a movement that spread into music, cinema, and theater, in an original and anthropophagic reading of Brazilian mass culture. In this work another of Oiticica's relationships with the image of Brazil and its clichés emerges.

«The principal *Penetrável* [Penetrable] that comprises the environ-mental project was my maximum experience with images, with a sort of experimental field of images. For that I created a kind of trop-ical scenario, with plants, parrots, sand, stones…» After entering this *Penetrável*, after having passed through various tactile-auditory experiences, the participant creates feelings and at the end of the labyrinth comes across a TV set that is on: «it is an image that devours the participant, because it is more active than his sensory creations.»[5]

5 Hélio Oiticica, «Tropicália 4 de março de 1968,» in *Catálogo Hélio Oiticica,* p. 124.

Here Oiticica creates what he calls «tactile-images,» a «limit-attempt to check that dislocation of the IMAGE (visual and sensory: the WHOLE OF THE IMAGE) in a sort of multimedia salad with little ‹meaning› and no real ‹point of view›…; as concrete as what it seemed to evoke: the fragmented foundation of the limits of rep-resentation.»[6]

6 Ibid, p. 125.

The relationship between environment-body-image, the dissolution of narrative in the name of fragmentation—this aleatory experience of the image, a multisensory experience without boundaries—also will be sought by Oiticica in his «quasi-cinema» experiences, in which the «ex-spectator» is stimulated to participate in a visual-sen-sory experience, immersed in a box of images and sounds in real space where he enters into contact with the most diverse materials: sand, vinyl, water, cloth, balloons, mattresses. He takes stock of the space, is prompted to act and react, bodily, to the projected images and sounds.[7]

7 In *Apontamentos 22 de junho de 1973,* unpublished notes in NTBK 2/73, archives of Projeto Hélio Oiticica, Rio de Janeiro.

In the «image boxes» created for the *Cosmococas*, works that configured the concept of «quasi-cinema,» the artist proposes that the «participant» walk through the environment, lie down, sit, file his nails, swing on a hammock, or, in one of Oiticica's more radical proposals to the public (*CC4 Nocagions*) swim in a pool with his body completely immersed in fluid materials: images, lights, water.

The filmmaker Neville D'Almeida, coauthor of the first five *Cosmo-cocas* — themselves a program in progress, designated by the abbreviations CC1 to CC5 — underlines the relation between photography and cinema that marks the work. Here the artists reverse their usual roles: D'Almeida, the filmmaker, draws/arranges/makes-up existing images, and Oiticica, the plastic artist, photographs the sequences.[8] The make-up, a white line of cocaine that obscures/reveals the original drawing, is accompanied by a sequence of images (a photo of each set up) that follows the flux of the «make-up» without repeating or interrupting its progress. The transformation of the drawing is accompanied by changes in angle, in lighting, in framing.

The *Cosmococas* are projections of fixed images (slides) in «prepared» environments; the series has directions (instructions on the sequence and duration of the slide projection); cinematography (notes on the creation and montage of environments); and soundtracks (musical tracks, fragments of ambient sound, tracks taken from the radio, poetry readings, noise, etc.). The movement, however, takes place between the images and not inside the image-movement, as in film, and, the «participant,» unlike the spectator of a film, reacts to fragmented images in a tactile fashion and with his or her entire body. According to Oiticica, the «quasi-cinema» was born of «my dissatisfaction with ‹cinema language›: not to be contented by the relationship (mainly the visual one) of spectator-spectacle (nurtured by cinema-disintegrated by teevee)...» He continues, «the spectator's hypnosis and submission to the screen's visual and absolute super-definition always seemed to me too prolonged... then G-O-D-A-R-D: how can anyone muse over the ‹art of cinema› yet ignore GODARD's meta-linguistic questioning of the very quintessence of filmmaking?: as with MONDRIAN in PAINTING there came to be a *before* and *after* GODARD.»[9]

Oiticica seeks this new cinematographic experience through the fragmented cinema of Jean-Luc Godard, the aesthetic of television, the experience of rock — all inaugural events in a new relation between existence and aesthetics. The importance of his collaboration with D'Almeida, director of a series of films that broke apart traditional language — *Jardim de Espumas* [Garden of Foam] (1970), *Mangue Bangue* (1971) — comes from cinema's capacity to abandon the «glorification of the visual for its fragmentation... as if it were a long strip taken from cartoons and turned into a sequence.»[10]

The experience of the *Cosmococas* also passes through Oiticica's connection to underground Brazilian cinema (as represented by such directors as Júlio Bressane and Ivan Cardoso, as well as D'Almeida) and the political-experimental cinema of Glauber Rocha, through the desire to dismiss «the unilateral nature of cinema-spectacle,»[11] the desire that has fed cinematographic vanguards of every epoch. The decisive question is less a moral condemnation of spectacle, which fascinated Oiticica, than the desire to open

8 Neville D'Almeida's ideas about his collaboration with Oiticica were presented in a statement to the author in March 2000. Carlos Basualdo points to the relationship among narrative, photography, and cinema as one of the keys to Hélio Oiticica's «quasi-cinemas» in a preliminary description (1999) of *Hélio Oiticica: Quasi-Cinemas* provided to the author.

9 Hélio Oiticica, «Bloco-Experiências,» in *Catálogo Hélio Oiticica*, p. 174.

10 *Catálogo Hélio Oiticica*, p. 177.

11 Hélio Oiticica, «Bloco-Experiências,» in *Catálogo Hélio Oiticica,* p. 177.

cinema and its language to other realms: «in Bressane's *Estrangula-dor de Louras* [Strangler of Blondes] the first blonde to be strangled is the language of cinema devoured in its verbalism… in extreme cinematic experiences all ‹innovation› is ‹devouring› and any attempt to see beyond it is the ‹end of cinema› as an important language: would cinema become a mere instrument?»[12]

Along with aesthetic experimentation, Oiticica found an ethical-existential posture in underground cinema, one that was close to his anarchic and political project: «Be marginal, be a hero,» a statement that eulogized the deceased bandit Cara de Cavalo. Violence and misery take on an existential and aesthetic meaning in a film like *Câncer*, begun in 1968 by Glauber Rocha, in which Hélio Oiticica participated, and which stages the encounter/confrontation between black samba musicians from the *favelas*, petty thieves, and Rio de Janeiro's middle class.

The film combines the pedagogy of violence, paternalistic lyricism, and the desire for an art that would cross the boundaries of class, status, culture. *Câncer* is part of a movement toward a *favela* where the middle class mingles with the samba, the marginalia of the hills, the pickpockets, the underworld of the police stations. The middle class talks about communism with them, about sex, poverty, revolution, in an attempt to incorporate the everyday life and aesthetic of the slums.

Other important elements in the *Cosmococas* are drug culture and celebrity culture, which Oiticica looks at as laboratories for his sensory and behavioral experiments. The fact that he uses cocaine as make-up that will effectively be snorted, in a literal consumption and dissolution of the work, created, according to D'Almeida, the total and absolute impossibility of showing these works in 1973. That would explain why the works in the series were shown for the first time almost twenty years after they were made, in an exhibition of Oiticica's work that traveled from Rotterdam to Paris to Barcelona to Lisbon to the United States and Brazil, a show that put Oiticica on the international art circuit.

«You don't ask a painter what brand of paint he uses in a painting,» says D'Almeida, echoing Oiticica's phrase: This «INVENTION» is «just another twist in the general hoax… and why not? if smelling paint and other shit is part of the plastic art ‹experience› then why not the shining-white PRIMA so appealing to most nostrils?»[13] The idea, says D'Almeida, is to think of the cocaine as a cosmic «coca» or cosmic paint, hence *Cosmococas*, which would be the transmutation of cocaine into an expressive material. It is necessary to remember that in the 1960s and 1970s drugs were still part of a romantic or experimental moment, linked to revolution and the counterculture and not to a drug economy supported by organized crime on a worldwide and highly professional scale.

12 NTBK 2/73, pp. 10–11. The film mentioned is *Memórias de um Estrangulador de Louras* [Memories of a Strangler of Blondes] by Júlio Bressane, 1972.

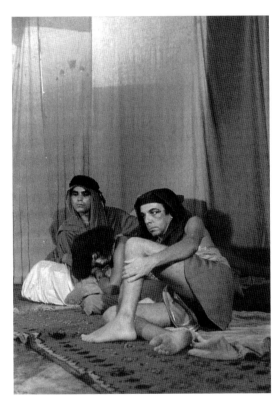

13 Hélio Oiticica, «Bloco-Experiências,» in *Catálogo Hélio Oiticica,* p. 190.

Hélio Oiticica and Marcos Palmaira in Ivan Cardoso's film *The Mummy's Secret*, 1979
Photo: Eduardo Viveiros

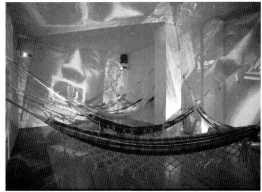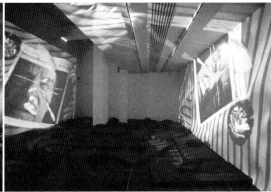

But what is in question in the *Cosmococas*, in this game, this joke with drugs and celebrities?

Chance. In *CC1 Trashiscapes*, the face of the filmmaker Luis Buñuel on the cover of the *New York Times Magazine* set off the first experiment of the *Cosmococas*, a casual and quotidian element that will be valorized by Oiticica: «the chance arrangement of the slides that make up EXP. CC1 is important in how it plays with the sequence of MAQUILAR [putting on make-up]: it is as accidental as MAQUILAR's transformations: it transforms the ultra-visual framing of the MAQUILAR sequence into a new organic fluency… these are not photos just to be photos: nor sequences with an end in sight: not settling on a definite order for the slides is important: it's a game of positions on the soundtrack, a game of projection (they play with the spectator/environment/circumstance position/etc.)»[14]

14 NTBK 2/73, p. 53.

Recognition of the body. Make-up renders Buñuel almost unrecognizable, with African and Asian traits that leave the participant in a state of doubt: who is this? Another important element is the photoposters of Luis Fernando Guimarães dressed in a *Parangolé*: in the slide a penknife touches, in a «cut-caress,» the nipples of the model in the process of being pinched, excited, in what Oiticica calls an objective recognition of the body.

Fluctuating attention. Fluctuating attention, distracted perception, is intentionally sought by Oiticica. He seeks this in the environment created by the projection of slides with mattresses, pillows, and a nail file [lixa de unhas] given to each person — an ironic, casual element. The spectators are distracted watching TV or a film, doing something else, or as they say in Brazil «se lixando» [not giving a shit].

A phenomenology of celebrity. In *CC2 Yoko Mask,* Oiticica and D'Almeida start with the cover of Yoko Ono's book *Grapefruit*. Oiticica is fascinated by Ono because she extends her «public» activity to an aspect of the experimental: «the odd importance of her ‹public act as a celebrity› is that she invents a situation not assuming an ‹image› or the old star submission; she is the anti star-system to the maximum of ‹celebrity› maximum creative control:

Hélio Oiticica and Neville D'Almeida
*Block Experiments in Cosmococa,
Program in Progress,* 1973
CC5 Hendrix-War: slide series, hammocks, and soundtrack (left)
CC1 Trashiscapes: slide series, mattresses, pillows, nail files, and soundtrack (right)
Courtesy Projeto Hélio Oiticica and Neville D'Almeida
Installation views, Wexner Center for the Arts
Photos: Richard K. Loesch

15 Ibid, pp. 75–76.

16 Ibid.

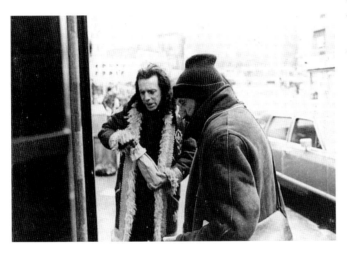

17 Ibid, p. 52.

18 Ibid, pp. 76 and 77.

19 From «instauration,» Ibid, p. 159.

Decio Pignatari and Helio Oiticica
in New York, 1975
Photo: Ivan Cardoso

LENNON ‹the wedding› in a double bed in days in the news: the ‹privacy› of the married couple exposed metacritically: a tribal media bed.»[15]

Oiticica compares Yoko Ono to Marilyn Monroe, who «wasn't able to glimpse a stable eternity, and became a void» and asks: «How do you satisfy the SUPER-GOD OF CONSUMPTION WHO CON-SUMES: Yoko is transmuted like No.»[16]

CC3 Maileryn is the best-known and most often exhibited work in the *Cosmococa* series, set off by the beautiful cover of Norman Mailer's book on Marilyn Monroe, with the big and luxurious face of the star, covered in cellophane and taking up the entire surface.

Fragmenting the super-cliché. The make-up and projection sequence of Marilyn's masks on four walls and on the roof create a series of dislocations in the images, which dissolve, deform, wound the star-image. The penknife cuts the white mouth and lets you see red-blood lips. In a make-up effect, Marilyn appears with painted eyes and mouth, like a clown. The projection of the slides creates effects of fragmentation, fusion, animation, light effects on her plastified face. Marilyn appears and disappears under lines of cocaine, fragmented in her eyes, her mouth, her eyebrows. «The snorted line dresses/undresses the supposedly finished surface: *fragmenting the finished = adding the plagiarism-mask or sacred pretense.*»[17]

The proposed environment is ludic and characterized by small ritu-als: taking off your shoes to walk on a floor lined with sand and vinyl; touching, playing with, hugging the white balloons that float in the space. Oiticica intends for the viewer to be amused by and sur-rounded by the environment, wrapped in the hot Latin soundtrack. He sees Marilyn as the incarnation of the paradoxes of the star-system and of American mythology, a «hole» and dysfunction in the efficiency of the Hollywood image: «Marilyn incorporates a synthesis-cliché of the ‹media› cinema/advertising as a *concrete element*… she ducks the standards of a fixed-image: she *cannot be classified*… as a perfect professional she incarnates and plays at ‹being a star› in a way that is more concrete and essential: *the myth* is what emerges from that encounter-fusion of the star with herself the recognition-identification with the very situation of being a star.»[18]

Rock and the end of the audience. CC5 Hendrix-War, made on 26 August 1973, was born of the true obsession of «Hélio-Neville» for Jimi Hendrix, and especially for the album *War Heroes*. For Oiticica, Hendrix is an «instaurator,»[19] like Godard in cinema, Malevitch in art, John Cage in music. If rock disconnected music from the earth, is airborne, different from samba, danced on the tip of your toes, says Oiticica, then Hendrix inaugurated the tragic in rock and rein-vented performance, dismissing the spectacle that's simply meant to be seen. «Everything begins at MONTEREY POP (everything

changes, rather) JIMI HENDRIX brings all the old references to an ecstasis: ‹guitar-amplifier-mode of playing: body-hands-microphone›: his peak performance was not only ecstatic but a historical limit or breach… as important as the Malevitchian white-on-white, or Mallarmé with his *coup de dés*… as if orgasm-fire were consuming all the visual-spatial-linear forms of performance.»[20]

20 Ibid, p. 6.

In Hendrix's masks and make-up, fire emerges in a box of matches with the Coca-Cola logo, and the soundtrack, prepared by D'Almeida, brings a selection of five or six songs with tracks of Hendrix's own powerful singing. The coke trace on Hendrix's face on the album cover transforms him into a monumental mask, a «totemic-black-indian icon.» The coke «make-up» follows this «totemic» trail, creating geometric and ethnic figures on the surface of his black skin.

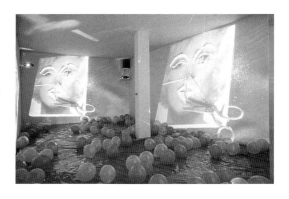

The environment for *Hendrix War* is an intricate «network,» a web formed by layers of hammocks (used primarily in the north of Brazil), in which the participant can lie down or swing. The hammock, an indigenous technology, made of cloth and used originally by Brazilian Indians, envelops the body creating a sensation of relaxation and involvement. Just as in Hendrix's show, in the *Cosmococas* Oiticica tried to incite the participant to «live his end as audience.»

Oiticica made the first five blocks of *Cosmococas* (CC1 to CC5) with D'Almeida, but in his notebooks we find a series of other «programs in progress,» proposals to be produced by artists, friends, «conceptual characters»; these for Oiticica raise new questions in his work. He proposes producing a *Cosmococa* with Guy Brett, on the aboriginal concept of «DREAMTIME,» described by Mircea Eliade as a period in which a member of the tribe is freed from his obligations, and he relates this concept to such works of his as *Eden, Barracão,* and *Crelazer.* [21] He also proposes a piece by Silviano Santiago entitled *Über Coca* or *Vigilia,* which examines the experience of simultaneity,[22] not to mention works proposed to the artist Carlos Vergara (*Coca Oculta*) and Thomas Valentin.

21 Ibid, pp. 97–100.

22 Ibid, pp. 103–109.

In his notebooks Oiticica also describes the environment for *CC4 Nocagions,* [23] with slides made of the white cover of John Cage's book *Notations*. The «design-plan for performance» calls for a mechanism for projecting the images in public pools, with screens at the bottom, where people will swim, prior to the projection, in the water illuminated in different colors (blue and green), with boom boxes on the edge of the pool playing a piece by John Cage.

23 Ibid, pp. 56–62.

The *Cosmococas* are not unlike Jack Smith's experiments with slides and film (*Flaming Creatures*). «for me JACK SMITH was its precursor: he extracted from his cinema not a naturalistic vision imitating appearance but a sense of fragmented narrative mirror shatters: the slides displaced ambience by a non-specific time duration and by the continuous relocation of the projector framing and

Hélio Oiticica and Neville D'Almeida
*Block Experiments in Cosmococa,
Program in Progress,* 1973
CC3 Maileryn: slide series, sand, vinyl,
balloons, and soundtrack
Courtesy Projeto Hélio Oiticica and
Neville D'Almeida
Installation views, Wexner Center for
the Arts
Photos: Richard K. Loesch

24 Catálogo Hélio Oiticica, p. 180.

25 According to Guy Brett, «Bodywise» would be the name of one of fourteen chapters of a book called *Newyorkaises* or *Conglomerado*, a collection of New York projects that were never produced. See *Catálogo Hélio Oiticica*, p. 208

26 Helena Lustosa lives and works in Rio de Janeiro. In the 1970s, she was an actress in such films as *Nosferato no Brasil* [Nosferatu in Brazil], *Chuva de Brotos* [Rain of Buds/Babes], and *Sentença de Deus* [God's Sentence], super-8 features directed by Ivan Cardoso. She also worked as an actress in *Jardim Botânico Real Horto* (1979) and *Noite* [Night] (1981), both directed by Gilberto Loureiro. She makes short animation films related to visual arts, such as *Gineceu* (1986) and *Mademoiselle Cinemá* (1996).

27 See Hélio Oiticica's letter to Waly Salomão in the brochure *Hélio Oiticica e a cena Americana* [Hélio Oiticica and the American scene] (Rio de Janeiro: Centro de Arte Hélio Oiticica, 1998).

reframing the projection on walls-ceiling-floor: random juxtaposition of sound track (records).»[24]

The combinatory of «quasi-cinema»—the editing of slides, the ambient music and its modulation—suggests a tactile dimension that Marshall McLuhan attributed to television, images and sounds that caress us and instill their meaning under our skin, an idea that seduced Oiticica. McLuhan is a constant reference in his writings, as are Friedrich Nietzsche (the will to power, the tragic) and Jean-Paul Sartre (nothingness, revolt, existence).

Agripina é Roma-Manhattan is a super-8 filmed in New York in 1972, about 15 minutes long, and defined (as are *Neyrótika*, 1973, and *Helena inventa Ângela Maria*, 1975), as a «non-narrative» in which what is in question is not the images or the narrative but a body-performance that exposes and displays itself taking on new masks and sexual roles: «Bodywise,»[25] which emerges in the exuberant femininity of Helena Lustosa[26] inventing a pop-icon, singer Ângela Maria; in the prostitution and transvestism staged by Agripina; or in the androgyny and pansexual aesthetic of *Neyrótika*.

In *Agripina é Roma-Manhattan*, the cliché staging of the female prostituted body dissolves in monumental images of a classical, «Greek» New York: stairways and «Greco-Roman» columns serve as an environment in which the body is staged. A woman (Cristiny Nazareth), who is wearing a very short red dress and «Greek» sandals laced up her legs, is made up like Cleopatra and glides through the streets of Manhattan solemnly led by her Latin lover. «Agripina» slides between columns and stairways, as in Cecil B. DeMille's Hollywood epics, except that the Greco-Roman temples are replaced by urban monuments: Trinity Church Wall Street, the Empire State Building, the New York Stock Exchange. In another sequence a girl in a skin-tight blouse and a mini turns tricks on a busy corner.

In the final sequence, two people get out of a car: the Brazilian artist Antônio Dias and the transvestite Mario Montez, an actor in *Flaming Creatures* by Jack Smith (Oiticica met the mythic filmmaker in New York in a «quasi-cinema» experiment in which Smith presented *Travelogue of Atlantis*[27], a slide projection accompanied by a soundtrack in which the projector was manipulated). Montez, dressed as Carmen Miranda or a «Spanish woman,» then plays a game of dice in the middle of the sidewalk with Dias. Art, chance, play, transexuality, the deciphering of signs of consumption, and clichéd images staged in a monumentalized urban space are some of the elements of this «unfinished» super-8, in which art pleasurably plays dice with the city-cinema-prostitute.

To experience the other through masks, images, poses, and figures that underline the sexuality and fungibility of masculine/feminine is characteristic of *Agripina*, *Neyrótika*, and *Helena inventa Ângela-*

Maria. It is a pansexuality that appears in the study of fragmented bodies and faces of beautiful boys, who assume not-quite-explicit sexy and sensual poses in *Neyrótika* (1973), which is composed of something like 250 slides, to be projected with a ninety-minute soundtrack.[28]

In the lineage of the *Cosmococas*, the seven blocks of slides and the soundtrack of *Neyrótika* constitute a non-narrative «because it isn't a little story or pure photographic images or something despicable like an ‹audio-visual› project.»[29] Each series is identified by the name of Oiticica's boys/lovers/friends — Joãozinho, Dudu, Cornell, Romero, Didi, Carl, Artur — photographed in the «nest/ environments» of his cell/apartment.[30]

Each series creates a style — different blocks of light, colors, poses, and «reactions» to the camera. According to Oiticica, «NEYRÓTICA is NONSEXIST,» «NEYRÓTIKA is what is pleasurable.» The photographs create distinct atmospheres, the languid and casual series on Joãozinho (João Carlos Rodrigues, one of the few models Oiticica used that we've been able to identify); the enchanting, violent-red images of a glamorous she-male; Dudu, blond and sexy,

28 Oiticica speaks of «80 slides with time codes and soundtrack: unfinished,» probably referring to the presentation of this work in *Expo-Projeção* held in São Paulo in 1973. But we found seven series or blocks with seven different «models» for a total of almost 250 slides identified in the archives of the Centro de Arte Hélio Oiticica by the name of the model.

29 Hélio Oiticica, in *Neyrótika,* cited by Lígia Canongia in *Quase Cinema: Cinema de Artista no Brasil 1970/80* [Quasi-Cinema: Artists' Films in Brazil 1970/80] (Rio de Janeiro: Funarte, 1981).

30 Oiticica transformed the apartments where he lived in New York into environments, «sheltered worlds» where he placed «nests,» sensory spaces, where he put his friends and visitors. The lofts were given names like BABYLONESTS, HENDRIXSTS and became, like people, material for conceptualization and experimentation.

Hélio Oiticica
Neyrótika, 1973
Slide from series
Courtesy Projeto Hélio Oiticica

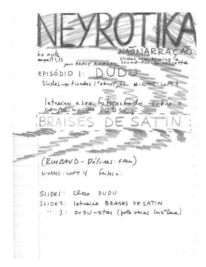

with long hair, wearing a light lipstick that sweetens his virility; a young black man, Cornell, meditating and assuming sensual poses, naked except for a hat.

The rhythm of the projection of the images creates a «quasi-animation»: arms and hands change position, body parts approach and move farther away, a body «stands up» through a simple change in framing; a horizontal becomes a vertical and vice-versa.

The images explore this movement of the models' faces and bodies, quartered and fixed by the framing and «reconstituted» by the projection sequence. The horizontality of the bodies—lying in nests, nets, and mats—is made vertical in Oiticica's framing, leaving the bodies «standing.» Romero, who appears in many of the New York works wearing *Parangolés* is photographed in *Neyrótika* in a red hammock, his chest bare and in close-up. The images explore Romero's face and naked torso, his long hair and classical profile. The sequences of the images create a disjunction of the face/body—quartered in frontal close-ups of legs, torso, profiles—and explore, in the passage from one slide to the next, the change of vertical and horizontal axes, of straight and oblique angles.

João Carlos Rodrigues, «Joãozinho,» describes a photo session, done in 1972, in which he was a model, contacted by a friend at Oiticica's request, a session that lasted four to five hours: «We talked for an hour about various things, among them music, Dalva de Oliveira and Yma Sumac. Hélio showed me other series of slides, that were already finished, of a Puerto Rican, of a black man, and another young man that might be Dudu. Since I had worked on the theater play *Roda Viva* [Live Wheel], he suggested whiteface, like the kind used in No theater. He even made me up. The photographs were done in a sort of bunk bed [the ‹nests› scattered around the apartment], Hélio would circle around saying what he wanted: how to position my legs, my body. I picked up a magazine to read and he thought that was great and incorporated it. There was music and the radio was on.»[31]

The result of the series «Joãozinho» are photographs that seem not to have been posed, which were taken in a sexy and intimate environment. In other series (Didi, Carl, Artur), Oiticica explores low-angle shots, light/dark contrasts, strong colors (blue, yellow), and natural light that is soft and «casual,» «not ‹artistic› photography.» Seen today, these takes of boys in casual, everyday poses have the freshness, rawness, and lightness actively sought by fashion photography and by the fashion world, usually unsuccessfully.

Oiticica does not make «pretty» pictures of pretty boys: «one night I sat Beauty on my knees—I found her bitter—I cursed her,»[32] he says, photographing desire desiring. In some sequences, the boys show off for the camera, such as Didi, photographed against dark

31 From a statement to the author in March 2000. João Carlos Rodrigues is a researcher and film critic and director of a series of videos on the radio stars/icons of the 1950s.

32 Hélio Oiticica, in *Quase Cinema: Cinema de Artista no Brasil*, p. 22.

From a notebook entry dated April 11, 1973, Neyrótika NTBK, p. 1

or blue grounds and from low angles, wrapped in a very short skirt/towel. The sequences explore unusual angles, from low to high. In the sequence of photos of Artur, Oiticica uses a soft and enveloping light, delicate counter-lights in his hair that emphasize the skin; the model doesn't look at the camera, he is photographed in profile looking in opposite directions. The sequence of slides creates surprise by changing the direction of the gaze: outside the frame; to the right, to the left, above.

Between the slides of *Neyrótika* is a photograph of the recorder and the radio used in composing the soundtrack: «the soundtrack is continuous but punctuated by improvised, accidental interference in the structure recorded from the radio which is arbitrarily linked to the slide projection sequence and not used for emphasis — it is *play*-invention.»[33]

33 Ibid.

In composing his non-narrative, Oiticica breaks and bars «the artistic» from his photographs or even their direct erotic charge with a soundtrack of interference taken from New York radio (music, ads, lectures, the time and weather, serious, childish, seductive, funny voices) and bits of poems by Arthur Rimbaud (from *Illuminations*) he reads himself.[34] This sound environment, next to the projection-rhythm of the slides (a rhythm that depends on who is operating the projector), interrupts and in the end undoes the configurations of the images. Incidental radio-poetry-sound, rhythmic projections, invention and improvisation in the sound and projection that empty the images of their immediate meaning create new associations and sensations beyond those moments of surprise at the sudden change in the direction of the gaze, the light, the framing angles.

34 Oiticica's voice and characteristic tone were explored in videos and films made in his honor, such as *H. O. N. Y.* (1986) by Marcos Bonisson and Tavinho Paes and *HO* (1979), a short by Ivan Cardoso.

In *Helena inventa Ângela Maria,* the last work in the «quasi-cinema» series, the artist Helena Lustosa plays the mythic popular Brazilian singer, Ângela Maria, who was a smashing success in the golden age of Brazilian radio in the 1950s and became a definitive part of the pop cultural imaginary as the synthesis of femininity and vigor: a kind of popular Brazilian version of Maria Callas, one who could actually be seen and heard. The photographs reveal Oiticica's fascination with exuberant and strong femininity: Marilyn Monroe, Elizabeth Taylor, Yoko Ono, Yma Sumac (on the soundtrack of *Cosmococas*), Maria Callas, Ângela Maria.

Lustosa's youth and beauty, her strong face and violent sensuality, also fascinated Oiticica. Now a visual artist and movie director, Helena Lustosa was at that time doing experiments in underground cinema with Ivan Cardoso[35] and in vaudeville theater with Carlos Machado. When she met Oiticica and started going to his apartment in New York, from July 1975 to January 1976, she wandered the streets of Manhattan wearing clothes and accessories that she made herself — an inventiveness in daily life, clothing and displaying herself, that captured the artist. Lustosa would walk down Fifth Avenue with her friend and would attract attention — something that

35 The films from the series *Quotidianas Kodaks* [Daily Kodaks] (1970–1975): *Piratas do sexo voltam a atacar* [Sex Pirates Attack Again], *Nosferato no Brasil* [Nosferatu in Brazil], *Sentença de Deus* [God's Sentence], *A Múmia volta a Atacar* [The Mummy Attacks Again], etc.

36 A statement from Helena Lustosa given to the author in March 2000 in Rio de Janeiro.

intrigued Oiticica, who was used to the cool indifference of New Yorkers.[36]

In *Helena inventa Ângela Maria*, the actress's performance, her improvisations in the composition of a «sensual,» tragic, and mysterious diva goes from absolute expressivity (the pride and fragility of a face) to the mask-pose of a doll. It is a real contribution to the invention of an iconic image that is neither transvestism nor fantasy (Helena Lustosa «dressed» as Ângela), but a composition of signs (dark glasses, a red rose and mouth, teased hair, the suit, the fabrics, the shininess and lights) that fragment and reinvent Ângela Maria, whose velvety soothing voice and whose lyrics already evoke other times, narratives, worlds.

Oiticica's compositions based on Lustosa's performance achieve an extreme sophistication and sumptuousness in this work. Her half-naked body emerges wrapped in shiny fabrics and plastics, or half-hidden by canvases and nets. Filming at night, in the streets of Manhattan, in darkness, with few points of light (garages, docks, Wall Street, references that disappear in these dimly illuminated scenarios), Oiticica creates black ground punctuated by points of light and explores the counter-light and Lustosa's body, which emerges from the light or plunges into darkness.

In a few slides, the lights transform the asphalt into a mirror of water. Bluish brilliance and the blackness outside contrast with the reds and silvers that illuminate the face and body of Helena Lustosa inside: «my love, when I kiss you, I see the world become delirious, I see the sky here on the ground, and the ground in the sea,» goes the song by Ângela Maria we hear on the soundtrack.

The undefined backgrounds—asphalt, the sea and sand of lights, plastic, cloth—enter into a relationship and contrast with the body-face of Helena, enormous surfaces of soft skin that fill the frame. In some takes, «Hélio-Helena» invent true contemporary «still lifes»: body, hair, eyes, wrapped or exposed breasts spilling out in sophisticated arrangements. A super-sensual and melancholic diva, a delicate doll, a pin-up, a tragic and beautiful woman. The sequence of photographs and music explores the contrasts of a passive body that receives the gaze with the violent eroticism, «in flagrante,» of the body that exhibits itself and returns the camera's or the spectator's gaze.

Ângela Maria's enveloping voice on the soundtrack (entire songs are played) functions to provide «narrative» fragments (lacerated lives, troubled loves, the exaltation of beauty and of the Brazilian woman), a whole emotional world that contrasts with the iconic images, both pop and contemporary, of the invented Helena-Ângela: in a leather coat and dark glasses, half-naked, wrapped in a red bandage, covered in canvas.

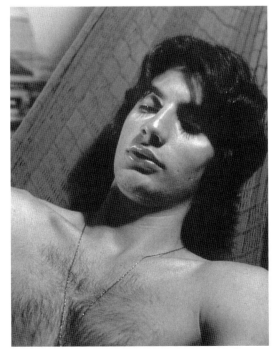

Hélio Oiticica
Neyrótika, 1973
Slide from series
Courtesy Projeto Hélio Oiticica

Pop mixes with tragic, romantic iconography. The red rose held in the mouth, the lacerating stares, the sad song: «Whoever pulls back the curtain on the ballerina's life will see horrors,» but also an exultant march about Rio de Janeiro and Brazilian women whom it describes as «coquettish dark beauties,» «mermaids who make you dream.» The song concludes with the superior sensuality of Rio over Paris: «They talk of Paris, of France, of love, saying that there everything is good. But it is here that you feel in this hot, hot Rio the true beat of love.»

In that work, as in many others by Oiticica, the relationship Helena-Ângela came afterward, from the photographs. «Creation is blind,» «if we already knew what we were doing, why do it, then?» This is the question Helena Lustosa repeats and that, for Oiticica, always defined the «experimental.»

Oiticica, in that work, poses a new and disquieting question: How to reinvent a public persona, how to «appropriate» her image for ends other than representation/imitation or caricature, how to experience the «other» through image-performance? How to experience Ângela Maria or Marilyn or Yoko or Liz Taylor inside myself? How to become other in a way that disqualifies the mere imitation of an idol, of dressing like, of acting like. Oiticica radicalized the cannibalistic pop culture that eats the signs of the other and reinvents it and reinvents itself in devouring the other. His «quasi-cinema» is an attempt to institute a new relation with the images of the world, a seeing with the body.

Ivana Bentes is a film and art critic, professor at the School of Communications, Universidade Federal do Rio de Janeiro, and author of *Glauber Rocha: Cartas ao mundo* [Glauber Rocha: Letters to the World] and *Joaquim Pedro de Andrade: a revolução intimista* [Joaquim Pedro de Andrade: Intimist Revolution].

Bibliography

Canongia, Lígia. «Cinema de Artista: a experiência brasileira e o contexto internactional» [Artist Cinema: the Brazilian experience in the international arena]. In *A Missão e o Grande Show: políticas culturais no brasil dos anos 60 e depois* [The Mission and the Big Show: Brazilian Cultural Politics from the Sixties Onward]. Ângela Maria Dias (Org.). Rio de Janeiro: Editora Tempo Brasileiro, 1999.

Canongia, Lígia. *Quase Cinema: Cinema de Artista no Brasil, 1970/80* [Quasi-Cinema: Artists' Films in Brazil 1970/80]. Rio de Janeiro: Funarte, 1981.

Clark, Ligia, and Hélio Oiticica. *Cartas, 1964–74* [Letters, 1964–74], 2nd edition. Rio de Janeiro: Organização de Luciano Figueiredo; Editora UFRJ, 1998.

Favaretto, Celso. *A invenção de Hélio Oiticica* [The Inventiveness of Hélio Oiticica]. São Paulo: EDUSP, 1992.

Ferreira, Gloria. *Hélio Oiticica e a cena Americana* [Hélio Oiticica and the American scene]. Rio de Janeiro: Centro de Arte Hélio Oiticica, 1998.

Oiticica, Hélio. *Apontamentos 22 de junho de 1973* [Notes from 22 June 1973]. NTBK 2/73. Unpublished transcript of Oiticica's notebook. Archives of Projeto Hélio Oiticica, Rio de Janeiro (February, March 2000).

Oiticica, Hélio. *Aspiro ao Grande Labirinto* [I Aspire to the Great Labyrinth] (selected writings, 1954–69). Rio de Janeiro: Ed. Rocco, 1996.

Oiticica, Hélio. «*Mangue Bangue.*» In the brochure *Quasi-Cinema: Hélio Oiticica (Filmes de, com e sobre)* [Quasi-Cinema: Hélio Oiticica (Films by, with and on)]. Cinemateca do MAM and Centro Cultural de São Paulo.

Oiticica, Hélio. «*Neyrotika.*» In *Expo-Projeção.* São Paulo: 1973.

Oiticica, Hélio et al. *Catálogo Hélio Oiticica.* Rio de Janeiro: Centro de Arte Hélio Oiticica, 1996.

Salomão, Waly. *Hélio Oiticica: Qual é o Parangolé?* [Hélio Oiticica: Which is the Parangolé?]. Rio de Janeiro: Relume Dumará/Rio Arte, 1996.

Filmography
Compiled by Ivana Bentes

Based in part on notes by Hélio Oiticica in *Quase Cinema: Cinema de Artista no Brasil, 1970/80* and *Apontamentos 22 de junho de 1973*, unpublished notes in NTBK 2/73, archives of Centro de Arte Hélio Oiticica, Rio de Janeiro, and on «Filmography,» *Catálogo Hélio Oiticica* (Rio de Janeiro: Centro de Arte Hélio Oiticica, 1996), p. 270.[1]

Quasi-cinemas
Brasil Jorge, c. 1971, super-8

Agripina é Roma-Manhattan, New York, 1972 — unfinished super-8: made to be used as part of a future program.

Neyrotika, New York, 1973 — a non-narrative filmed in NEW YORK April/May 73: 80 slides with projection times and soundtrack, unfinished.

Cosmococa. program *in progress*, New York, 1973 — composed of EXPERIENCE-BLOCKS designated CC from CC1 to CC5 with NEVILLE D'ALMEIDA from 13 March 1973 inaugurating the concept-designation of *quasi-cinema.*
CC1 — TRASHISCAPES
CC2 — ONOBJECT
CC3 — MAILERYN
CC4 — NOCAGIONS
CC5 — HENDRIX-WAR
CC6 — with THOMAS VALENTIN
CC7 — with GUY BRETT
CC8 — alone or with VIGILIA/ÜBER COCA proposal for SILVIANO SANTIAGO [Mr. D. or D. of Dado]
CC9 — COCA OCULTA proposal for Carlos Vergara
They are BLOCKS composed of slides-soundtrack-INSTRUCTIONS: these INSTRUCTIONS are particular to each case demanding the construction of an appropriate environment-occasion.

Helena inventa Ângela Maria, New York, 1975 — 5 BLOCK-SECTIONS to be taken in the same way as COSMOCOCA and NEYRÓTIKA as experiences of quasi-cinema: the INSTRUCTIONS vary according to the situation: the soundtrack too: there is a maquette of the PENTAGON-environment made as a prototype for presentation: new and special programming will be arranged for each presentation.[2]

Norma inventa La Bengell [Norma invents La Bengell], New York, 1975, unfinished. (The following information was provided by Norma Bengell in a short statement for this catalogue, August 2001.)

1 Film footage and other materials by Oiticica discovered in Rio de Janeiro just as this catalogue went to press will doubtless result in additions and changes to this list.

2 Although the slides appear to have been taken in 1975, a draft of instructions in the artist's notebooks is dated October 8, 1976.

–What is the idea for «Norma invents La Bengell»?
–I don't know, Hélio was quite creative and he came up with this phrase, do you know I never saw the photos? I was introduced to Hélio by Neville in New York. I don't remember the exact date but I think it was in 1975. I was rather timid since he was being very funny and I had to remain serious. The weather was excellent and it was very cold out, his house was beautiful, there was a wire sculpture there something like a chicken coop and each [different part] led into a box.
–How many photos were taken?
–Several, even including some on the fire escape outside where he lived.

Participation in Films

Câncer by Glauber Rocha 1968–72, 16 mm. With Hugo Carvana, Antonio Pitanga, Odete lara, Rogério Duarte. Oitcica acts, in a minimalist performance, with samba dancers from Mangueira.

Mangue-Bangue by Neville D'Almeida, 1971. With Paulo Villaça, Maria Gladys, Erico de Freitas, Maria Regina, Neville D'Almeida. A reference/manifesto film that triggered the work on *Cosmococas*.

O Gigante da América [The Giant from America] by Júlio Bressane (1978). Oiticica produces the *penetrável Tenda-Luz* [Light-Tent], with an environment.

O Segredo da Múmia [The Mummy's Secret] by Ivan Cardoso (1979). A combination of horror and *chanchada*, in which Oiticica plays an Egyptian.

Others Films That Include Hélio Oiticica's Work

One Night on Gay Street, by Andreas Valentin, 1975, New York, 1975, super-8.

Dr. Dyonélio, by Ivan Cardoso, 1978, Rio de Janeiro, 35mm.

Uma Vez Flamengo, by Ricardo Solberg, 1979, Rio de Janeiro, 1979, 35mm.

Lágrima Pantera Míssil, by Júlio Bressane, 1973, New York, 16mm.

Kleemania Cajú, by Sonia Miranda, 1979, Rio de Janeiro, video.

Pau Brasil, by Jef Conelis, Chris Dercon, 1991, p. BRTN Brussel, video.

Boards of Trustees

Published in association with the exhibition
Hélio Oiticica: Quasi-cinemas, curated by
Carlos Basualdo.

Co-organized and presented by the Wexner
Center for the Arts at The Ohio State University,
the New Museum of Contemporary Art, New
York, and the Kölnischer Kunstverein.

Presented at the Wexner Center with major
support from BrasilConnects. Additional support
provided by the Corporate Annual Fund of the
Wexner Center Foundation.

Presented at the Kölnischer Kunstverein with
the support of Stiftung Kunst und Kultur des
Landes NRW and Stadtsparkassse Köln.

Exhibition Itinerary

18 September–30 December 2001
Wexner Center for the Arts
The Ohio State University
Columbus, Ohio, USA

16 February–7 April 2002
Kölnischer Kunstverein
Cologne, Germany

27 April–23 June 2002
Whitechapel Gallery
London, UK

25 July–5 October 2002
New Museum of Contemporary Art
New York, New York, USA

Editorial Concept
Carlos Basualdo

Edited by
Carlos Basualdo, Ann Bremner, Wexner Center
for the Arts

Translations
Sheila Glaser, Brian Holmes

Graphic Design
Saskia Helena Kruse, Munich

Reproduction
Franz Kaufmann GmbH, Ostfildern-Ruit

Printed by
Dr. Cantz'sche Druckerei, Ostfildern-Ruit

Published by
Kölnischer Kunstverein
New Museum of Contemporary Art
Wexner Center for the Arts, The Ohio State
University

in association with
Hatje Cantz Publishers
Senefelderstraße 12
73760 Ostfildern-Ruit
Germany
Tel. +49/7 11/4 40 50
Fax +49/7 11/4 40 52 20
Internet: www.hatjecantz.de

DISTRIBUTION IN THE US
D.A.P., Distributed Art Publishers, Inc.
155 Avenue of the Americas, Second Floor
New York, N.Y. 10013-1507
USA
Tel. +1/212/627 1999
Fax +1/212/627 9484

ISBN 3-7757-1095-7

Printed in Germany